RISO

The new spirit of printing

MANIA

Risomania – The new spirit of printing

The Deutsche Nationalbibliothek lists this publication in the Deutsche Nationalbibliografie; detailed bibliographic data are available on the internet at http://dnb.dnb.de

ISBN 978-3-7212-0966-2

© English edition 2017 Niggli, imprint of Braun Publishing AG, Salenstein - www.niggli.ch

2nd edition 2018

A Vetro Editions project - www.vetroeditions.com
© Vetro Editions
© Texts: John Z. Komurki (unless otherwise credited)

Author
John Z. Komurki

Curated by
Luca Bendandi and Luca Bogoni

Design
Luca Bogoni - www.lucabogoni.com

Risograph, Mimeograph and Other Stencil Duplicators

RISO MANIA

The new spirit of printing

Written by
John Z. Komurki

Curated by
Luca Bogoni and Luca Bendandi

TABLE OF CONTENTS

A Gallery of Artworks/Prints by: 476, Alt Går Bra, Atto, Bananafish Books, Bene Rohlmann, Calipso Press, Charles Nypels Lab, Colorama, Colour Code, Corners, DDG, Dizzy Ink, Drucken3000, Eleonora Marton, Fazed Grunion, Fotokino, Gato Negro Ediciones, Hansje van Halem, Hato Press, Hurrikan, Ink'chacha, Inkwell Press, Issue Press, Knuckles & Notch, Knust Press, Lentejas, Levi Jacobs, Meli-Melo, Paper! Tiger!, Print Club Torino, Printed Goods, Riso Club, Riso Presto, Risotrip, Risomat, RISOTTO Studio, Sandwich Mixto, Sigrid Calon, Studio Kkoya, Super Terrain, Tan & Loose, Topo Copy, Viktor Hachmang, We Make It, Woolly Press, &soWalter

RISO WORLD: GLOBAL HUBS, PRESSES AND COMMUNITIES

169

STENCIL BASICS: A STEP BY STEP GUIDE TO RISO & MIMEO PRINTING

213

STENCIL DUPLICATING: PAST, PRESENT AND FUTURE

THE RISOGRAPH

The Risograph, Riso printer, or RISO printer-duplicator is a stencil printer designed principally for high-volume duplicating. As a printing method it sits somewhere on the spectrum between screen printing and offset lithography, but what sets Riso apart is the unique aesthetic and highly tactile finish of the prints.

Although to the untrained eye the Riso duplicator may look a lot like a Xerox photocopier, the core Riso process is not entirely dissimilar to that of screen printing. Riso prints can, however, be produced at a fraction of the cost and effort of screen prints.

The first step in Riso printing is to create a thermographic master screen, or stencil. Stencils are made from a film of polyester resin bound to thin fibrous paper, the whole sheet being only a few microns thick. They can be created either by scanning an image directly into the printer, or by using software like Photoshop. To do this, you create a series of separate greyscale PDF files, one for each of the colours that are to feature in the final print. These are then sent via digital signals to a

thermal head within the duplicator, which burns perforations in the blank stencil.

The first of these stencils is then automatically wrapped round the rotating drum inside the Riso. During printing, this spins at high speed to push ink through the perforations in the screen and print the master image onto the paper. Once the first colour has been printed in this way, the master for the second colour is prepared and placed on a different colour drum; the paper is then fed back into the machine for the second colour layer to be printed on top of the first.

Riso inks are liquid and not coated or fully opaque. They come in a range of 21 standard colours as well as 50 custom colours which do not adhere to the Pantone system. There are a range of different effects and colours that can be obtained by overlaying individual colours and varying the paper stock. Most Riso prints tend to be either A4 or A3, but Riso also offers an A2 model.

The Riso is much more environmentally-friendly than other printing methods. Riso ink is made of soy oil. Soy inks contain lower levels of volatile organic compounds (VOCs), and using them

Opposite page: *Riso Print Guide* by Erica Wilk, 2015. Moniker Press

Below: Issue Press. Image of the studio. Photo courtesy of Jaimé Johnson

Issue Press. Detail from *Lest the Wild Beasts Outnumber You*, Rand Renfrow, 2014. Photo courtesy of Jaimé Johnson

Previous spread: Topo Copy, colour chart

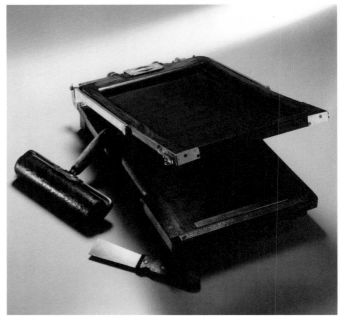

results in lower amounts of air pollution from toxic emissions being generated. In addition, because real ink rather than toner is used, there is no need to fix the image on paper with heat, as photocopiers or laser printers do (this is why photocopies come out warm to the touch). So Riso printers use less energy than heat-intensive devices. They are also faster, and some can produce up to 130 prints a minute. In addition, with the Risosolar project, "the world's first solar-powered, off-the-grid printing solution," Risograph has cemented its place at the forefront of environmentally viable printing.

In recent years, Risograph printing has become more and more popular with artists and designers around the world, and these economically- and environmentally-friendly aspects are key motives for this surge of interest. Fundamental, too, is the freedom that Riso printing confers. With a Riso, the artist is able to manage every step of the process, designing, printing, and then adapting the work based on the initial results. Working with a Risograph gives you total artistic independence, and the hands-on nature of the machine encourages experimentation and growth.

These and more factors lie behind the fact that more and more people are going crazy for Riso.

And, despite the quantity and diversity of creators who use Risographs, far from all of the potential of the medium has so far been explored. There is no doubt that the distinctive Riso touch will become increasingly prominent in the graphic fields over the coming years.

ORIGINS AND DEVELOPMENT OF RISO TECHNOLOGY

As we read in John Ross' authoritative *Complete Printmaker*, since 500 CE the Japanese have been innovators in the field of stencil printing for artistic ends. Ross describes how, "in their search for greater detail and precision," Japanese textile designers were innovators in the field of stencil printing: "They cut intricate images of great complexity and delicacy from double sheets of thin, waterproof papers. Between the double sheets they glued fine threads of silk or human hair to hold free-standing stencil forms and thin linear areas together."

Japanese stencil making techniques were much more sophisticated than any in use in Europe, and with the opening up of Japanese trade in the 19th century, European stencil makers incor-

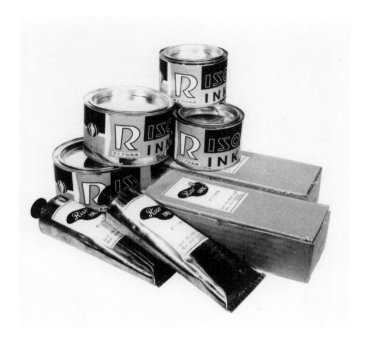

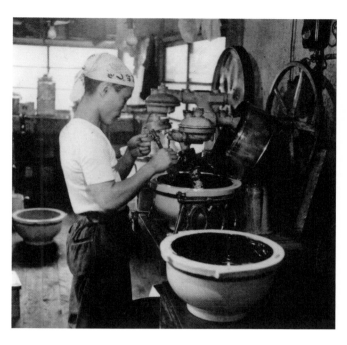

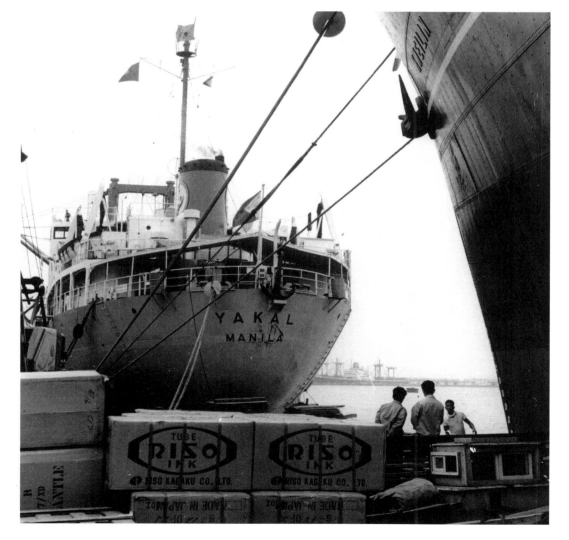

Opposite page, left:
Riso founder Noboru
Hayama in 1952.
Image courtesy of
Riso Kagaku Corp.

Opposite page, right:
The first Riso-Graph, made
in 1958, was a flatbed
duplicator, on which you
could make only one copy
at a time. Image courtesy
of Riso Kagaku Corp.

Above left:
Riso Ink, Japan's first
emulsion ink, was developed
in 1954. Image courtesy of
Riso Kagaku Corp.

Above right:
The Riso Ink laboratory and
ink factory. Image courtesy
of Riso Kagaku Corp.

Crates of Riso Ink ready for
export. Image courtesy of
Riso Kagaku Corp.

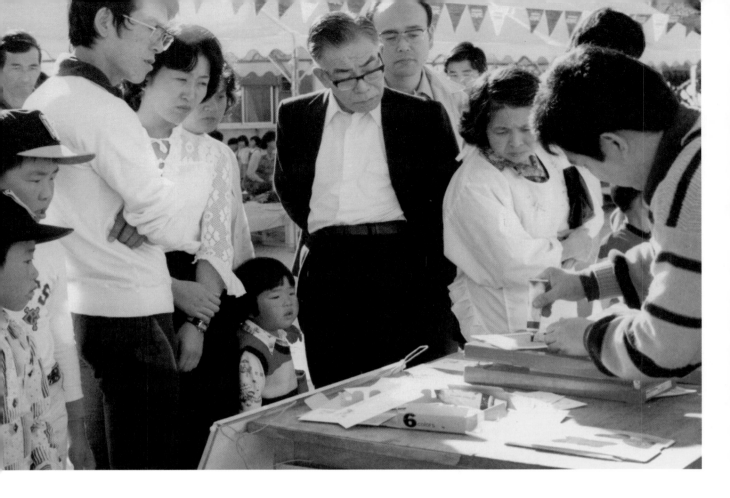

Above:
Demonstration of a Print
Gocco in action in 1977,
Japan. Image courtesy
of Riso Kagaku Corp.

Manufacturing line of Print
Gocco, a domestic screen
printing-type device that
was huge in Japan.
Image courtesy of Riso
Kagaku Corp.

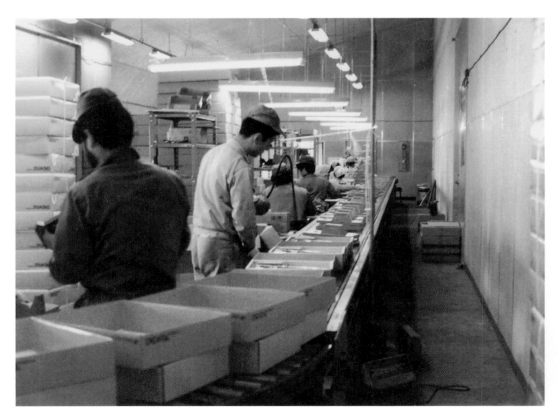

Opposite page:
A groovy Gocco kit made
in 1977. Image courtesy
of Riso Kagaku Corp.

porated many of them. And of course it was in the 19th century that Japanese woodcut prints began to arrive in Europe and the US, having a huge influence on artists including Van Gogh, Manet and Whistler. The distinctive *ukiyo-e* (or 'pictures of the floating world') woodcut technique was centred on water-based inks and the blending of watercolour washes, and could be used to create prints of great delicacy and expressiveness.

In short, Japan has for centuries boasted stencil-making and print-making cultures of extraordinary refinement. It is against this backdrop that we should place the emergence of Risograph technology.

In 1946, when Noboru Hayama set up a mimeograph printing company that he called 'Riso-sha' (Riso meaning 'ideal'), Japan was going through a period of numerous shortages, and emulsion ink was only available as an expensive import. By 1954, Hayama had developed Japan's first emulsion ink (Riso Ink). The first 'Riso-Graph' was a mimeograph-type duplicating device, released in 1958 and geared towards office use.

Then in 1959 Xerox launched their 'xerographic' or photocopy technology, and immediately began to edge mimeographs out of the market. It seems that the newly incorporated Riso Kagaku Corporation did not try to compete with the Xerox in terms of copying documents, and instead spent the 1960s refining and perfecting their ink and stencil duplicating products.

Having developed the ink, Riso concentrated on the stencil making process. In 1967, it started to produce a high-speed master-making machine called the RISO FAX JF-7, and towards the end of the 1970s it launched the Print Gocco, the first hit for the Riso brand. Derived from the Japanese word for 'make believe', the Gocco was a massive success on the home market (in decline since the 1990s, it has been estimated that at one point a third of Japanese households had one). Sold in a neat plastic kit and fusing the principles of

screen printing and rubber stamping, the Gocco was used above all to produce things like greetings cards; in the right hands, the Gocco can be made to produce an effect not dissimilar to that of the Riso proper. The Gocco was clearly not conceived for large volume printing and for that reason does not really feature on our radar here. But what it shows is that the Riso company was always working towards a level of finish that goes beyond the purely functional.

The two other major Japanese duplicator manufacturing companies, Duplo and Ricoh, are less well known by anyone but the general consumer. Ricoh is in fact one of the largest manufacturer of copiers in the world (having bought up competitors Gestetner and Rex Rotary Nashuatec), but while its machines are used all over the world for business purposes, it seems that not many artists or designers use Ricoh duplicators, and few of the studios we feature later in the book have one. Duplo, likewise, seems to be solely an office-orientated brand.

The Risograph as we know it today was launched in 1980. More than for producing multiple copies of documents, the Risograph was geared towards large-volume print runs, using original duplicating technology to do print in-house and at a fraction of the price of a print shop. 1984 saw the release of the Risograph 007, which integrated the stencil-making and printing functions

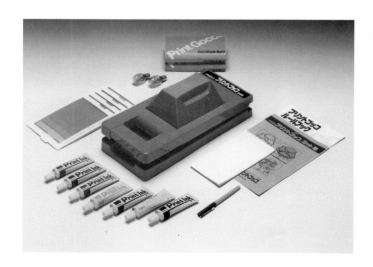

in one machine, and in 1986 a fully digitalized version as launched.

The marketing principal was quite straightforward: if you need to make more than 50 but fewer than 10,000 prints of something, it's cheaper to do it with a Riso. Using this clear and entirely accurate pitch, the company directed their products towards churches, schools, prisons and small political parties. And the Risograph quickly began to enjoy worldwide success. Riso Europe was set up in 1989, and all through the 1990s every year new subsidiaries were opened all over the world. Still today every few years a new one opens, the most recent being Riso Turkey Baski Cozumleri A.S. in 2016, and there are now more than 20 Riso subsidiaries worldwide.

And Riso continues to innovate, launching ranges of new printing devices that build on the core Riso technology. The artistic community, however, tend to prefer to use traditional models: the RISO MZ series that features dual drums, allowing two colours to be printed in one pass, is popular, as is the Full Colour Ink Jet Printer ComColor series.

RISO RENAISSANCE IN ART AND DESIGN

Over the last decade or so, more and more artists, designers and publishers have started to use Riso duplicators for visual projects, and small Riso studios have been opening around the world, from Sydney to Mexico City. As we have seen, one reason for this is undoubtedly the fact that Riso printing is so economical. Another is the environmentally-friendly nature of the whole process. But perhaps the most important factor is the finish of the print itself.

Above all, because Riso uses real ink, Riso prints are very tactile – you can really feel the ink. Stencil ink is a lot like oil paint, and works best on uncoated paper that absorbs more and creates a deeper image. The colours are incredibly bright and vivid, and it is easy to combine them by overlaying colours on top of colours, giving rise to a wide range of chromatic possibilities. Another characteristic of the Riso printing process is that, despite being digitally-based, there will always be minute variations between prints, even from the same run. This confers a palpable handmade aesthetic, and in principle means that each print is a unique piece. In addition, there will often be a few millimetres of 'misregistration', where the two masters didn't quite line up, or a slight mark where ink has clung to the rollers inside the machine. All of these details combine to confer on Riso prints a distinctive, attractive look, that is at the same absolutely contemporary and evocative of a different era.

The world is ever more digitalized, and the graphic arts are suffused with a slickly anonymous aesthetic that never leaves the computer screen. So it is that, while on the one hand the Risograph harks back to venerable Japanese stencil and printmaking traditions, on the other, to use a Riso is also in many ways an act of defiance to the digital homogenization of the arts.

There is something defiant, too, in the way that Riso makes the studio the focus of production, putting the power squarely in the hands of the makers. This fact reflects the inherently democratic potential of the technology. The nature of the process also encourages artists to develop grassroots networks of collaborators and like-minded creators, which, while they may not be geographically linked, have all the characteristics of a tight-knit local scene.

Risomaniacs are at the forefront of a growing movement that is recuperating older stencil-printing techniques and in the process bringing those technologies to unexpected and exciting new places. It makes sense to consider the Riso in the context of other stencil-duplicating methods which, while they may not be as widespread as the Risograph currently is, are nonetheless arousing increasing interest among a new generation of artists.

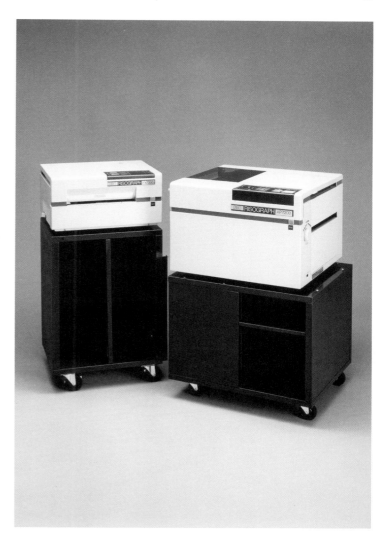

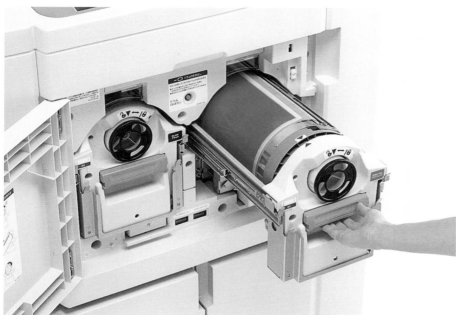

Above left:
Released in 1984, the
Risograph 007 integrated the
stencil making and printing
functions in one machine.
Image courtesy of Riso
Kagaku Corp.

Above right:
Risograph AP7200 and
FX7200. From 1980, the first
generation AP7200 is a
duplicator (for print only) and
the FX7200 is a master
(stencil) making machine.
Image courtesy of Riso
Kagaku Corp.

One of the two colour
cylinders inside a RISO MZ
(2 colour) series. Each
cylinder contains one colour.
Image courtesy of Riso
Kagaku Corp.

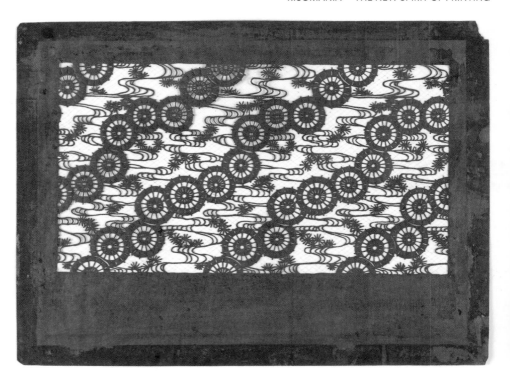

Unknown artist: Umbrellas, water and pine needle clusters. A stencil print from the late 19th century. Mulberry paper, lacquer made from persimmon juice, silk thread. Part of the collection of the Smithsonian Design Museum

Neolithic stencil printing from a cave wall in Cueva de las Manos (c.7,300 BCE), Rio Pinturas, Argentina

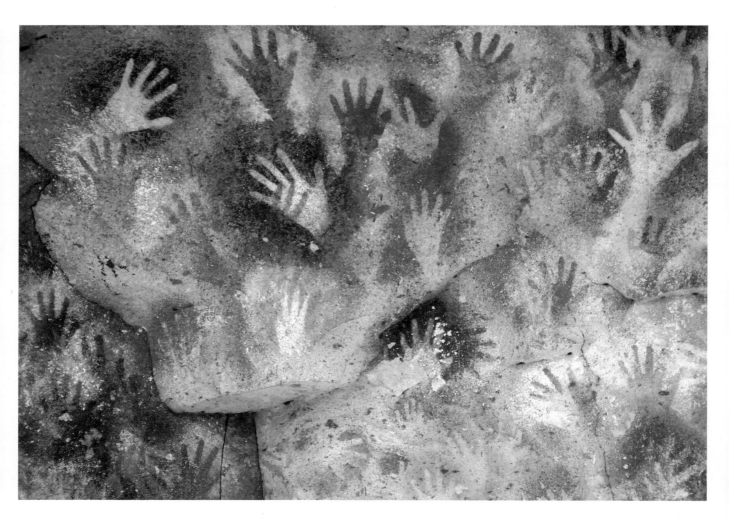

THE HISTORY OF STENCIL DUPLICATORS

Like the Buddha's life story or the Sun Ra discography, the history of stencil duplicating is characterized by confusion and controversy. To date there has been no comprehensive account published of it, although there are many books waiting to be written. Here, all we have the space to do is lay out the essentials of the development of this technology, and try to straighten out some of the misconceptions that bedevil the field.

One principal problem is that, barring digital duplicators like the Risograph, all stencil duplicating devices have long been obsolete. While anyone who worked in an office up until the early 1970s will be instantly transported back in time by a whiff of mimeo ink, if you were born later you would be baffled by this once all-but-ubiquitous machine, just as the youth of today would have a hard time even switching on an MS-DOS computer. An effect of this is that it is easy to assume that the Riso emerged fully-formed, or that it is some way a cousin of the Xerox. Both of these common assumptions are, however, completely unfounded, and the only way to dispel them is to go back to the origins of stencil duplicating techniques, and trace their evolution.

FROM THE NEOLITHIC TO THE INDUSTRIAL REVOLUTION

The first use of stencils occurred over 35,000 years ago, when *Homo sapiens* all over the world began pressing their hands to the walls of caves and carefully blowing pigment over them, leaving an imprinted outline. These imprints can still be seen from Argentina to Indonesia.

The idea of the stencil has thus been with us from the outset, and stencils have been used to apply patterns to cloth and other materials for countless centuries. The word stencil in fact originally referred to the parts that were cut out from a metal sheet to make shapes. In the Middle Ages, these sparkly scraps of tin were hung up at festivals to catch the light, and the word 'stencil' actually comes from the Latin 'scintillare', or 'sparkle' (as does the word 'tinsel', in fact). Most people's idea of a stencil is based on this principle of cutting shapes or letters out of a sheet, in order to paint onto textiles, walls, or paper. But stencil duplicating, while based on this premise, involves a vastly more complex use of stencils.

Around the middle of the 1800s, business and industry in the modern sense began to grow exponentially, above all in the US and the UK, as symbolized in 1851 by the Great Exhibition in Hyde Park, a celebration of the merciless expansion and consolidation of the British commercial empire. And a key feature of commerce is bureaucracy. Prior to around this period, there was no way to make multiple identical copies of the same document. But the increasing demands that this upsurge in international business placed on offices around the world created a need for a technology that would enable firms to produce many indistinguishable copies, whether for administration or what we today call marketing purposes.

During the Victorian era, manpower was cheap. One solution to the new demand for multiple copies of documents was to employ numerous copy clerks, who worked sitting on high stools for long hours in archetypically Dickensian surroundings, copying ledger entries and letters by hand (think Bob Cratchit in *A Christmas Carol*). Clearly, however, this solution was unsustainable and imprecise, as well as laborious and time-consuming.

The real revolution was to come in the 1870s, when people first began to consider how to apply stencil-based methods to copying. These methods enabled a massive increase in the amount of copying that could be undertaken, and with it the reach and impact of a company. Indeed, we may be inclined to agree with W.B. Proudfoot, one of the most renowned historians of stencil duplicators, that "the evolution of the modern office began with the invention of the stencil."

EDISON'S ELECTRIC PEN

The last 30 years of the 19th century were a time of astonishing scientific and technical as well as commercial progress: the typewriter was invented in 1872, the telephone in 1876, and the electric light in 1880. And Thomas Edison, one of the age's biggest names, also left his mark on duplicating technology, with his invention of the Electric Pen.

The basic process of all stencil duplicating technologies is the same. A special sheet of paper, often coated with wax or another impermeable substance, is inscribed with a suitable tool, perforating tiny holes in the paper. Ink or dye is then pushed through the perforations on this piece of paper (the stencil) onto a blank one, creating an imprint of whatever was inscribed on the stencil.

Edison was the first to develop an electrically-operated tool with which to 'write' on the paper, making the tiny holes needed to create a stencil. It consisted of a metal tube that connected a needle to a small electric motor, connected in turn to a battery, which enabled it to move up and down rather like the needle in a sewing machine

and make about 135 perforations a second. The Electric Pen came accompanied by a frame and flatbed. Once perforated, the stencil was laid atop a blank piece of paper within the flatbed, and a roller used to push the ink through it (Edison in fact did not use the term stencil, but called the process Autographic Printing). Around five copies could be run off every minute.

Both US and UK patents were granted in 1876, and the Electric Pen seems to have been a success. Some contemporary advertising promised that it made '5000 COPIES FROM A SINGLE WRITING'; we cannot overestimate the impact this development must have had on the business world, which had only just got used to the idea of the typewriter. No wonder the Electric Pen was taken up by, as the same ad proclaims, "City and State Governments, Railroad, Steamboat and Express Companies, Insurance and other Corporations, Colleges and Schools, Churches, Sabbath Schools, Societies, Bankers, Real Estate Dealers, Lawyers, Architects, Engineers, Accountants, Printers and Business Firms in every department of trade." In short, just about everyone saw the value of a duplicating machine.

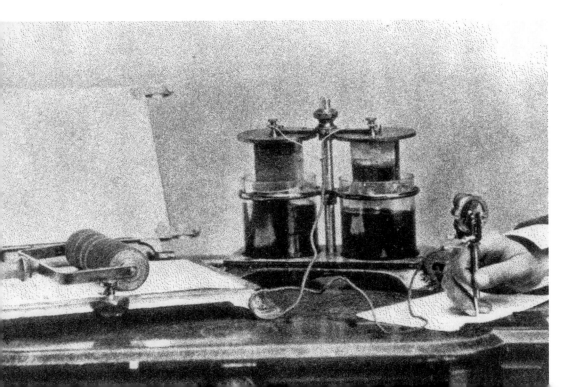

Thomas Edison's Electric Pen, an ancestor of both the mimeograph and the tattoo needle, was a successful product in the mid-1870s

Opposite page:
A period advertisment for the Electric Pen

EDISON'S
ELECTRIC PEN and PRESS

5000
COPIES FROM A SINGLE WRITING.

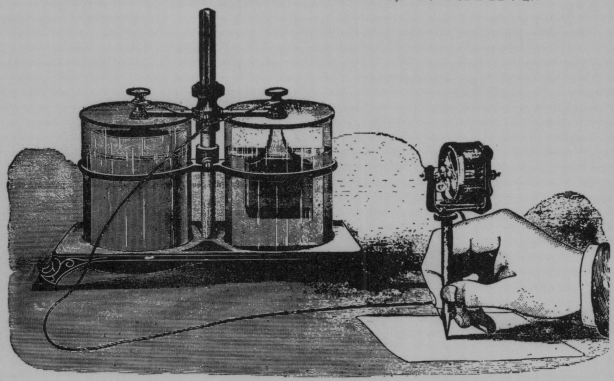

THE ELECTRIC PEN AND DUPLICATING PRESS

Was invented three years ago. Many thousands are now in use in the United States, Canada, Great Britain, France, Germany, Russia, Australia, New Zealand, Cuba, Brazil, China, Japan, and other countries.

Stencils can be made with the Electric Pen nearly as fast as writing can be done with an ordinary Pen. From 1,000 to 15,000 impressions can be taken from each stencil, by means of the Duplicating Press, at the speed of five to fifteen per minute.

The apparatus is used by the United States, City and State Governments, Railroad, Steamboat and Express Companies, Insurance and other Corporations, Colleges and Schools, Churches, Sabbath Schools, Societies, Bankers, Real Estate Dealers, Lawyers, Architects, Engineers, Accountants, Printers, and Business Firms in every department of trade.

It is especially valuable for the cheap and rapid production of all matter requiring duplication, such as Circulars, Price Lists, Market Quotations, Business Cards, Autographic Circular Letters and Postal Cards, Pamphlets, Catalogues, Ruled and Blank Forms, Lawyers' Briefs, Contracts, Abstracts, Legal Documents, Freight Tariffs, Time Tables, Invoices, Labels, Letter, Bill and Envelope Heads, Maps, Tracings, Architectural and Mechanical Drawings, Plans and Specifications, Bills of Fare, Music, Insurance Policies, Cypher Books, Cable and Telegraphic Codes, Financial Exhibits, Property Lists, Manifests, Inventories, Schedules, Shipping Lists, College and School Documents, Rolls, Examination Questions, Examples, Illustrations, Scholars' Reports, Lecture Notes, Regulations, Blanks, Official Notices, Mailing Lists, Committee Reports, Sermons, Lectures, Pastoral Information, Manuscripts, Journals, Fac-Similies of Papers, Drawings, Hieroglyphics, Programmes, Designs, etc.

Circulars prepared with the Electric Pen pass through the mails as third class matter at one cent per ounce or fraction thereof. Additional information and samples of work furnished on application.

PRICES—No. 1 Outfit, with 7×11 Press, $40.00.
" 2 " " 9×11 " 50.00.
" 3 " " 9×14 ". 60.00.
Sent C.O.D., or on Receipt of Price.

GEO. H. BLISS. GENERAL MANAGER, 220 TO 232 KINZIE STREET, CHICAGO.

LOCAL AGENCY, 142 La Salle Street, Chicago. | PHILADELPHIA AGENCY, 628 Chestnut St., Philadelphia.

DOMINION AGENCY, 44 Church Street, Toronto, Ont. | GEN'L EASTERN AGENCY, 20 New Church St., New York.

Vol I

The Herald

No 1

February 1885.

Edited and published by
F. W. G. Gilby.

6 Queen Margarets Grove London N.

Price one penny.

But the Electric Pen was not as perfect as it might have been. The pen itself was top-heavy and did not handle like a normal pen, while the copies were slightly unclear and visibly dotted, having what one historian calls "a distracting pointillist quality." The battery in particular was problematic. Being such a novel concept, many office workers were not able to fix it when it went even slightly wrong and, as Edison's collaborator Charles Batchelor noted, "it has kincks [sic] which deter it from going out to anybody but a man that understands a little about electricity." This led to a rival launching a similar product powered instead by a foot pump, as a sewing machine was. Nevertheless, the Electric Pen was still in use in the States in the 1890s, when it was finally killed off by new developments in the field.

THE PAPYROGRAPH, THE TRYPOGRAPH, AND THE FILE PLATE PROCESS

Often in the history of technical progress there comes a point when the zeitgeist simply demands that a certain step be taken, and different people independently rise to the challenge. This was the case with the Papyrograph.

While Edison was working on his Electric Pen at Menlo Park in New Jersey, in London the Italian law student Eugenio de Zuccato was trying to find a way to make multiple copies of handwritten legal documents, and in 1874 he obtained a patent for a device he called the Papyrograph. It worked in the following manner: first, you took a piece of paper varnished with ink-impermeable lacquer and "rendered limp and pliable by being impregnated with glycerine," in the words of the patent; this you wrote on using a steel-nibbed pen filled not with ink but with caustic soda, which ate through the lacquer and created your stencil. It was in fact Zuccato who first used the word stencil in the context of this machinery.

Zuccato went into business with Wolff, a stationer, and in 1877 marketed an improved version, which, according to the manufacturer, meant that "from 300 to 1000 facsimile impressions can be taken... direct from the original writing." This was a time-consuming and rather messy process, which all the same enjoyed some success, and as late as 1885 advertising copy was boasting that thousands of Papyrographs were in use in the US and abroad.

Also in 1877, Zuccato patented a different kind of stencil duplicating technology called the trypograph, from the Greek *trypan*, 'to bore'. This worked using a sheet of very thin paper coated with paraffin wax, and a metal plate with a surface like a file, covered in thousands of tiny points. The paper was placed wax-side-up on the plate and written on with a metal stylus "and a firm hand." The pressure caused the tiny sharp points on the metal plate to perforate paper and wax, creating a stencil. Oddly or, as we have noted, not, Edison was working simultaneously on a very similar principle, obtaining in 1880 a US patent for a device

A rare image of the Papyrograph designed by Zuccato

Opposite page:
A magazine produced using the File Plate Process. Courtesy of The Royal National Institute for the Deaf, London

that involved a bed of needle points or file-like metal plate as well as a blunt metal stylus, the tools needed for what he referred to as the File Plate Process (observe that in Europe and the US the same or very similar processes were called by different terms – this will continue to be the case). But Edison was busy with his Electric Pen and, boat missed, in 1885 he sold the patent, with the scattershot insouciance of the prolific inventor, to a man named Unz in Philadelphia.

The File Plate Process, meanwhile, was taken to Japan by a Mr Horii, who founded a stencil-making company that continued to file stencil-related patents well into the 1950s. This technique enjoyed considerable success in both Japan and China, even after it had been superseded in the US. This might be explained with reference to the different requirements of alphabets based on ideograms; indeed, it seems that these writing systems were better served by hand-stencilling methods than typewriters, which needed to feature many different characters. In his *Origin of Stencil Duplicating*, W.B Proudfoot notes that (in 1972) "the Chinese

Bookshop in Great Russell Street, London… still uses book lists prepared by this method." He includes a photo featuring a Chinese-made stylus and file plate, and a Japanese stencil.

The success of File Plate and later mimeograph technology in Japan may also shed some light on the emergence of the Risograph. We saw that stencil-based printing had been central to Japanese culture for centuries. If we accept that stencil-printing is well-suited to Japanese scripts – perhaps even better suited than duplicating methods based on the conventional keyboard – then it makes sense that a Japanese firm should have been pioneering in stencil duplicating when the rest of the world had turned its back on the method. But let's get back to our chronology.

THE MIMEOGRAPH

In 1884, 'Professor' Samuel F. O'Reilly got out of jail and started work on the world's first electric tattoo machine, for which he was awarded a pat-

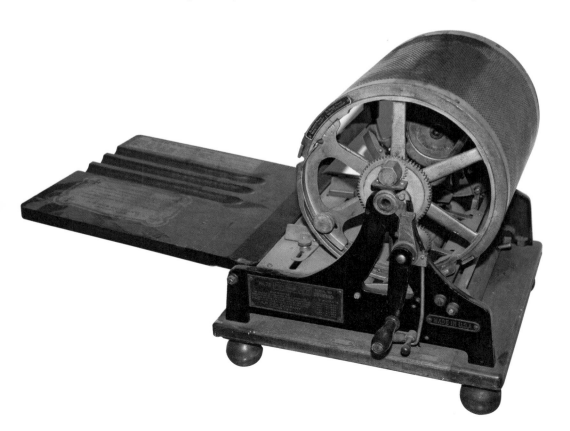

An A.B.Dick Mimeograph. The easiest way to distinguish a mimeograph from a Gestetner is to count the cylinders. Image courtesy Erwin Blok

Opposite page: From a Greif flatbed mimeograph promotional leaflet

SPRING'S HARVEST

Now the days are almost sure to be what we make them. They are likely to flower in rich plentifulness—for those who have the right equipment. The rapid and economical duplication of forms, bulletins, letters, drawings, etc., is today, more than ever before, a vital factor in business procedure. A thoughtful investigation of the Mimeograph's remarkable economies is now emphatically worth while. Write A. B. Dick Company, Chicago—or see classified 'phone directory for nearest branch.

EDISON-DICK
MIMEOGRAPH
CHICAGO

ent in 1891. His design was essentially a reworking of Edison's Electric Pen with an added reservoir of ink, making tattoo artistry yet another field which Edison had a hand in modernizing. (As it happens, stencil duplicating and tattooing have another connection, in that tattoo artists have long used mimeograph stencils to trace designs onto skin.)

But, barring this application, by the 1880s the Electric Pen was obsolete. As a Mr Johnson of the Edison Telephone Company of London wrote to Edison himself, "there are now a multitude of new devices for transferring letters, many of them very simple & effective – & cheap. It is too late to make any headway with the E.P. against a field borne of its own seed."

In the event, the field came to be dominated by another creation of Edison's, thanks to the intervention of Albert Blake Dick, proprietor of the A.B. Dick Company, Wholesale Dealers in Hardwood. Dick was an enterprising businessman interested in streamlining his office, to which end he developed a duplicating apparatus very similar to the File Plate Process, as well as a stylus that transferred ink to the paper, making him the third man in a decade to independently come up with what was broadly speaking the same technology.

When Dick decided to patent his apparatus, he found that Edison already had a patent similar enough to his own design to have to ask permission to use it. Granting this, Edison in turn had to chase down the Philadelphian Unz to whom, you will remember, he had sold the rights a few years earlier.

Dick re-christened the device a Mimeograph, a combination of Greek words meaning 'imitate' and 'write'. As he himself explained in 1934, in terms characteristic of the age, "an old friend hit upon the combination of 'mime' and 'graph.' But it didn't have the right swing. It wasn't euphonious. Then the 'o' was added, to give it the swing – and the right euphony was acquired."

It was a big hit from the get-go. Marketed as the Edison Mimeograph, the machine came to domi-

nate the US duplicating market: by 1910, there were 200,000 Mimeograph machines in use; by 1940, around 500,000. In his 1935 tract *Office Duplicating*, George H. Miller wrote that "[T]here is little doubt that stencil duplicating in America owes its rapid and widespread growth to the Mimeograph machines and stencils as developed by the A.B. Dick Company." For decades, if you needed to produce only a handful of copies of the same document, you would use carbon paper, inserted beneath the sheet you were typing on (the 'c.c.' field in emails refers to the practice of 'carbon copying' letters), while if you needed to make several thousand, then the print shop was probably your best bet. But for everything in between – from office circulars to school exams to church newsletters – there was the mimeo.

The success of Dick's apparatus was such that 'mimeograph' ended up becoming what is known as a generic trademark – that is, a brand name which is the generic word that people use to refer

TYPING BY AN OPEN WINDOW MAY BE
PLEASANT IN WARM WEATHER, BUT WATCH
OUT FOR GRITTY PARTICLES WHICH
MAY BLOW IN AND CAUSE 'PINHOLES'
WHEN COPIES ARE DUPLICATED.

to any of the different incarnations of that particular product, like kleenex, aspirin, or band-aid. In Europe the picture was a different one, as it was there that David Gestetner developed his cyclostyle technology, based on a similar mechanism, to which we will return in due course. But this fact – that 'to mimeograph' became the go-to verb to refer to many different kinds of stencil duplicating – generated some classificatory confusion. The Gestetner brand of duplicating machines, for example, are not mimeographs, and the brand always tried to clarify this, much as Dyson emphasises that they make vacuum cleaners not hoovers.

There was also a parallel technology known as spirit duplicating, often referred to as Ditto in the US and Banda in the UK, due to the leading manufacturers in those regions, which worked on a very different principle, but produced prints that were not too dissimilar to classic mimeo prints. Many people seem to confuse or conflate the two technologies.

We will return to spirit duplicating briefly later. For now, it is worth laying out the specifics of the Edison Mimeograph. The first model to be produced

was the Model O Flatbed Duplicator in 1887. This worked on the flatbed/squeegee model we are now familiar with. But by 1900, Dick had developed what he called a Rotary Mimeograph. These worked on the principle – very distinct from that of the flatbed – of wrapping the stencil round a cylindrical drum that was rotated using a handle. Ink was placed inside the drum, whence it passed through perforations into a felt pad that served as an ink-screen, as well as supporting the stencil. This method made it faster and easier to run off copies, and the basic principle of drum plus handle was not to change over the next 70 years of existence.

Whether for flatbed or drum, the preparation of the stencil was the key step in the process. The stencils for the original Model O were made from waxed mulberry paper, later substituted for porous, thick-fibred plain paper, immersion-coated in plasticised nitrocellulose and backed with a sheet of stiff card. The stencil was placed in the flatbed and a lanolin-based ink forced through it using the squeegee. Later on, an oil-based emulsion ink was adopted which contained turkey-red oil (sulphated castor oil), giving it a distinctive, Proustian aroma.

The Gestetner Ream model was the first machine able to fit 480 sheets (a ream). Image courtesy of Erwin Blok

Opposite page:
Illustration taken from a 1960s Gestetner manual on how to prepare stencils. Image courtesy of Erwin Blok

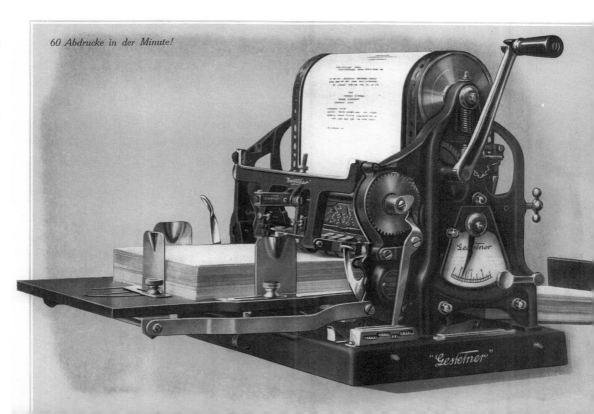

60 Abdrucke in der Minute!

In an office context, black ink tended to be most common, but colours such as blue, violet and green were also used. Mimeographed documents are highly distinctive, particularly when they feature hand-drawn elements. The line has a delicate, stippled effect to it, while the ink caused faint toning around the edge of the print, giving rise to the so-called 'halo effect'. In addition, as stencil-duplicating is a wet ink process, the underside of many prints feature a 'ghosted' reverse text, left by the preceding print in the stack (the same feature is evident in Riso prints).

A typical mimeo print would combine both hand-designed and typewritten elements, and you could buy pre-made layouts into which you simply inserted your text. Journalist Harmon Jolley recalls in an article how text "had to be left and right-aligned, which required that I insert enough extra spaces between words to create an even right margin. To do that, I had to type a draft of each article, pad each line with slashes (/), and then re-type it while I counted the number of slashes and inserted extra spaces to match."

By today's standards, preparing mimeo stencils could be an absurdly painstaking process. In her biography *Recollections of My Life as a Woman*, beat poet and mimeo pioneer Diane Di Prima recalls typing "onto green [...] mimeograph stencils with my ancient, heavy IBM typewriter. [...] Correcting mimeograph stencils was painful and painstaking. You applied a liquid plastic, also green, which closed over the typing as it dried, making a new plastic 'skin.' You had to make sure the schmear of fluid didn't adhere to the stencil's backing sheet, or it would tear off again leaving a big hole in the stencil just when you were ready to print [...] Painful and nerve-wracking, it was the worst part of the process and makes it clear to me that computers came none too soon."

In addition, the stencil would stretch and warp with use, limiting the number of copies that could

op edge,
permost.
r passed
d to the
g sheet,
ring that
per (put
t.

 with a
 waxed
 the Neo
silk. Pro-
essed in

ally hap- ▶
iter. The
he impact
ncil tissue
he centres
ition and

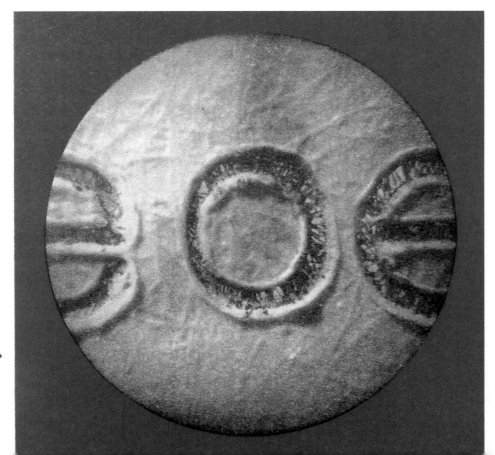

A Gestetner stencil under the microscope. We can discern the effect of the typewriter that strips away the ink but leaves the fibrous structure of the stencil. Image courtesy of Erwin Blok

Opposite page:
From a period Gestetner manual, a diagram illustrating the different components of the stencil. Image courtesy of Erwin Blok

Gestetner

DUROTYPE № 6

BEFORE TYPING STENCIL PLACE TOP EDGE OF PAPER TO BE PRINTED AGAINST THIS LINE
WHERE IT IS DESIRED THAT PRINTING SHOULD COMMENCE. SET POINTER OF MACHINE TO
AUTOMATICALLY OBTAINED WHEN PRINTING COPIES

NOTE NUMBER OPPOSITE ON SIDE OF FRAME
ZERO AND THE DESIRED POSITION WILL BE

0 10 20 30 40 50 60 70 80

BEFORE TYPING STENCIL INSERT CARBON SHEET COATED SIDE UPWARDS
DO NOT TYPE OUTSIDE THIS FRAME

SIXMO SIZE PAPER POSITION

OCTAVO SIZE PAPER POSITION

20 30 40 50 60 70 80

GUARANTEED AND MADE ONLY BY

Gestetner LTD.

LONDON. N.17. ENGLAND

HEADING

GUIDE LINES

STENCIL PROPER

THUMB HOLE
TO SEPARATE
STENCIL AND
BACKING SHEET

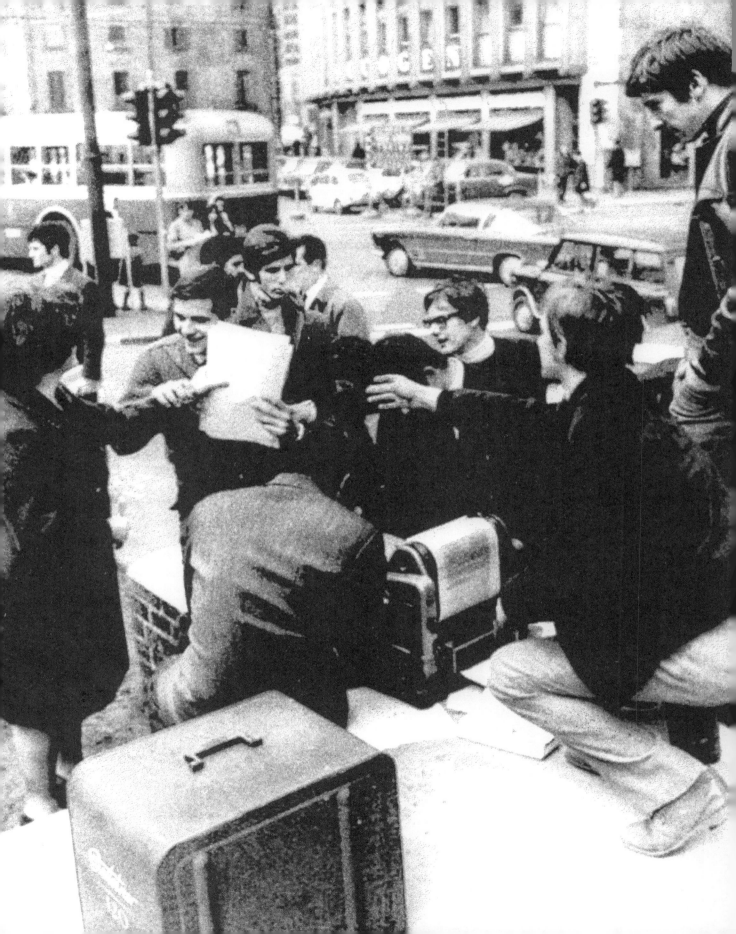

Examples of mimeo-printed Sci Fi zines *Spaceship* and *Cactus* from the Lenny Kaye Collection. Images courtesy of Boo-Hooray

Opposite page:
Risograph print of a photo of a meeting of students in Milan in 1968, when the mimeograph was synonymous with the spread of radical ideas

be made. This stretch effect would start near the top, where the stencil was pulled through the machine, giving rise to a recognisable 'mid-line sag' on prints, which would get progressively worse until the stencil gave up the ghost completely. Another issue was that the insides of closed letterforms ('a', 'b', 'd', etc.) tended to fall away.

But these limitations and frustrations did not detract from the revolutionary impact that the mimeograph and similar technologies had. We have seen that stencil duplicating transformed the office, and radically expanded the printing opportunities of community organizations. But one of the more memorable impacts of the mimeograph was on small-scale independent publishing. Being so cheap, easy to use and flexible, it enabled artists, writers and agitators to disseminate their work more quickly than ever before. Lincoln Cushing, authority on political poster art, underlines how, while it may be hard to believe in an age "when 'colour separation' isn't even a conscious act and photographs can be effortlessly published on a webpage […] this clunky technology was a breakthrough aesthetic boon to democratic media."

The first subculture to realize this, it seems, were Science Fiction authors and fans, who from the 1920s onwards used stencil technology to produce a whole galaxy of magazines and other publications. You can get an idea of how vibrant and varied the scene was from the collection of musician Lenny Kaye, owned by the University of Miami (the invaluable Boo Hooray project organized a seminal exhibition drawn from Kaye's archive).

The mimeograph was also adopted for more explicitly political ends, notably among the gay and lesbian community and other activist groups. But it is the world of alternative or countercultural literature that is most often associated with mimeograph-type technology. There was such a flowering of 'little magazines' in the US in the 1950s and 1960s that people talked about a Mimeograph Revolution involving many of the lit luminaries of the day. Not many people know, for example, that Allen Ginsberg's epochal *Howl* was first published on a mimeograph (typed up by Martha Rexroth and printed by the legendary Robert Creeley).

Based primarily in New York and San Francisco, the Mimeograph Revolution gave rise to a slew of

3 klactoveedsedsteen 3

William S. Burroughs
Jeff Nuttall
Kwee Sinh
Jm LeSidaner
Peter S. Beagle
Alex Hand
Pieter Beek
Glyn Pursglove
Dan Georgakas
Paul Wiens
Vilmos K. Last
Carl Weissner

May 1966

influential magazines, among them such colourfully monikered titles as *Runcible Spoon, Angel Hair, L=A=N=G=U=A=G=E, Salted Feathers, Toothpaste, Wild Dog, Floating Bear,* and *Fuck You: A Magazine for the Arts*. Among these, Diane Di Prima and Leroi Jones's *Floating Bear* and poet Ed Sanders' *Fuck You* are mentioned as being particularly influential, while Jack Spicer's *J* magazine has been called the most beautiful. Mexico too saw a mimeo revolution, its most well-known proponent being the legendary *El Corno Emplumado*.

It is worth remembering that many of the key magazines in the Mimeo Revolution were not actually mimeographed, and many of them also featured offset and letterpress elements. Nevertheless, there is no question that the aesthetic and the 'people power' energy of the movement were defined by the mimeograph. In the words of Detroit filmmaker and beat veteran Cary Loren, "[E]ach of these small press mimeo-gangs participated in a 'collage' aesthetic. Working as tiny collectives they experimented patching new media together in unique designs and combinations. Presentation, delivery, politics and authorship were challenged [...] Ideas that were soon spilling over into the contemporary art scene battled there [sic] way awkwardly and beautifully

through the pages of these small journals." Or, to put a slightly different spin on it, we could quote German philosopher Theodor Adorno, who in 1951 wrote that, "[I]f the invention of the printing press inaugurated the bourgeois era, the time is at hand for its repeal by the mimeograph, the only fitting, the unobtrusive means of dissemination."

And the mimeo reigned supreme for a long while. Indeed, it was only really with the advent of the unlovely Xerox that mimeographed copies ceased to be a feature of day-to-day life. The desktop laser printer was the final nail in the coffin: A.B. Dick went bankrupt in 2004.

In some parts of the world, however, mimeographs remain popular. In Lahore, Pakistan, for example, in the area around the Anarkali Bazaar you can still find numerous print workshops that work primarily with mimeographs, some of them of considerable antiquity. This is partly because running mimeos is cheap, and does not depend on electricity – a crucial factor, given that the city experiences daily power cuts. In addition, an experienced mimeo printer can fix pretty much anything that goes wrong with his or her machine, something that is not true of a Xerox.

Left and opposite page: Some examples of publications from the Mimeo Revolution: *Klactoveedsedsteen*, and *Fuck You*. Images from the Reality Studio archive

Tangerine Zine. Cover is overlaid with orange acetate. 1980s. Image courtesy of Boo-Hooray

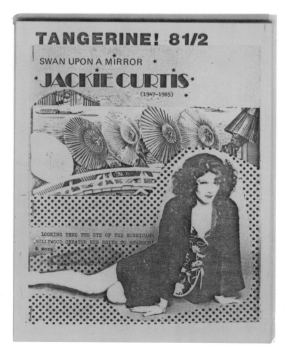

THE GESTETNER

In the context of the Mimeo Revolution, it is important to highlight once again that 'mimeograph' was a kind of catch-all term for every kind of stencil duplicating process, and was often used willy-nilly to include techniques that had nothing to do with stencils at all.

In fact, very often when people refer to mimeographs, what they are really talking about is the Gestetner duplicating device; in the literature on the era it is even common to hear people talking about a 'Gestetner mimeograph', which, as any Gestetner-head will tell you, is a bit like saying 'a Coke Pepsi' or 'a Microsoft Mac'. Indeed, there is a crucial difference which equating the mimeograph and the Gestetner belies, namely, the fact that the mimeo has one drum and the Gestetner two.

There is one source that is under no misapprehensions regarding the difference between the Gestetner and the common or garden mimeo, namely, Dr. Gafia's Fan Terms, a fascinating online compendium of terminology dating from the golden age of Science Fiction fandom, curated by a certain rich brown [sic]. It defines the Gestetner in this way: "An English brand of mimeograph that for many years was unavailable in the U.S. [...] Where U.S. models had cotton ink pads, Gestetners utilized a silk screen; where American mimeos relied on internal brushes and centrifugal force (or, on cheaper machines, outside applications with a brush) to spread ink around, the Gestetner used far superior waver rollers. The Gestetner also had a sophisticated method of adjustment that allowed for better registration (establishing where the print area will hit on the page), which made it vastly superior for two- and three-color mimeograph work."

It seems that the terminological confusion stemmed from the fact that Dick's Edison Mimeograph was launched in the US around the same time as David Gestetner launched his cyclostyle in the UK. While, as Dr. Gafia affirms, the mimeograph was perhaps the predominant exemplar of this technology in the States, in the UK and Europe the cyclostyle, or simply Gestetner, was the most visible duplicator. To illustrate the point, if you type 'mimeografo' into Wikipedia in Italian,

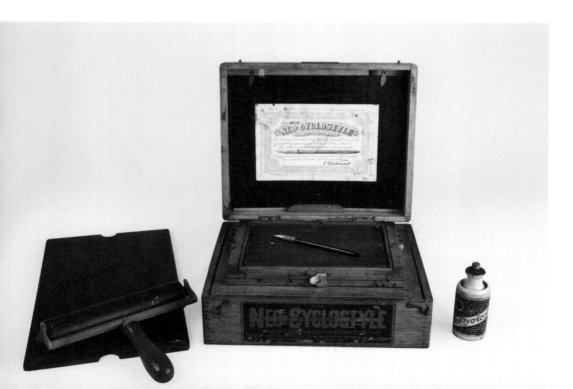

A Gestetner Neo-Cyclostyle. One of the first flat-bed model produced. Photo by Maria Silvano. Image courtesy of Erwin Blok

Opposite page:
A vintage french Gestetner ad. Image courtesy of Erwin Blok

Mais oui
j'ai le temps !

.. mon Gestetner imprime l'urgent, comme en se jouant !

Lorsque mon chef est pressé, je puis toujours compter sur mon Gestetner —
pourvu que je frappe convenablement mon stencil et que je prenne soin du tirage.
Bien perforer le stencil : voilà l'essentiel de mon travail, car mes copies ne seront
parfaites que dans la mesure où mon stencil le sera également. Quant au tirage,
il a, certes, son importance aussi, mais mon Gestetner en fait un jeu d'enfant.

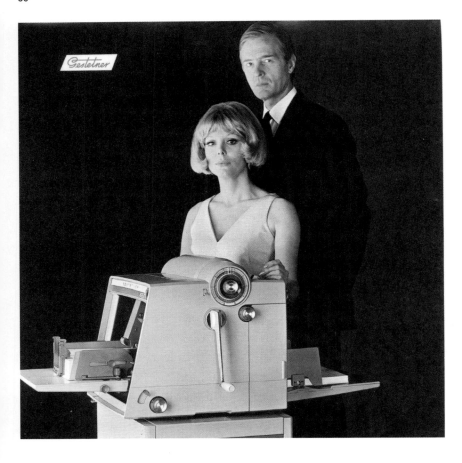

The Gestetner was the
duplicator of choice for hip
young things, as seen in this
contemporary advertising.
Image courtesy of Erwin Blok

The first and last models of
the Gestetner stencil
duplicator. Image courtesy
of Erwin Blok

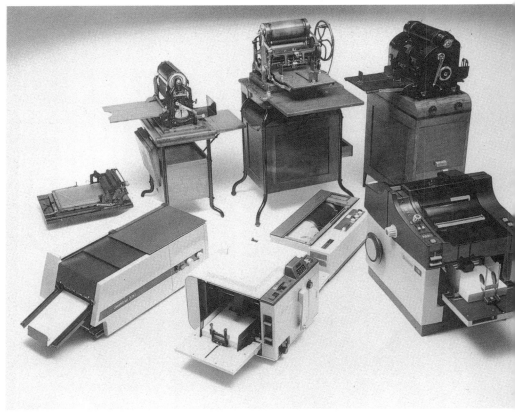

it will redirect you to the 'ciclostile' page, which opens: "Il ciclostile, o duplicatore stencil (raramente mimeografo)". (Meanwhile, perplexingly, in German a mimeo is sometimes referred to as a 'Hektograph'). So we can see that the terms in which your grandparents thought about stencil duplicating depended largely on which side of the Atlantic they were born.

David Gestetner himself was born in 1854 in Hungary. In 1873, he found himself selling Japanese kites on a Chicago street corner, having occasion to note the long, strong fibres of the lacquer-coated paper used in their assembly. In 1877 he went back to Vienna and into business selling hectograph copying devices with his uncle, with such little success that he eventually moved to London and found work at a stationer's near Liverpool Street.

The next we hear of Gestetner is in 1880, when he is granted a patent for "a board or plate on one surface of which a series of fine wires were laid side by side to form a writing bed for waxed paper stencils placed on it and written with a blunt metal stylus." But the big breakthrough came the following year when he patented a sort of pen for making the stencils, consisting of a wooden holder containing a steel shaft, in which was mounted a small, tooth-edged wheel.

Named the cyclostyle, this device's importance resides in the fact it was the first tool that could make good uniform perforations in the stencil, enabling one to print close representations of handwriting. (Shortly afterwards, Gestetner patented a similar device to print staves for musical notation, which featured not one but five of the same wheels.) The apparatus that went with the cyclostyle was a flatbed, similar to that of the Dick Mimeograph, but wider. The ink was also applied by hand with a squeegee.

The only issue with the cyclostyle was that the axis of the wheel was set at right angles to the stylus, which meant it had to be held vertically. In 1888, Gestetner obtained a patent for an improved version with a bent tip that allowed the user to hold it just as they would a pen. In addition, the tip was shaped like a pen nib, making the process even more like handwriting. This improved version was known as the neo-cyclostyle in the UK and the neostyle in the US, and came in an elegant, brass-hinged oak box. Later on, different types of stylus were introduced that created a different effect or thickness of line; some artists even used engraving tools to create stencils.

Another important innovation that David Gestetner brought to the duplicating sphere was in terms of the paper used for making stencils. It was he who first hit on a type of Japanese paper (remember the kites) called Takamatsu, made from bamboo fibre. As the *Journal of the Society for the Arts* explained in 1880, Japanese paper was notable for its pliancy, wet strength, fineness and lightness, and imperviousness to insects and larvae. In addition to these qualities, its long, fine, tough fibres form a relatively open-texture sheet, which allowed the cyclostyle to make perforations without breaking any fibres. Early advertising claimed that 2000 copies could be made from one stencil. Later, Gestetner produced stencils that could be cut in a typewriter. These used Japanese Yoshino paper, made from the paper mulberry plant, substituted by the 1930s with an industrially-produced version.

The US patent for the Gestetner cyclostyle was granted in 1885, two years before the Dick mimeo was launched, and the neostyle was put on the US market in 1888 bearing the guarantee signature 'D. Gestetner'. An ad for the Pennsylvania Cyclostyle Company from 1889 features a small text box headed with the following admonitory sentence: "Caution – The suit pending since 1887 between Edison and ourselves was decided April 5 1889, by Judge Coxe […] in our favor."

The next big step for Gestetner lay in automating the whole process. 1893 saw the launch of the automatic cyclostyle; some contemporary ad copy shows that he was still worried about

piracy: "Patented in all civilized countries. Infringers prosecuted to the full extent of the Law." Interestingly, around this point Gestetner and Dick entered into several reciprocal business arrangements for the sale and production of stencils and equipment, and it seems we may infer from this that the market had already begun to be threatened by inferior knock-offs.

David Gestetner initially ran his business out of a small room in Sun Street, Finsbury Circus, London; he later moved to Bunhill Row (*salve magna parens*) near Old Street and from there to Tottenham, where the Gestetner factory stood for many decades. The development that gave rise to the need for a substantial factory was the introduction of rotatory duplicators.

The early 1900s marked a seismic shift in the world of commerce, as businesses became bigger and more formalized, and consumers more sophisticated. In addition, the simple fact that more people than ever before could read led to greater demand for printed material, a demand which could only be met by streamlining the duplicating process.

As we have seen, A.B. Dick launched his Rotary Mimeograph in 1900. Gestetner's rotary cyclostyle, produced a few years later, functioned on a very similar basis, with the one fundamental and far-reaching difference, that it featured two drums rather than just one. It worked by passing the silk ink-screen round two cylinders, to one of which ink was applied. The ink was transferred from the ink-screen to the stencil laid on top of it. As in the mimeo, a mangle was then turned, pressing the copy paper against the ink-impregnated stencil.

Proudfoot gushingly describes the No. 3 Rotary Cyclostyle as "the epitome of Edwardian elegance in office furniture"; it is, indeed, magnificent. Superseding two short-lived prototypes, the No. 3 was not discontinued until 1950, a testament to Gestetner's engineering genius. While several different patents were granted for single-drum

devices, no company other than Gestetner manufactured a two-drum duplicator.

It was around this time that Klaber, Gestetner's US distributor, went rogue and moved to London to market his own single-drum duplicator, which he named the rotary neostyle. Gestetner sued, and the High Court obliged Klaber to change the name of his product, which he duly did by combining the first syllables of rotary and neostyle and setting up Roneo Limited in 1907 (there is still a 'Roneo Corner' in Romford, Essex, where the Roneo factory once was). For many people, the Roneo is another synonym for mimeograph, and it is indeed an essentially identical machine.

The Gestetner was and is by all accounts a great machine to use. The two drum system was easily lent to artistic ends. In a fascinating snapshot of how Gestetners were operated during the 1960s, California artist and printer Jane Norling described how little magazines were turned out: "The Gestetner process allowed us to create artwork with pencil and marking pens directly on letter or legal-size paper, affixing strips of type, gluing paper with typewriter text to layout, placing on scanning drum and etching stencils. [...] Limitation: scans from photography produced murky color prints. My workaround was to trim photos in erratic shapes to catch the eye, so content of images was less of a concern. The technology was the message."

Norling mentions another important innovation: the Gestefax scanner. In the words of Claude Hayward, founder of the Communication Company, a street press run in San Francisco's Haight-Ashbury neighbourhood in the 1960s, the Gestefax was "a stencil cutting machine that would reproduce a layout as a stencil for the mimeograph machine. Its pre-digital technology involved a beam of light reading the original as it spun on a revolving drum while burning through the thin rubber paper-backed stencil, rotating simultaneously next to the original, with a spark modulated by the scanning light [...] It allowed us to reproduce anything from text to halftones faithfully and rapidly."

erformaat

pierformaat 38 x 25.5 cm.

rukformaat 33 x 21 cm.

EXPRESS" INKTING

oor het simpel overhalen
n een handle voert men
inkt over de gehele
reedte van de cylinders of
ver een deel hiervan toe.

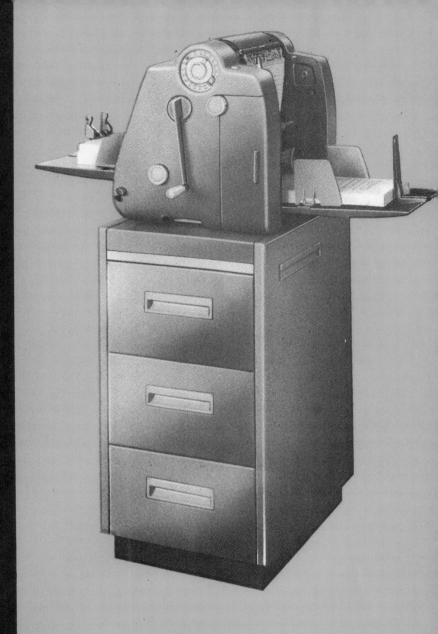

CABINET

Een nieuw ontworpen cabinet is
verkrijgbaar bij de 320. De
bovenlade is speciaal ingericht
voor het opbergen van
kleurendruk accessoires. In
de onderste laden is ruim plaats
voor andere Gestetner
materialen.

A page from a 1960s
pamphlet on the Gestetner
320. Image courtesy of Erwin
Blok

OTHER DUPLICATORS

In this book we focus on the Risograph in particular and on stencil duplicators in general. But there is or was a whole universe of other duplicating techniques out there, some of which preceded the stencil, and some which co-existed alongside it. Here, it makes sense to look at a few of these technologies, albeit briefly, to get a sense of the many different solutions that were devised to the problem of copying documents. Some of these alternatives have fallen by the wayside; others retain a niche presence in the world of printing; some would be well worth reviving.

There is a sense in which desktop publishing really began in 1856, with British chemist William Perkin's discovery of aniline purple, the world's first synthetic dye. Aniline purple enabled the development of the first method of mechanically reproducing documents. This process involved writing on a sheet of paper with the copying ink; another moistened sheet of tissue paper was then placed on top of it and the two clamped together in a massive iron press, meaning that a copy of the original letter was stamped onto the tissue paper. The thing was that the copy obviously picked up a mirror-image of the original, and had to be held up to the light to be read.

Aniline dye later made another copying process possible. Remember that David Gestetner at one point went into business with his uncle selling something called a hectograph? The hectograph (sometimes hektograph or jellygraph) worked on what today seems a rather charming basis. The key ingredient was gelatine, either in the form of a gelatine pad stretched in a metal frame or, simply, a pan full of solidified gelatine.

The master was created by writing on a sheet of paper with aniline ink. This you then pressed into the gelatine, which would absorb the ink, creating a mirror-image imprint in its surface. On top of this you would then place a blank piece of paper and leave it for a few moments, stroking gently the back of it, until it had picked up an imprint of the master. This process could be repeated a number of times, with the prints getting progressively fainter, until all the ink had been lifted off the gelatine.

Hectography was popular wherever funds or available technology were limited. Alongside school tests and church newsletters, it was widely used for making clandestine or cult publications. A famous example is the prisoners of war in Colditz during the Second World War, who faked documents using an improvised hectograph. Like the mimeo, the hectograph was also popular with Sci Fi fans. And it was sometimes used for artistic ends, maybe most notably by the Russian futurists.

But the hectograph was a notoriously fiddly, messy process, and it wasn't long before someone came up with a more efficient way to use aniline dyes to reproduce documents. This technology, patented by Wilhelm Ritzerfeld in 1923, was called spirit duplicating, although it was more commonly known as Ditto in the US and Banda in the UK, after the biggest producers in those respective countries.

The 'spirit' part of the name came from the alcohols that featured prominently in the solvents used as ink. A vivid, unmistakeable purple called 'crystal violet' was the most commonly-used colour. It was very similar, naturally, to that of hectograph prints. But with spirit duplicators you never needed to get your hands dirty. To make a master, you simply typed or wrote on the master sheet which was backed by a second sheet of paper, one side of which was coated with dye. What you wrote appeared on the back of the Ditto sheet in mirror image. This you placed in the machine along with another sheet moistened with an alcohol-based liquid. This dissolved some of the ink on the master, allowing the image to be transferred, right-way-round, to the blank sheet.

This alcohol-based liquid (10% monofluoro tri-chloro methane, 90% a mixture of methyl

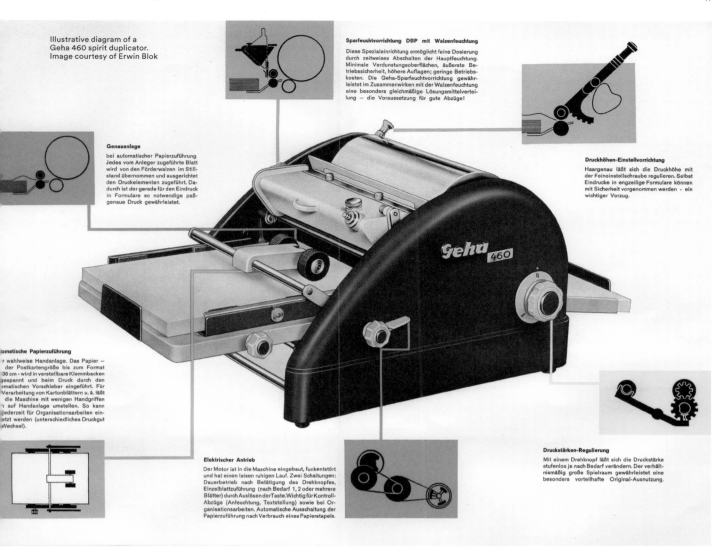

Illustrative diagram of a
Geha 460 spirit duplicator.
Image courtesy of Erwin Blok

Sparfeuchtvorrichtung DBP mit Walzenfeuchtung

Diese Spezialeinrichtung ermöglicht feine Dosierung durch zeitweises Abschalten der Hauptfeuchtung. Minimale Verdunstungsoberflächen, äußerste Betriebssicherheit, höhere Auflagen; geringe Betriebskosten. Die Geha-Sparfeuchtvorrichtung gewährleistet im Zusammenwirken mit der Walzenfeuchtung eine besonders gleichmäßige Lösungsmittelverteilung – die Voraussetzung für gute Abzüge!

Genauanlage

bei automatischer Papierzuführung. Jedes vom Anleger zugeführte Blatt wird von den Förderwalzen im Stillstand übernommen und ausgerichtet den Druckelementen zugeführt. Dadurch ist der gerade für den Eindruck in Formulare so notwendige paßgenaue Druck gewährleistet.

Druckhöhen-Einstellvorrichtung

Haargenau läßt sich die Druckhöhe mit der Feineinstellschraube regulieren. Selbst Eindrucke in engzeilige Formulare können mit Sicherheit vorgenommen werden - ein wichtiger Vorzug.

omatische Papierzuführung

r wahlweise Handanlage. Das Papier –
der Postkartengröße bis zum Format
36 cm - wird in verstellbare Klemmbacken
gespannt und beim Druck durch den
omatischen Vorschieber eingeführt. Für
Verarbeitung von Kartonblättern u. ä. läßt
die Maschine mit wenigen Handgriffen
h auf Handanlage umstellen. So kann
jederzeit für Organisationsarbeiten ein-
etzt werden (unterschiedliches Druckgut
Wechsel).

Elektrischer Antrieb

Der Motor ist in die Maschine eingebaut, funkentstört und hat einen leisen ruhigen Lauf. Zwei Schaltungen: Dauerbetrieb nach Betätigung des Drehknopfes, Einzelblattzuführung (nach Bedarf 1, 2 oder mehrere Blätter) durch Auslösen der Taste. Wichtig für Kontroll-Abzüge (Anfeuchtung, Textstellung) sowie bei Organisationsarbeiten. Automatische Ausschaltung der Papierzuführung nach Verbrauch eines Papierstapels.

Druckstärken-Regulierung

Mit einem Drehknopf läßt sich die Druckstärke stufenlos je nach Bedarf verändern. Der verhältnismäßig große Spielraum gewährleistet eine besonders vorteilhafte Original-Ausnutzung.

alcohol, ethyl alcohol, water, and ethylene glycol mono-ethyl ether, in case you wondered) gave spirit-duplicated sheets a lush, memorable scent, lusher even than mimeo prints. In the 1982 high school classic *Fast Times At Ridgemont High*, a teacher gives out to the class a test that has been run off a Ditto machine: when they get their copies, all the students hold them to their noses and inhale deeply.

Spirit duplicators co-existed happily alongside mimeo and Gestetner for many decades. Even among people who grew up with these devices, there exists a lot of confusion as to which was which (the most common misconception is that Ditto and mimeo were simply the same thing).

But the differences between the two methods became entirely academic with the advent of the Xerox photocopier, which provided a cheaper and more efficient alternative to other types of duplicating. The only problem with Xerox copies, of course, is that they aren't very nice to look at. Or even sniff.

And this is where the older forms of duplicating and printing remain relevant – more so today, in fact, than ever before. Because if you want to run off 60 copies of a chemistry test, then use a photocopier. But if you want to make a print that has character and aesthetic presence, is memorable and worth keeping, then old school is for you.

MAPPING THE MOVEMENT: PIONEERS AND INNOVATORS

BULLETIN FROM THE ACADEMY: AN INTERVIEW WITH JO FRENKEN, HEAD OF CHARLES NYPELS LAB

Located in Maastricht, the Van Eyck Academie is a post-academic institute for the development of artistic talent. The Van Eyck has a multiform structure that brings together various different elements, among them the Charles Nypels Lab. Named after the Maastricht typographer and de-signer Charles Nypels (1895–1952), the Lab invites artists, writers, designers, photographers, poets, scientists and essayists to develop and print their work. Equipment for relief printing (letterpress, wood and lino cuts, polymer) and screen printing (Risography, silkscreen) for processing and finish-ing, enables them to experiment while creating editions of their own work.

The Charles Nypels Lab offers all the expertise necessary for making publications, from editing and translation to types of paper and binding meth-ods. The Lab's strength is the combination of tech-niques, such as silkscreen printing or Risography with offset print work. Thanks to its partnership with RISO France and Benelux, the Lab received the first RISO A2 Duplicator in the world outside of Russia, organized the first Magical RISO Expert Meeting in 2014 and the second in 2016, and will host the RISO Art Week – RAW. Riso pioneer and lynchpin of the Charles Nypels Lab, for over 30 years Jo Frenken has been a tutor at the Van Eyck Academie in various print-related functions, and for 20 years has been teacher of graphic design at the Academy of Architecture in Maastricht. He talks to us about the history of the Van Eyck and his own experience of Riso printing.

When did the Risograph first come to promi-nence? Who were the first people to adopt it in the context of art and graphic design?

At the end of the 1980s, Riso Kagaku put their first duplicator on the market. My colleagues at Knust Extrapool were among the first to use it in an art context; they were already experimenting with the mimeograph. The love of these obsolete printing techniques comes and goes in waves. The intro-duction of the Risograph was a big leap forward in extending the possibilities of self-publishing. And then there is its much-loved aesthetic aspect.

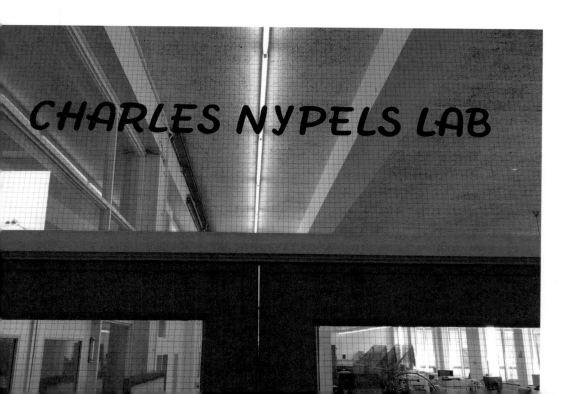

The hallowed entrance to the Charles Nypels Lab, one of the first post-graduate bodies to incorporate the Riso. Photo by Luca Bogoni

Opposite page:
Inside the Lab

Previous spread:
Topo Copy,
colour chart

Two portraits of Jo Frenken,
one printed on a Risograph.
Photo courtesy corners.kr
and Erling S. Rohde

Below: Work by the artist
Marine Delgado printed at
Charles Nypels Lab. Photo
courtesy the artist

Who were some of the key figures using stencil-based techniques during the 1970s and 1980s?

When I started as a student at the Jan van Eyck Academie in the mid-1970s, quite a few artists there were using the mimeograph, producing artists' books in conceptual art, mail-art and activism. I suppose they were not especially interested in the aesthetic qualities so much as in self-publishing aspects. These little booklets started a passion for artists' books I've had ever since.

What kinds of experimenting you've been doing at C.N. Lab? Could you highlight some projects in particular that stand out from a technical point of view (in terms of size, colour, approach)?

I'm not a Risograph purist as such, and I love to combine it with techniques like the Riso Comcolor Inkjet, with the same kind of inks, screen print and letterpress. The first Risograph book printed at the Lab by Sigrid Calon was a big success at once. Another top hit was the book by Johannes Schwartz and Experimental Jetset, one of the collaborations with Roma Publications. I think that my experience over two decades of offset book production, and the fact that we have had quite a few graphic designers as participants, have shifted our focus somewhat towards typography and photography, whereas most Risograph printers work a lot with illustrators. I love the technical aspects of working with the rather stubborn Risograph technique, and I like to discuss these with my colleagues at our biennial Magical RISO Expert Meetings in November. Two years ago we acquired the first A2 duplicator outside Russia and I have been working with this beautiful press ever since. We produced some giant books with 10 cm and even 50 cm spines, and recently a big wall piece with the artist Marine Delgado.

What in your view are the principal limitations of the Risograph? And the principal advantages?

The principal limitations are also the principal advantages. The absence of solvents means the inks never dry, but it also means that you work with the most environmentally-friendly way of printing. The colours are super intense and quite archival thanks to the absence of aggressive chemicals. And last but not least, you never have to clean up after working. The non-drying inks also limit the paper choice: it has to be uncoated and bulky to allow the ink to sink in. These types of paper are the ones I love in any case. Clients with an offset way of looking at prints are also shocked by the imperfect registration, another fact that risolovers embrace.

Although it is perhaps less prominent than the Risograph, the mimeograph is increasingly being used by a new generation of designers. What are the characteristics of this technology that make it suitable for a re-evaluation? How does it stand in relation to the Riso?

In 2014 I finally found out where Erwin Blok lived, a collector and expert in mimeograph machines. I made a movie about his collection and showed it during Magical RISO 2014, together with the highlights from his collection. In addition, we did some successful mimeograph workshops. These workshops were then copy-pasted all over Europe, with Erwin touring around like a rock band. There is a vintage trend in the skill aspects of art production. But as I said before, I think it comes in waves and will fade out to revive again in another decade. During those workshops, the majority of the participants preferred to use digital means to make the masters, ignoring the genuine analogue master production that goes with this special technique.

In which ways does using these machines influence the work one produces? Would you say that the technique and the aesthetic influence your creative approach?

There is a very prominent Riso-filter on all works printed with the duplicator; you either love it or you hate it. For me the most rewarding aspect of working with artists is to work with those who love the imperfections. Sometimes, against my nature, I have to print even more out-of-register or allow the inks to smudge.

MIMEOMANIA: ERWIN BLOK AND THE MIMEO APOSTOLES

by Joseph S. Makkos*

To get two mimeograph machines through the back door of the Cabaret Voltaire required an act of faith and the careful navigation of a Renault station wagon through a maze of narrow streets in Zurich's Old Town. And then when we got to the final square, Erwin had to somehow turn the car, filled with hundreds of pounds of outmoded printing equipment, inks and paper, and back it down a steep, icy incline, mere blocks from where Lenin once plotted his revolution, and within earshot of where, decades ago, the first Dadas carried on into the night, pronouncing strange words that didn't exist, until they did.

The story goes something like this: Erwin and I decided to venture together to Zurich on our way to Paris to bring duelling mimeographs (or Gestetners, I should say) into the Cabaret Voltaire, and do some live duplicating of the mid-century modern style: two-coloured stencil prints flying off the machines as quickly or as slowly as I read my Zaum Clouds – visual language poems composed a week earlier on a variable element IBM Selectric typewriter.

The crowd watched us set up these bizarre looking machines: they knew we were up to something, carrying in odd peripherals the likes of which most of them had likely never seen before. As foreign as my voice may have been, the sound a Gestetner makes when it is producing prints is like no other machine I've ever heard. It doesn't resemble the gridded electronic sliding of a modern home-office printer or the robotic humming of a Xerox machine – it sounds more like the spinning of a stationary bicycle, riding over a ream of clean white copy paper. With bold inks and a Dadaist composition, we rocked the Cabaret that night, as far as esoteric, nerd-printing allows.

This mission into the heart of Zurich to make prints is a prime example of the continued adventures of a hold out: Erwin Blok, the guy who

Erwin Blok, hero of the mimeo revival and world authority on Gestetners, in his warehouse

Opposite page:
Period Dutch Gestetner marketing collateral

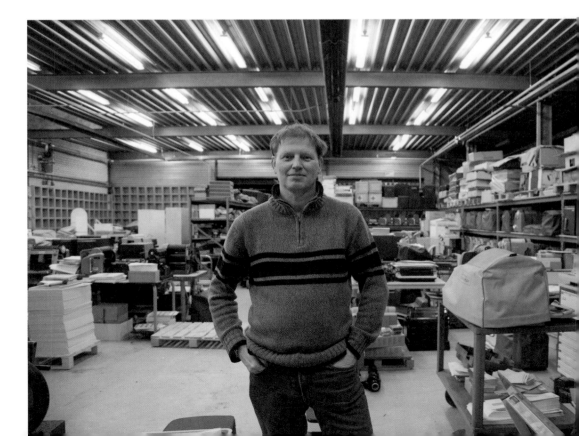

mijn *Gestetner*

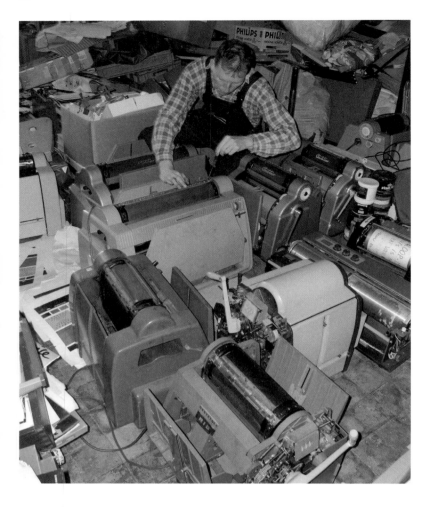

Erwin in his element, up to
the elbows in Gestetners

A three colour Gestetnered
print by Erwin Blok himself,
of Milan from the Dome

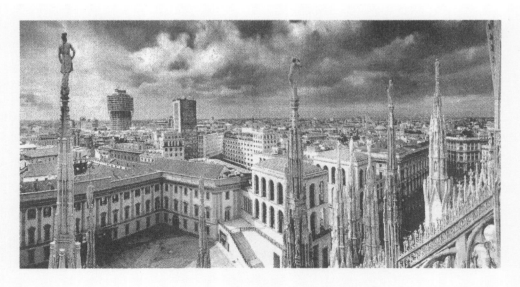

Gestetneryellow Gestetnerblue Gestetnered

cares enough to keep mimeography and Gestetner stencil-printing alive. The most confounding part is that Erwin himself isn't actually a poet, or an artist, really, or a professor pushing his conceptual treatise on planned obsolescence; he is a tinkerer, a trainspotter, and a printer (by hobby or by trade isn't clear) who, while managing his vast duplicator collection, makes trips around Europe to various art schools and visits with engaged collectives and printer groups, sharing the beauty of the stencil machines, showing how they work, and teaching this all-but-forgotten process to a new generation of would-be stencil artists.

INSIDE ERWIN'S ARK

In February of 2016 I ventured to the small town of Almelo in the Netherlands on a mission to meet Erwin Blok and see what promised to be one of the most mysterious and unique print shops in all of Europe.

Erwin's collection is housed, appropriately, in an old puzzle-manufacturing factory, in a nondescript business park in a small town located in what was described to me as the Bible belt of the Netherlands. Behind the unassuming red, blue, and yellow facade is a small workspace where Erwin has situated his office and working archive. His break room doubles as a Gestetner printing studio where he has four machines lined up on two tables, one colour of ink on each one, for quick and easy multi-colour printing. Instead of the original oil-based Gestetner inks, he now uses vibrant soy-based Risograph inks and can keep them going on the machines as long as necessary – months even. The inks he mixes in Florence are still good, with a little refreshing, for his next workshop in Italy.

The Gestetners themselves are either tan or green, depending on the model. Their cases make them resemble foreign-looking home appliances rather than duplicating machines. Each one features red, blue, and yellow colour-coded buttons – blue controls the ink, yellow controls the paper, and red controls the motor: intuitive, practically foolproof controls for the mid-century office employee.

My learning curve was steep, but by the first day I was already composing visual works on the IBM Selectric and doing cut-up collages. I looked at some of the prints and publications that had been created by other artists to get an idea of what could be done with the process, to see how some simplified the concept, and how others pushed it a little further with layering and texture. Erwin showed me a three-colour print of a train he had produced using colour separations and half tones. Strangely enough, his HP printer couldn't accurately produce the correct half-tone angles, so he had to print them out at 30 degrees and then match them up on the light-box for accurate registration.

The electronic stencils themselves are produced directly by copying the original artwork, using a Risograph machine and a coated stencil. Erwin has hacked into the software and rigged up the hardware in order to have the Risograph produce a usable stencil that can be removed and transferred over to the Gestetner by applying a custom dye-cut header (that Erwin has cleverly devised as well): combining early 21st century technology with machinery of the mid-20th century to produce fabulous new outcomes for the designs of young practitioners. Erwin is ushering in a brand new generation of stencil artists by enabling us to manifest our visions using a process that seems new, yet is over a century old.

Erwin's collections of offset presses, stencil machines, and various other printing machines and historical ephemera date back to the beginning of the 20th century. He has stencil machines manufactured by Geha, Pelican, Roneo, A.B. Dick and more, encapsulating a large part of the lineage of the history of stencil-duplicating inventions. He shows me one of the original Gestetner machines, which folds out of a wooden box and appears more like an antique mobile screen printing set-up than one of the new fangled

modern-looking models we 'Gestetnered' on. Erwin is also the keeper of the actual Gestetner Company archives, including year books and manuals, and even a bronze bust of the company's founder David Gestetner. One part of the archive is a collection of company magazines that dates as far back as the late 1920s, containing some of the most beautiful multi-coloured print-work ever produced, by the very people who invented the machine, on the machines themselves. These tomes provide a key to the past of a material culture, showing what was possible using the technology way back then, and will hopefully serve as a research resource and educational tool to inspire this next generation of printers.

RE-INVENTION

This spirit of reinvention signals an unexpected part of the narrative: where new materials can be applied to old technology to create incredibly fresh and modern compositions. Coupled with digital design and photography, there is fertile ground to expand upon an all-but-dead means of stencil reproduction. This all coincides with the budding maker movement, where people are looking back to old printing tech for new points of inspiration. We've seen it with letterpress already for a while, but now perhaps it's mimeo's turn.

Meanwhile Erwin is in Almelo, wrenching on presses and experimenting with his innovations. His Renault station wagon will be parked out front, ready to be weighted down by several Gestetners, a Risograph, and fresh inks, to wait for the call to travel off to the next art school or stencil workshop. It's nothing short of mimeomania.

Joseph S. Makkos is a New Orleans-based media archaeologist and the chief curator of NOLA DNA digital archive.

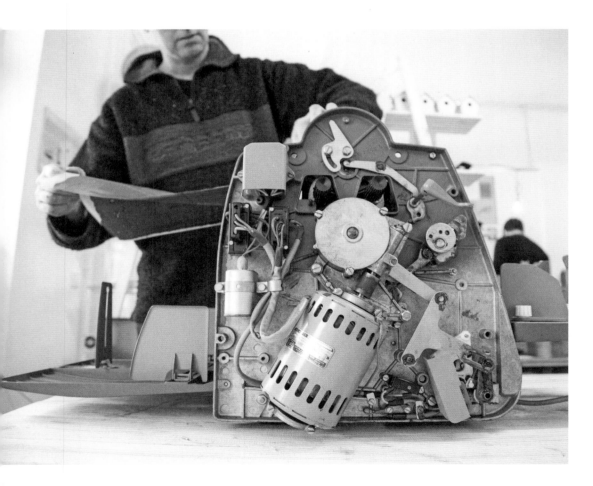

Erwin must be one of the few people alive today who know how to fix a Gestetner

The immortal Raymond Loewy Gestetner 360, landmark in industrial design

Gestetner

A NEW STENCIL DUPLICATOR DESIGNED FOR THE NEEDS OF A SPACE AGE

MODEL 360

STYLED BY *Raymond Loewy* ASSOCIATES

FROM MIMEO TO RISO AND EVERYTHING IN BETWEEN: AN INTERVIEW WITH KNUST/EXTRAPOOL

by Melanie Yugo*

An artist-run publishing organization and print workspace based in Nijmegen, the Netherlands, Knust is a pioneer in stencil-duplicating for art and publishing. It was initially led by Jan Dirk de Wilde and later joined by Joyce Guley and others; Knust is also the name of the graphic department of artist-run organization Extrapool. Here's what they had to say about their work.

How would you describe Knust to someone who is hearing about it for the first time? What would one expect to find at Knust in terms of print and other creative services and facilities?

Knust is an artist-run publishing organization. Knust has a lot of DIY equipment for printing and binding, and specializes in mimeograph printing techniques. Knust makes books and zines and has artists in to make books. Knust has three workshops, two in Nijmegen and one in Amsterdam, where you can print and bind books yourself. Knust books are considered to be rough by appearance, in terms not only of printing, but also paper choice and binding.

Knust was founded in the early 1980s. What was the catalyst for starting an initiative which specializes in stencil printing? Were other approaches to printing considered? How did you both become involved with Knust?

Knust was founded by Jan Dirk de Wilde in 1983. It had been a loose group of zine and comic makers since the early 1980s. At first, we ourselves had no intention of printing. There was enough opportunity for relatively cheap printing at alternative offset and silkscreen printers in the squatting movement [in Nijmegen at the time]. We wanted to make real zines and therefore did not want to use stencil machines or mimeographs, which were the low cost DIY alternative at the

time, but seemed always to produce low-quality print work: they very much had the aura of activism and were not taken seriously, we thought. So the first zines were offset printed and very comic-like. We never think about them now and were surprised that some were shown in a museum in an exhibition about the Punk era. After some time, we found out why so much printed matter was only black and white, or had only one spot colour extra: printers had to clean extensively between colour runs, and if they went for a break, the ink started drying out.

One day, somebody brought in a Gestetner stencil machine from the 1930s, used in a school decades before. We bought a tube of ink to continue printing with the machine. We then thought we could use stencil machines much like laser and inkjet printers are used nowadays. We thought it would be great if we had a machine for every colour, to be able to leave it and only print a copy when we needed it, a kind of printing on-demand. The stencil ink is completely non-drying and very oily.

We found ways of printing much more deeply than was common with stencil machines, and to deal with overset. We discovered the Roneo multi-colour system, which was far more sophisticated than regular stencil machines. Roneo is a true ancestor of Riso, because it uses exchangeable colour drums, where others had fixed rollers. We started collecting these machines, as they were being replaced everywhere by photocopy machines. By the end of the 1980s we were seen as the stencil printing specialists. Our books became much wilder and more complicated, with books inside books, different page sizes and fold-outs. In 1990, Joyce Guley joined with the beginning of Extrapool. She started doing the sound art programme in Extrapool, and picked up printing when the first Riso digital duplicator was bought. Other brands existed too, and came in 1991. So we did become printers in the end!

You are known as pioneers of stencil printing. How did you start to integrate the use of the Risograph into Knust? What kinds of machines were you using before the Risograph?

We made many books with mainly Roneo stencil machines. Stencils were made with a stencil cutter which burns holes in the plastic stencil. It is very good for abstract, wild, uncontrolled, multicolour printing. Small text and photos are poorly reproduced by analogue stencil cutters. Sometimes we brought text and photos to offset printers, just to make them readable and clear, and then added colour with the Roneo machines. We bought our first digital duplicator in 1992. It was a Ricoh Priport, the first machine with a bigger format than B4: the A3. For some years we used this machine together with the Roneo machines. We managed to make our own Roneo ink after experimenting with different oils and pigment.

Things changed further by the time colour scanners became cheaper in 1995 and we did not need not to do full colour work on the analogue machines anymore. In 1997, we bought the first Risograph with a computer-interface and printing got much better, faster and easier, and we ended up using the Roneo machines much less. Now we use the Roneo as a special effects machine and a gimmick, much as when we first started using stencil machines.

What kinds of Risograph projects are people working on at Knust nowadays?

In the mid-1990s we became the alternative printer of Nijmegen and got more and more work from further away. You could not go out in Nijmegen without coming across posters and flyers which were printed at Knust. We were cheaper than regular printing. We invested in binding equipment and we grew. In the 1990s, the jobs we did were not so artistically interesting. It was our own publications which stood out.

Around the turn of the century, graphic designers started coming [to Knust]. The jobs we did became more special, and more artists came wanting to use our workshops and made proposals, some of which some fitted our budget.

What are some memorable projects that you have seen produced at Knust?

A memorable project was when Knust went to Geneva: we took two printing machines and lots of colour drums in a van and travelled two days to arrive at the Museum Contemporain to print the newest issue of *DotDotDot* together with the artists and designers.

Other memorable projects:
- Doing a workshop in Antwerp were we made *Rotkop 9* (an Antwerp-based art zine) in a shed in the garden.
- Making *Vernacular Painting*, a full-colour book in an edition of 1100, which freaked us out but was exciting in the end.
- Doing the exhibition *Rules of Hypergraphy* at Extrapool.
- Designing the book called *Draaiboek* (made around a gluestick spine) and the inventive collapsible *Post Westland Bode*.

How have you seen the types of projects change over the years since Knust was founded 30 years ago? For example, have you observed a new defining style, aesthetic or process every few years?

In the beginning our stencil printing was more of a gimmick and we were happy with anything that came out of the machines, if it came out at all. [The outcomes were] often beyond our control. Over time, our projects became more conceptual. The books we now make are much more aesthetically-based and really explore the technique. We generally print 300–700 copies. Of most books we have unbound copies in a box in the cellar. Sometimes we take a box and put 20 old books together. They always sell quite fast, though people say they like the forms and binding but the artwork is better in the new books. We see a big difference in work that comes our way. People want to print a lower amount of copies. There are many Riso-printers active in our country, meaning fewer people are coming to us.

In general, how have you seen the use of the Risograph impact the work of artists and designers over the years, whether at Knust, in your travels or in the creative milieu? Why do you

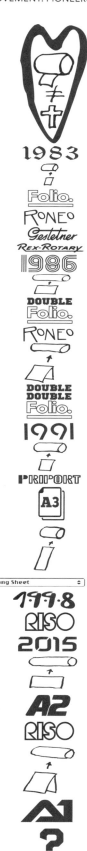

Above:
Printing at Knust

Left: A timeline of stencil duplicating technology at Knust

Previous spread left:
From Judy Radul's book *Boner 9190 and the Weak*, printed at Knust in 1989

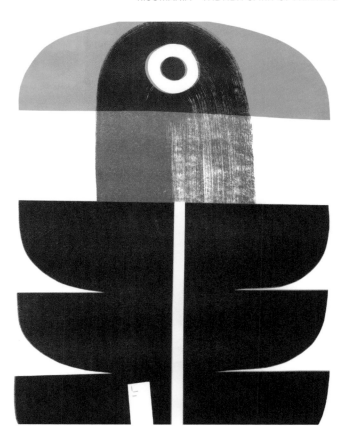

Above left:
At the Extrapool A2 Festival

Above right:
A poster by the Nous Vous
collective printed at Knust

Left:
Some trademark Knust
Riso-printed wallpaper

Opposit page:
Installation for Standort
Museumsnacht

think people want to continue to use the Riso-graph instead of other print forms?

You can get a second-hand Riso machine quite easily and really print a sufficient amount of copies and pages for a book yourself. Even with 20-year-old machines it goes well. Riso printing is special because it puts real ink on paper. Stencil ink resembles oil paint and is at its best on rough paper, because this absorbs more ink, meaning the image is deeper. Riso printing is thus very physical and gives the reader dirty hands. Not so long ago we were the only ones at bookfairs with Riso books and always had to explain about the printing technique. Now, if you go to the New York Art Book Fair, you will find dozens of Riso printers. Riso books stand out in relation to digitally (offset) printed work; they are more primitive and have a DIY feel, and still more like books than zines produced on laser-printers/copy-machines. For us, it comes down to the quality of our printing, along with the artwork and selection of people we work with.

Knust has the unique quality of being part of an interdisciplinary art and sound space, Extrapool. What is the relation between the two spaces? In what ways do you think print is influenced by sound and art at the space, if at all?

Knust is much older than Extrapool. Knust is one of the founders of Extrapool. Extrapool began in 1990 in an old warehouse. It was set up as a studio building. We made the right decision to have a public/project space and small guesthouse. This made it possible for Extrapool to grow over about ten years into a real art organization with a lot of performances, sound, exhibitions and workshops. Knust grew sort of parallel to it. In 2009, the space underwent huge renovations: Knust got a new workshop and beautiful guest rooms were made. Our production had become a bit fragmented over time and we felt the need to have more influence over the books which came out of the workshops. We also started two residency series: Art Prison and Work Holiday, coordinated

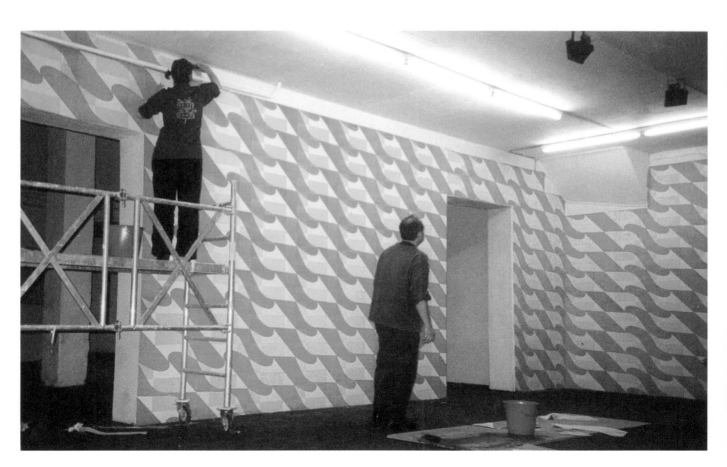

Kai Nodland during his
participation in the Art
Prison residency at Knust

Below left:
Print by Amanda Marie

Below right:
Print by Danielle Lemaire

by Astrid Florentinus, who joined in 2010. Art Prison is curated and Work Holiday is open call. Knust projects are now integrated into Extrapool programming. There is much more connection between the two spaces now.

Knust used to specialize in the printing of posters and flyers and the SlimTarra wallpaper project. At the end of the 1980s, we starting to do shows/exposition/presentations of our work. Showing books in an exhibition environment is tricky. We produced a lot of misprints and used them as wallpaper. This was quite successful and clients, including gallery owners, came in for misprints to decorate their walls with. As we got better, we produced less misprints and had to design and print new wallpaper. Because we could only print A3, this became our thing. Extrapool later picked up the A3 wallpaper concept and called it Slim-Tarra. 'Slim' is the Dutch word for 'smart' and 'tarra' refers to the the weight of the package. It was a way to cover the white cube which Extrapool's exhibition space had become. In the beginning Extrapool pretended there was, as in so many art spaces, a special project space called room 0.2. In this case 0.2 meant 0.2 mm, the thickness of paper and the room it takes in the space. SlimTarra is now a strong part of the Extrapool identity.

Originally the Risograph was developed for use by schools, libraries, churches and other institutions trying to disseminate information. Now it's also being used by graphic artists, zine-makers, publishers and designers to disseminate ideas and share their work locally and globally. Where do you see the Risograph heading in the next 30 years? What do you think is the future of the Risograph and the work created by this machine?

We (wishfully?) think Riso printing will be still around, perhaps under a different name. There is a growing demand for real books. If you look at the expanding market for artist books, we think it will grow as an autonomous medium. They are not catalogues and reproduction of artworks anymore, but original works of art themselves. The artist book is a good way to get your work across to a certain number of people without interference. The fact that it is artist-made and ready and cannot be interfered with will be important properties. So there will be a guaranteed but small market for Riso, or any other company, to produce digital stencil duplicators. There is a Chinese company making digital duplicators and analogue machines. You now can get ink in China for your own Gestetner machine again. There could be a small company who would fill the art and design niche. They probably won't make a lot of money, but it could work.

A lot of the limitations of Riso come from the fact that the machines are made for high-speed, cheap printing. Every new Riso is faster. For artists, speed and even price of printing are less relevant. Control over the image processing and the feeding system, and adjusting the ink, is what matters. Riso and the other companies tend to make the machines work better with smoother (plain copy) paper all the time, though this is contrary to the basic characteristic of the technique, namely, drying by absorption. A machine specially made for artists would be somewhat different! Mimeograph techniques survived the emergence of toner based printing not because they are cheaper but because they are more physical. That's why, despite the digital screen revolution and the fact that inkjet gets faster and cheaper by the day, they are surviving. There is no technique as good at getting real oil-based ink, almost like oil paint, onto basic uncoated rough paper that looks like and, in fact, is paper.

When we started stencil printing, everybody thought the technique was dying out. People asked the same question more than 25 years ago and I would reply: we make our own ink and wait for a digital machine for colour separation. We did not have any notion of what would come about. It is great to find out now that there is a revolution happening in artistic media, and that this has made it possible for us to keep on doing what we were doing, and getting better all the time.

This interview is reprinted with permission of the author Melanie Yugo. It first appeared online as part of 'Prints & Inks Artists Profiles' on spinsandneedles.com

STATE OF
THE ART:
RISO PRINTING
IN THE WORLD
TODAY

1/20

Issue Press
—
Detail from *Cabin-Time*:
Wilderness,
various artists, 2013.
Performance by Mary
Rothlisberger, photo by
Carson Davis Brown

Below:
RISOTTO Studio
—
Knock Knock, 2013

Opposite page:
**Viktor
Hachmang**
—
Caligari, 2013

Previous spread:
Topo Copy
—
Colour chart

RISOTTO Studio

Freaky Freaky,
poster, 2014

Issue Press

Detail from *Cabin-Time:*
Archipelago,
various artists, 2016
Bright Red, Light Teal,
Federal Blue

Opposite page:
Tan & Loose
Press

Clay Hickson,
The Bath, 20

PRINTED BY TAN & LOOSE PRESS THE BATH HICKSON 2015

Hato Press
—
Studio Hato,
Cooking with Scorsese,
2013

RISOTTO Studio
—
Jonathan Meese,
Total Glasgow Erz Devil,
2014

RISOTTO Studio
—
Nice'N'Sleazy,
poster, 2015

Sigrid Calon
—
Rijnstate, site specific
installation, Arnhem,
2014

Paper! Tiger!

Aurélien Farina,
Voeux, 2013
Commissioned by
the Secours Populaire
Français
Flat Gold, Red

Opposite page:
Sigrid Calon

n Zoetendaal

Hato Press
—
Stationery designed
and printed
by Hato in their shop

Hato Press
—
Recycled Aoiro pencils

We Make It
—
Zyklop Business Cards,
2015
Black, Blue, Orange,
Hunter Green

We Make It
—
Maren Karlson,
Natural Beauty

We Make It
—
Maren Karlson,
Yohuna, poster

Opposite page:
**Tan & Loose
Press**
—
Clay Hickson,
Ruin, 2014

Printed by Tan & Loose Press "Ruin"

COZY MOSSEL

COSY COZY MOSSELAVOND
19.09　　　DOK　　　19:00
ONDER DE CIRCUSTENT　　　WEES SNEL!　　　MOSSELS & FRIET: 15 EURO
INSCHRIJVEN VERPLICHT (VIA DOKGENT.BE/COZYMOSSEL) MAXIMUM 200 PERSONEN

COZY BREUGHEL

COSY COZY BREUGHELAVOND
11.06　　　DOK　　　19:00
BEPERKTE CAPACITEIT • INSCHRIJVEN VIA: COSYETING@DOKGENT.BE • BREUGELSCHOTEL: 12 € P/P

Above left and right:
Topo Copy
—
Dries Deriemaeker,
DOKmarkt, posters, 2015

&soWalter
—
Viktor Nübel,
New Year Postcard, 2015

Opposite page, above:
Ink'chacha
—
Rex Hoo,
Only you can take me,
2015

Opposite page, below:
Issue Press
—
Unhappy Bison,
Studio Fluit, 2015
Co-published with
CCOOLL
Black, Flat Gold

"NO ONE WOULD EVER POINT A GUN AT ME AGAIN"

I HATE
BEING
HERE

CCOOLL & Issue Press

Knust Press
—
Wasco,
Untitled,
printed with Riso and Ricoh

Below:
Knust Press
—
Nous Vous Press,
site specific installation,
2015

Opposite page:
Sigrid Calon
—
Pages from the book
To the Extend of / \ |
& -, printed at Charles
Nypels Lab,
2012

Left:
Knust Press

—

Fien Jorissen,
inspired by photos of
Anton Fayle,
A2 Riso print, 2015

Below:
Topo Copy

—

Michiel Devijver,
We Became Aware

Opposite page:
Fazed Grunion

—

*#3 Remix Poster
Project,*
from clipart,
2016

Following spread:
RISOTTO Studio

—

Nice'N'Sleazy, monthly
listings, 2015

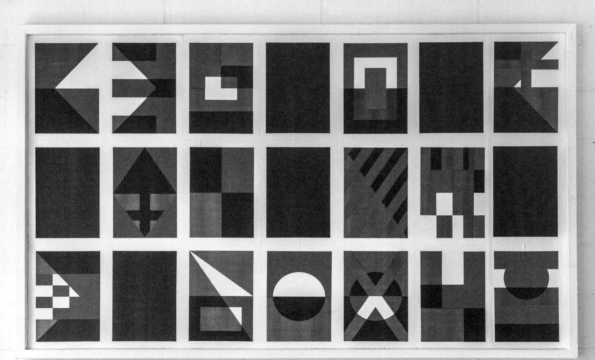

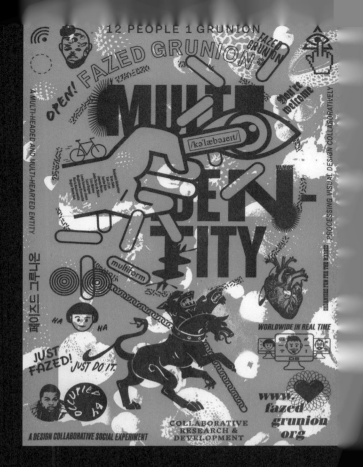

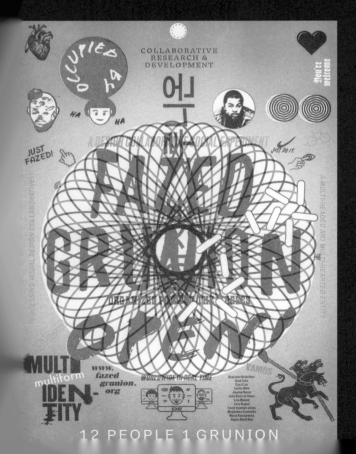

MAY

DEALS!
TUE. WED. THUR

VODKA & DASH £2.50
SKIPPER RUM + DASH £2.50
WHISKY + DASH £2.50
SKITTLEBOMB £2

b-movie classics, accidental comedies and awkward action flicks. Entry is free and the first film starts just after doors at 7pm. Check out our website for full listings information...

It's May and it's looking like another exciting, busy month in Nice N Sleazy. As usual we have a packed gig and club programme catering for sorts of musical tastes - check out our full listings on our website at www.nicensleazy.com.

Every Tuesday we have the Big Sleazy Quiz, kicking off at 6.30pm. Grab a table and enter free of charge for the chance to win cash and drink prizes. The quiz is followed swiftly by The Incredibly Strange Film Night, also taking place weekly on Tuesdays. Pop down for a double bill of weird and wonderful films in our basement, including

On Monday nights we welcome our cosy little acoustic night, hosted by the wonderful Gerry Lyons. Come play a song or two or check out some of the best new talent in Glasgow. Free entry and free beer for performers!

If all the entertainment on offer is not enough for you we have our award-winning Meathammer kitchen open 7 days a week, serving up home-made burgers and other gourmet treats. Come down and check what the hype is all about!

SEP TEM BER

NICE 'N' SLEAZY

Its September!
On top of our busy gig and club diary this month were delighted to announce the start of the 'The BIG Sleazy' quiz, hosted by Gerry Lyons on Tuesday from 6.30pm. Expect food and drink tasting, testing your general knowledge and loads of surprises! £150 cash prize and other treats up for grabs!

Gerry also hosts our Acoustic Open Mic Night every Monday from 8.30pm - free entry and free beer for players!

For more information on our gigs and clubs, as well all the upto date news, keep an our Facebook, Twitter and website - www.nicensleazy.com.

TUES ← WED → THUR

DEALS

RUM & DASH - - - £2.50
BTL KRONENBERG - - £2
SKITTLEBOMB - - - - £2
JAGERBOMB - - - £2.50

IT'S MAY! FOR THIS MONTH'S GIG PROGRAMME WE HAVE A DIVERSE SELECTION OF NIGHTS TAKING PLACE IN OUR DOWNSTAIRS VENUE ALMOST EVERY NIGHT OF THE WEEK. THIS MONTH'S HIGHLIGHTS INCLUDE SHOWS FOR TOURING ACTS SUCH AS DIRTY BEACHES, MOUNT EERIE, DRENGE, SHIELDS AND SPLASHH. GLASGOW IS NEVER SHORT OF HOME-GROWN TALENT TOO, SO WERE EQUALLY LOOKING FORWARD TO APPEARANCES BY THE LIKES OF TREMBLING BELLS, SUNSHINE SOCIAL, THE ROSY CRUCIFIXION AND MUSCLES OF JOY. IF YOU PREFER A MORE CHILLED OUT AFFAIR, EVERY MONDAY WE WELCOME OUR ACOUSTIC OPEN MIC NIGHT, HOSTED BY THE WONDERFUL GERRY LYONS. FREE ENTRY ALL NIGHT LONG AND FREE BEER FOR PERFORMERS!

EVERY TUESDAY TO SATURDAY FROM 11.30PM TO 3AM WE HAVE AN EXCITING VARIETY OF CLUBS DOWNSTAIRS, CATERING FOR EVERYTHING FROM PRIMITIVE ROCK N ROLL, OLD SCHOOL HOUSE AND LEFTFIELD DISCO TO INDIE AND SOUL. THIS MONTH'S HIGHLIGHTS INCLUDE THE RETURN OF NOTORIOUS HIP-HOP NIGHT 'HARSH TUG' AND THE LAST EVER NIGHT FOR ONE OF OUR LONGEST STANDING INDIE CLUBS - 'BOTTLE ROCKET'.

FOR FULL INFORMATION ON OUR GIG AND CLUB PROGRAMME, AS WELL AS THE LATEST NEWS UPDATES, KEEP AN EYE ON OUR WEBSITE - WWW.NICENSLEAZY.COM

RECENTLY AWARDED 'GLASGOW'S BEST BURGER' BY JAMES V'S BURGER, OUR MEATHAMMER KITCHEN SERVES UP DELICIOUS HOME-MADE TREATS 7 DAYS A WEEK, 12 - 9PM. LIVING UP TO THEIR CLASSIC-METAL INSPIRED NAMESAKES, THE 'ARCH STANTON', 'BEHEMOTH', 'BLACK FRIDAY' AND ALL OTHER BURGERS ARE ALL MADE WITH HOME-MADE BUNS, BURGERS, SAUCES AND CAREFULLY PICKED TOPPINGS. IF MASSIVE JUICY BURGERS AREN'T YOUR THING THEY ALSO SERVE UP SOUPS, QUESADILLAS, NACHOS, BURRITOS, SANDWICHES AND SOME VEGETARIAN OPTIONS. YUM!

MAY
NICE'N'SLEAZY

DEALS

TUES ← WED → THUR

RUM & DASH - £2.50

BTL KRONENBERG - £2.50

SKITTLEBOMB - £2

JAGERBOMB - £2.50

JUNE

REGARDLESS OF WHAT THE JUNE ELEMENTS MAY THROW AT US WE CAN OFFER YOU PURE JOY IN AURAL, EDIBLE AND LIQUID FORMS EVERY DAY OF WEEK, 12 NOON TIL 3AM...

THIS MONTH'S MUSIC PROGRAMME HIGHLIGHTS INCLUDE SHOWS FOR UPCOMING ALTERNATIVE INDIE ACT HOLY ESQUE, IDIOSYNCRATIC ROCKERS NORTH ATLANTIC OSCILLATION, INTIMATE FOLK ACT THE MUSIC TAPES (FEATURING MEMBERS OF NEUTRAL MILK HOTEL) AND A GUEST APPEARANCE FROM EXPERIMENTAL HOUSE ACT HEATSICK AT KINO FIST... IF YOU PREFER A MORE CHILLED OUT AFFAIR, EVERY MONDAY WE WELCOME OUR ACOUSTIC OPEN MIC NIGHT, HOSTED BY THE WONDERFUL GERRY LYONS. FREE ENTRY ALL NIGHT LONG, FREE BEER FOR PERFORMERS AND A WARM, WELCOMING ATMOSPHERE TO BOOT! EVERY TUESDAY TO SATURDAY FROM 11.30PM TO 3AM WE HAVE AN EXCITING VARIETY OF CLUBS DOWNSTAIRS, CATERING FOR EVERYTHING FROM PRIMITIVE ROCK N ROLL, NEW WAVE, OLD SCHOOL HOUSE AND LEFTFIELD DISCO TO INDIE AND SOUL.

FOR FULL INFORMATION ON OUR JUNE PROGRAMME - AS WELL AS NEWS AND OTHER UPCOMING EVENTS - CHECK OUT OUR WEBSITE AT WWW.NICENSLEAZY.COM

NOW CONSIDERED BY MANY AS THE BEST PLACE IN GLASGOW FOR BURGERS, OUR MEATHAMMER KITCHEN SERVES UP DELICIOUS HOME-MADE TREATS 7 DAYS A WEEK, 12 - 9PM. LIVING UP TO THEIR CLASSIC-METAL INSPIRED NAMESAKES, THE 'ARCH STANTON', 'BEHEMOTH', 'BLACK FRIDAY' AND ALL OTHER AWARD-WINNING BURGERS ARE ALL MADE WITH HOME-MADE BUNS, BURGERS, SAUCES AND CAREFULLY PICKED TOPPINGS. IF MASSIVE JUICY BURGERS AREN'T YOUR THING THEY ALSO SERVE UP SOUPS, QUESADILLAS, NACHOS, BURRITOS, SANDWICHES AND SOME VEGETARIAN OPTIONS. YUM! ALONGSIDE THE IMPRESSIVE SELECTION OF BEERS, SPIRITS, CIDERS, COCKTAILS, WHITE RUSSIANS AND BUCKAROOS IN OUR UPSTAIRS BAR, WE'RE EXCITED TO ANNOUNCE A NEW SELECTION OF NON-ALCOHOLIC TREATS, AVAILABLE ALL DAY LONG - INCLUDING OREO AND PEANUT BUTTER MILKSHAKES... AND IF WE CAN'T HEAL YOUR RAIN-INDUCED BAD MOOD, WELL WE ALSO HAVE SOME KINDER EGGS ONSALE AT THE BAR, TOO...

D TUE E WED A AND L THU S

BOTTLE KRONENBOURG = £2
SKITTLEBOMB = £2
JAGERBOMB = £2.50
GIN/VODKA/WHISKY & CUN MIX = 2.50

APRIL (top-left)

NICE N SLEAZY

APRIL

As usual we have another busy month welcoming a series of exciting gigs and clubs almost every day of the week. For full listings check out webite at www.Nicensleazy.Com.

This month we welcome to return of the incredibly strange film night - celebrating the best in weird and wonderful cinema every tuesday night in our basement. This month's programme includes titles such as american ninja, sleepaway camp, hercules in new york, rock 'n' roll nightmare and miami connection. Entry is free and 2 films will be screened each night, kicking off at 7pm sharp... For further information keep an eye on our website...

If all the entertainment on offer is not enough for you we have our award-winning meathammer kitchen open 7 days a week, serving up home-made burgers and other gourmet treats 12 - 9pm. Come down and check what

DEALS!

VODKA + DASH £2.50

SKIPPER RUM + DASH £2.50

WHISKY + DASH £2.50

SKITTLEBOMB £2

JULY (top-right)

AS USUAL WE HAVE ANOTHER BUSY MONTH WELCOMING A SERIES OF EXCITING GIGS AND CLUBS ALMOST EVERY DAY OF THE WEEK. FOR FULL LISTINGS CHECK OUT WEBSITE AT WWW.NICENSLEAZY.COM,

THIS MONTH WE WELCOME TO RETURN OF THE INCREDIBLY STRANGE FILM NIGHT - CELEBRATING THE BEST IN WEIRD AND WONDERFUL CINEMA EVERY TUESDAY NIGHT IN OUR BASEMENT. THIS MONTH'S PROGRAMME INCUDES TITLES SUCH AS AMERICAN NINJA, SLEEPAWAY CAMP, HERCULES IN NEW YORK, ROCK 'N' ROLL NIGHTMARE AND MIAMI CONNECTION. ENTRY IS FREE AND 2 FILMS WILL BE SCREENED EACH NIGHT, KICKING OFF AT 7PM SHARP... FOR FURTHER INFORMATION KEEP AN EYE ON OUR WEBSITE...

ON MONDAY NIGHTS WE WELCOME OUR COSY LITTLE ACOUSTIC NIGHT, HOSTED BY THE WONDERFUL GERRY LYONS. COME PLAY A SONG OR TWO OR CHECK OUT SOME OF THE BEST NEW TALENT IN GLASGOW. FREE BEER FOR PERFORMERS!

IF ALL THE ENTERTAINMENT ON OFFER IS NOT ENOUGH FOR YOU WE HAVE OUR AWARD-WINNING MEATHAMMER KITCHEN OPEN 7 DAYS A WEEK. SERVING UP HOME-MADE BURGERS AND OTHER GOURMET TREATS 12 - 9PM. COME DOWN AND CHECK WHAT THE HYPE IS ALL ABOUT!

DEALS

TUES ← W E D → THUR

RUM & DASH - £2.50

BTL KRONENBERG - £2

SKITTLEBOMB - £2

JAGERBOMB - £2.50

JULY

NICE'N'SLEAZ

MARCH (bottom-left)

MARCH

NICE'N'SLEAZY

Its March! Our diary is chocked full this month of brilliant gigs and clubs, so make sure to check out our website at nicensleazy.com for full listings, links to tickets and further information on each event.

Every Tuesday The Incredibly Strange Film Night presents a double bill of weird and wonderful films; everything from forgotten b-movies and awkward super hero flicks to the most ridiculous accidental comedies from the vaults. Entry is free and the first film kicks off just after doors at 7.30pm.

On Monday nights we welcome our cosy little acoustic night, hosted by the wonderful Gerry Lyons. Come play a song or two or check out some of the best new talent in Glasgow. Free beer for performers!

If all the entertainment on offer is not enough for you we have our award-winning Meathammer kitchen open 7 days a week, serving up home-made burgers and other gourmet treats 12 - 9pm. Come down and check what the hype is all about!

DEALS

TUE, WED, THU

VODKA + DASH £2.50

SKIPPER RUM + DASH £2.50

SKITTLEBOMB £2

WHISKY + DASH £2.50

FEBRUARY (bottom-right)

FEBRUARY

NICE'N'SLEAZY

DEALS

TUES, WED & THURS

Looking forward to another busy and exciting month in Nice N Sleazy with our packed gig and club programme. Check out our full listings on our website at www.nicensleazy.com

Every Tuesday we have the Big Sleazy Quiz, kicking off at 6.30pm. Grab a table and enter free of charge for the chance to win cash and drink prizes. The quiz is followed swiftly by The Incredibly Strange Film Night, also taking place weekly on Tuesdays - except on the 11th of February. Pop down for a double bill of weird and wonderful films in our basement, including b-movie classics, accidental comedies, awkward action flicks and seriously odd stuff. Entry is free and the first film starts just after doors at 7.30pm. Check out our website for full listings information...

On Monday nights we welcome our cosy little acoustic night, hosted by the wonderful Gerry Lyons. Come play a song or two or check out some of the best new talent in Glasgow. Free beer for performers!

If all the entertainment on offer is not enough for you we have our award-winning Meathammer kitchen open 7 days a week, serving up home-made burgers and other gourmet treats 12 - 9pm. Come down and check what the hype is all about!

VODKA + DASH £2.50

SKIPPER RUM + DASH £2.50

SKITTLEBOMB £2

WHISKY + DASH £2.50

NOVEMBER

SUN	MON	TUE	WED	THUR	FRI	
		1	2	3	4	
6	7	8	9	10	11	12
13	14	15	16	17	18	19
20	21	22	23	24	25	26
27	28	29	30			

JANUARY

SUN	MON	TUE	WED	THUR	FRI	SAT
31					1	2
3	4	5	6	7	8	9
10	11	12	13	14	15	16
17	18	19	20	21	22	23
24	25	26	27	28	29	30

Y

THUR	FRI	SAT	
4	5	6	
11	12	13	
18	19	20	
24	25	26	27

THUR	FRI	SAT			
		4			
2	3	4			
9	10	11			
8	9	15	16	17	18
15	16	22	23	24	25
21	22	29	30		
28	29	30			

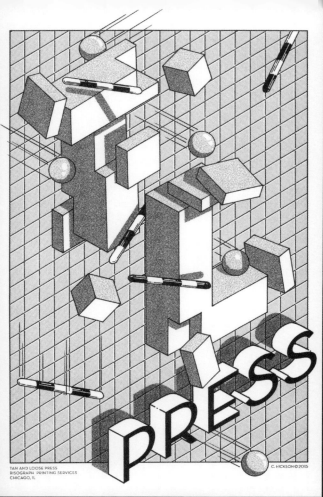

TAN AND LOOSE PRESS
RISOGRAPH PRINTING SERVICES
CHICAGO, IL

C. HICKSON © 2015

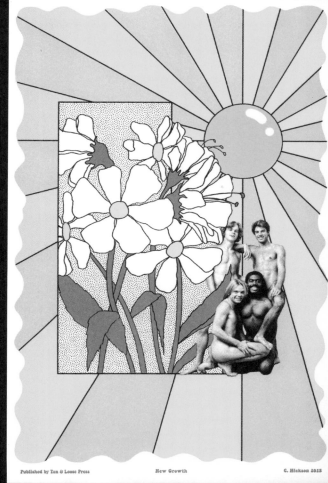

Published by Tan & Loose Press New Growth C. Hickson 2015

**Tan & Loose
Press**
—
Clay Hickson,
promo poster, 2015

**Tan & Loose
Press**
—
Clay Hickson,
New Growth, 2015

**Knuckles
& Notch**
—
Kristal Raelene Melson,
Someday Somdaze,
series, 2014

Opposite page:
RISOTTO Studio
—
The Mini,
calendar, 2016

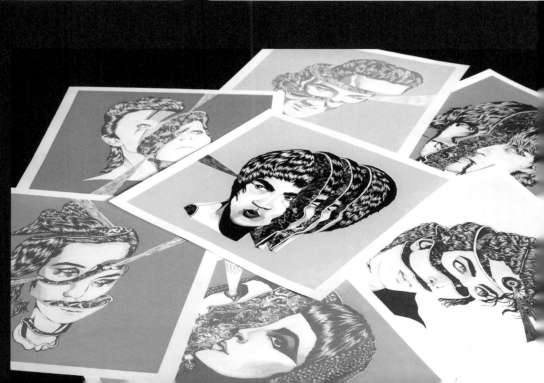

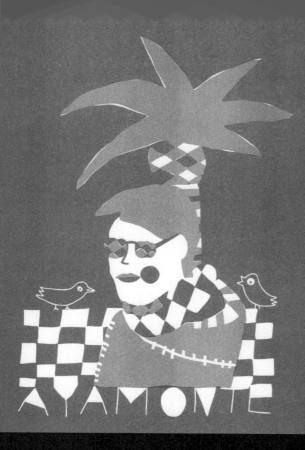

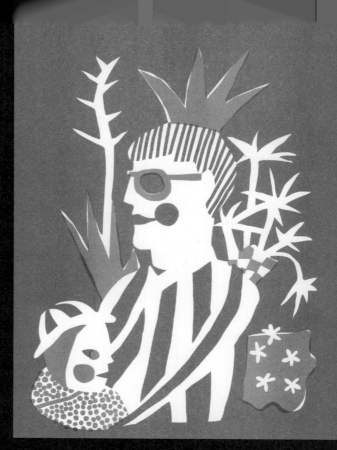

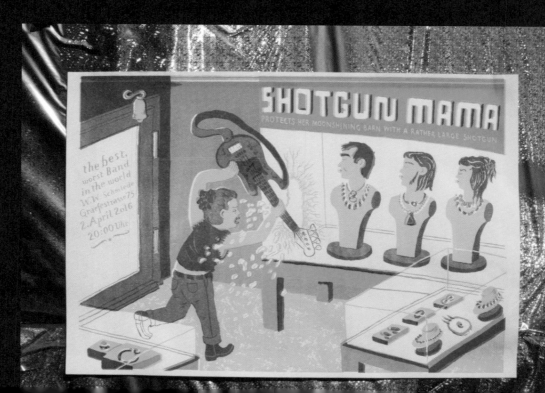

Meli-Melo
—
Test print

Meli-Melo
—
Nathalia Cury,
Riso Experiment, 20

Colorama
—
Ives, *Kirchen mit Insekten*
kids' workshop

**Charles Nypels
Lab**
—
Hansje van Halem,
*Galerie Block C presents
Esther de Graaf*, 2016
A2, Blue, Bright Red

KUNSTRUIMTE GALERIE BLOCK C
19 maart – 30 april 2016

ESTHER
DE
GRAAF

Kunstruimte Galerie Block C — opening zaterdag 19 maart 16-18 uur
Westerhavenstraat 10a — Groningen — tekeningen van Esther de Graaf
open vrijdag & zaterdag 13 – 17 uur — expositie i.s.m. Drawing Front Diepenheim
www.blockc.nl — www.estherdegraaf.nl / www.drawingfront.nl

VICE CITY

We Make It
—
Vice City Flyer,
2011/12

Colorama
—
Johanna Maierski,
Untitled

Colorama
—
Johanna Maierski,
Untitled

RISOTTO Studio

—

Freaky Freaky,
poster, 2015

RISOTTO Studio

—

Sweetie Bags, 2015

Opposite page:
Paper! Tiger!

—

Aurélien Farina,
Abolition du Travail Aliéné
poster,

Above:
Risotrip
—
A5 postcards,
first and second design
by Daniel Bicho; third
design by Igor Arume

Below, left:
**Gato Negro
Ediciones**
—
León Muñoz Santini,
*Cuando el tren se
detuvo...*,
2016

Below, right:
**Gato Negro
Ediciones**
—
León Muñoz Santini,
El Gemelo Que Se Va,
2015

Right:
**Print Club
Torino**

—

Panda

Below:
**Charles
Nypels Lab**

Martín La Roche,
Chapter III, 2015–2016
Leporello 600 × 38.5 cm
The index was printed
by Erwin Blok with Gestetner

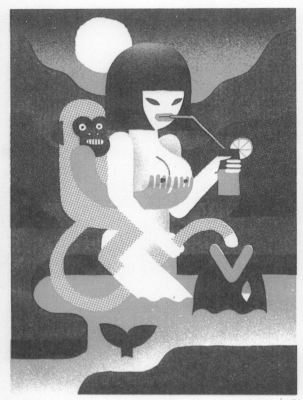

Above:
Levi Jacobs
—

Left: *Tropicana Girl*
Right: *Carpoedel 3*

**Print Club
Torino**
—

Studio picture:
used masters tray

Opposite page, above:
Colorama
—

Johanna Maierski,
Wrestling, 2016
Medium Blue, Yellow

Opposite page, below:
Topo Copy
—

Left: Jango Jim
Right: Emmeline Geiregat
From the series
*RISOGRAFIA #3
March to the beat of a
different drummer*

HAVE AN ANANICE DAY !

11 /40

Jango Jim

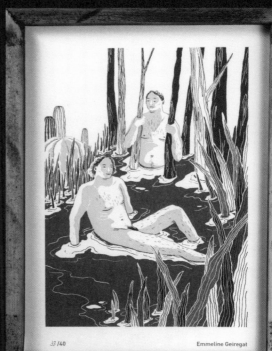

33 /40

Emmeline Geiregat

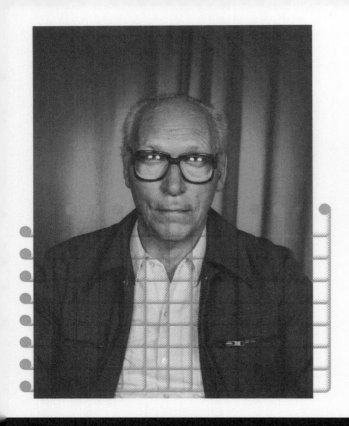

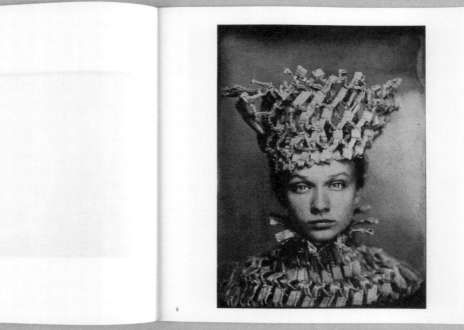

8

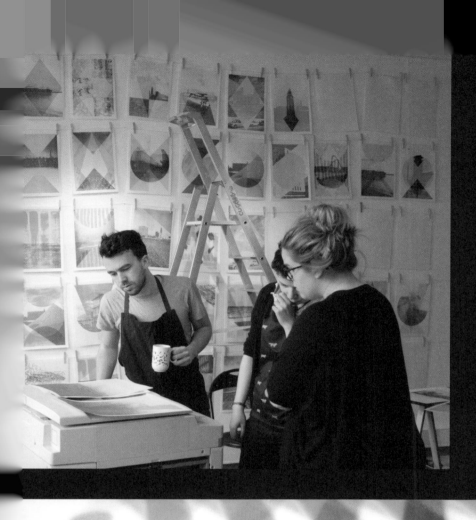

Opposite page, above:
Sigrid Calon
—
Sigrid Calon &
Willem van Zoetendaal,
Screening 1

Opposite page, below:
**Charles
Nypels Lab**
—
Paweł Smiałek,
Cardboard Queen Kinga,
from *Sarmad Magazine*:
Book Two,
2015

Super Terrain
—
*Ci-joint, le calendrier des
marées*,
printed as part of Club
Maximum Couleur

Below:
Sigrid Calon
—
Print detail

KUNSTRUIMTE GALERIE BLOCK C
14 mei – 18 juni 2016

kunstruimte Galerie Block C opening zaterdag 14 mei, 16–18 uur
Westerhavenstraat 14a – Groningen expositie John van de Rijdt
open vrijdag – zaterdag 13–17 uur "niet doen, maar toch"
www.blockc.nl www.johnvanderijdt.nl

Charles Nypels
Lab
—
Hansje van Halem,
A2 print. Blue, Fluor
Pink and Yellow

Riso Presto
—
Carlín Díaz,
J'aime les filles,
Presto Editions Books

RISOTTO Studio
—
Map Magazine,
festival booklet, 2014

**Charles Nypels
Lab**
—
Hansje van Halem,
De Context,
Museum Flehite
exhibition brochure
Orange, Green

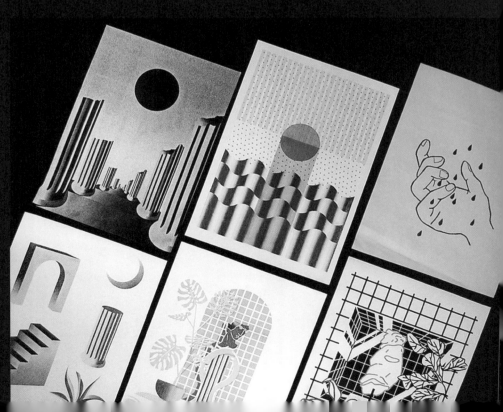

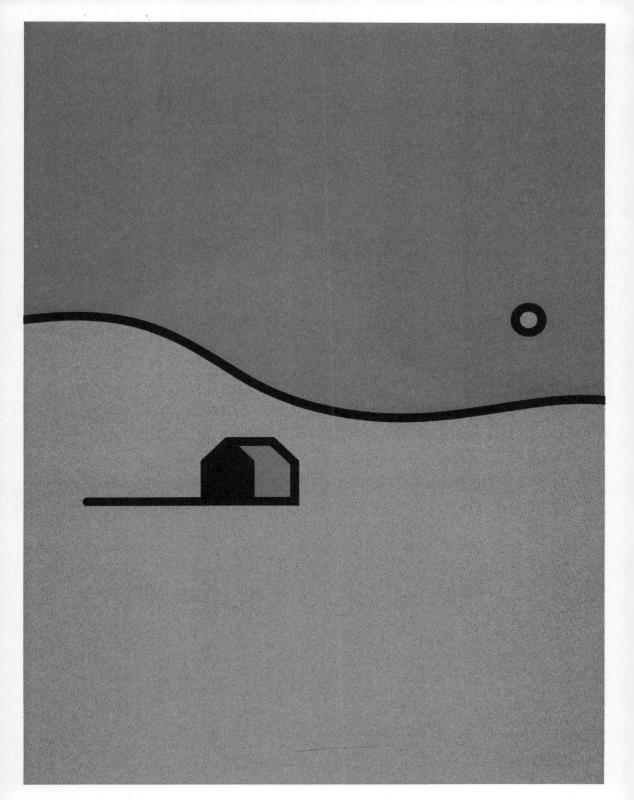

5/45 |1.76| ⌒

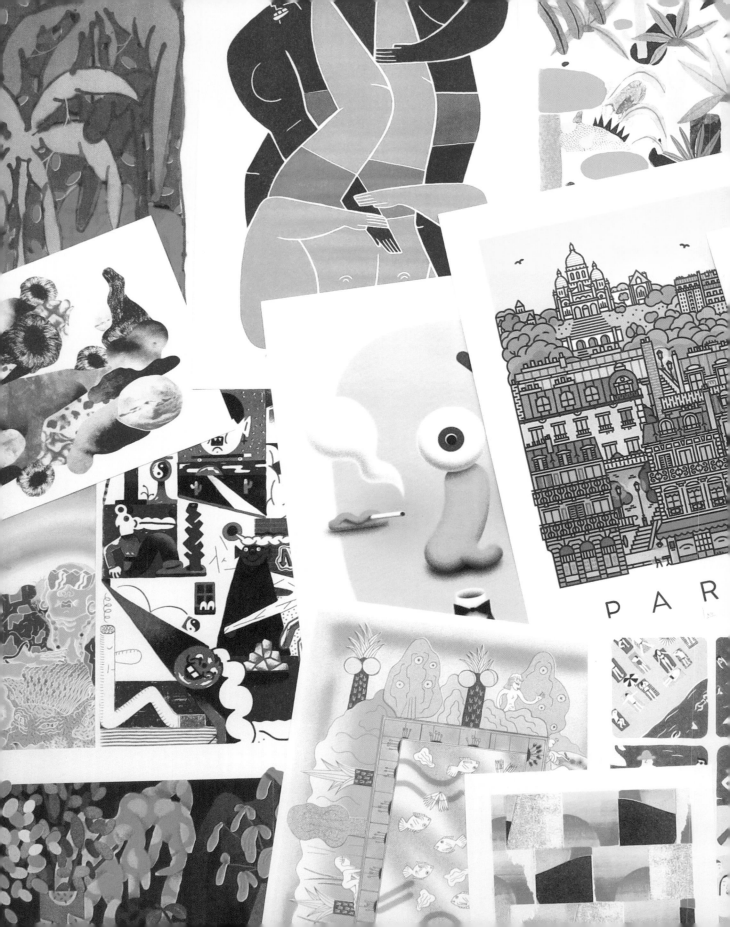

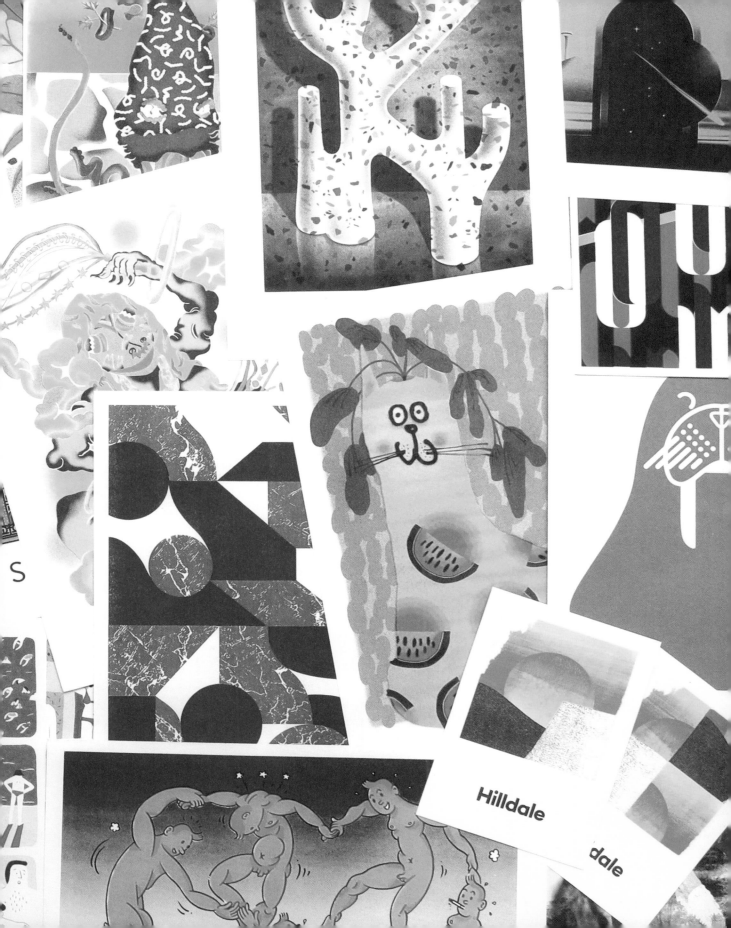

S

Hilldale

dale

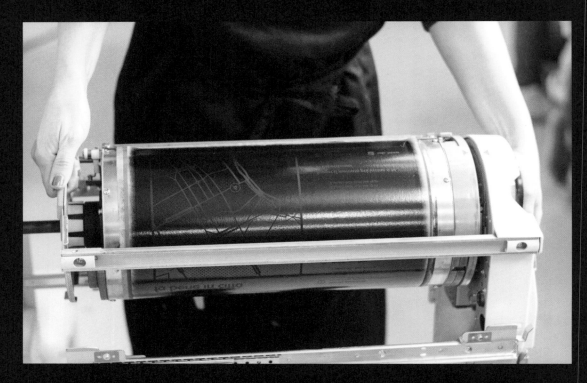

Print Club Torino
—
Studio picture: black cylinder with applied master

Fotokino
—
Tom Henni, *Promo-copain*, Riso workshop at La Fabrique de Fotokino, J1, 2013

Hato Press
—
Nicolas Burrows,
How It Is,
book and merchandising

Hato Press
—
Emily Rand,
In the City

Bananafish Books
—
Pausebread,
Risograph notebooks

Inkwell Press
—
Hiramatsu Sozo - Jiyucho,
Xmas Cards, 2015
Red, Teal

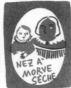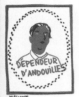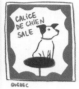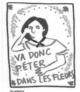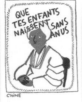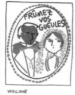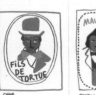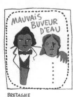

476
—
Camille de Cussac,
*Redites-moi des choses
tendres*

We Make It
—
Martina Flor,
*Crazy on the Dance
Floor*

Bananafish
—
Art Prints & Bananafish

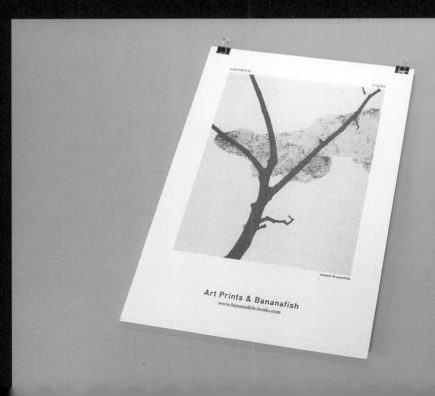

Opposite page:
Fotokino
—
Atak,
Atak,
2013

Studio Kkoya
—
Studio Kkoya,
Alphabet Poster

Opposite page, above:
Issue Press
—
George Wietor,
action shot

Opposite page, below:
Meli-Melo
—
Mateus Acioli,
Robauto

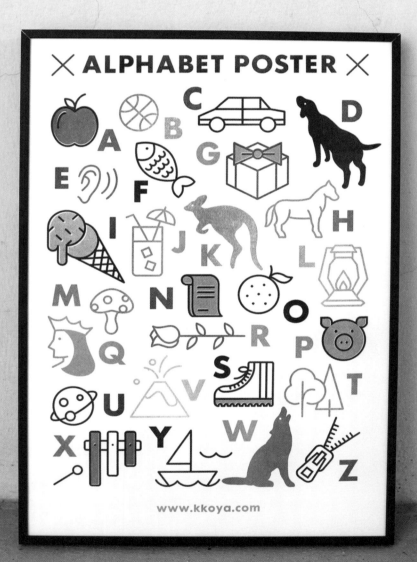

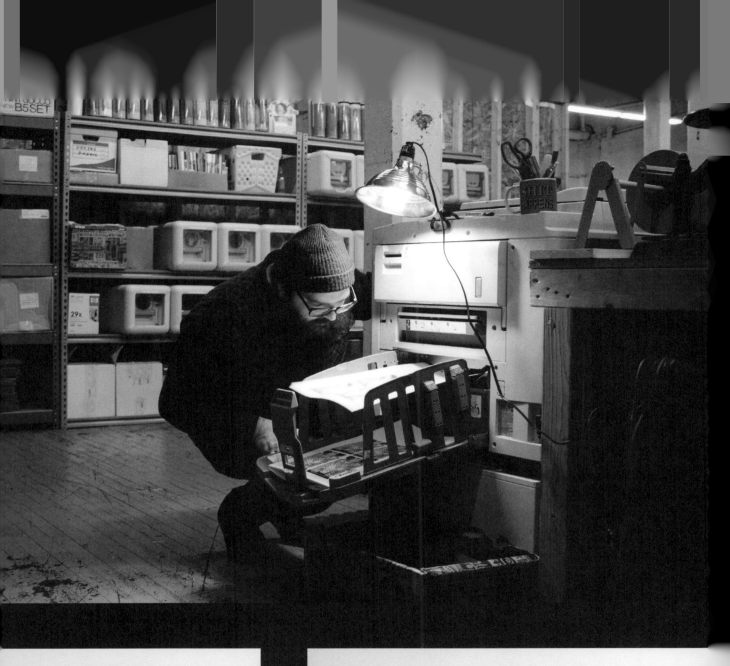

BIA REAL-
ACONTE-
A GENTE
S BOA-
E, ESTÁ-
ANTE DA
IADUTO.

DEPOIS DAS VIGAS DA PERIMETRAL,

54 TRENS SOMEM NO RIO.

— AS OBRAS JÁ COMEÇA-
RAM E HOJE, NA VERDADE,
A GENTE VEM AQUI ASSINAR
O CONTRATO COM A CAIXA
NUM GESTO SIMBÓLICO DO
PRESIDENTE, QUE FINAL-
MENTE VAI CONSEGUIR TI-
RAR AQUELE MONSTRENGO
QUE É A PERIMETRAL DA
FRENTE DA CIDADE DO RIO
DE JANEIRO.

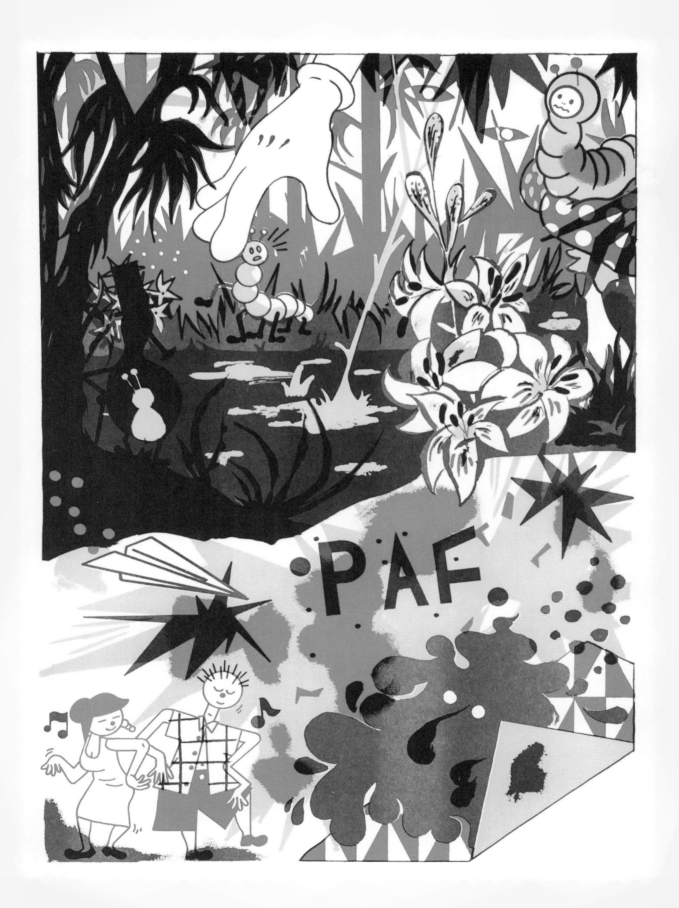

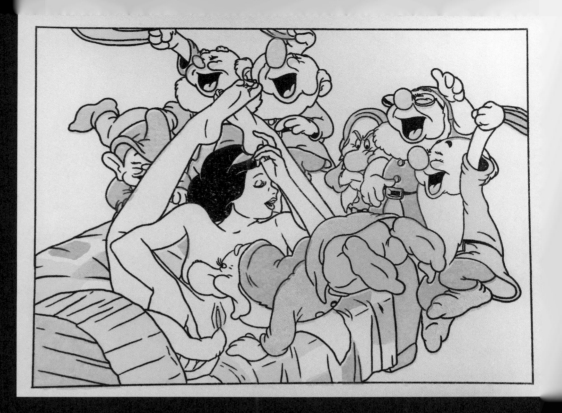

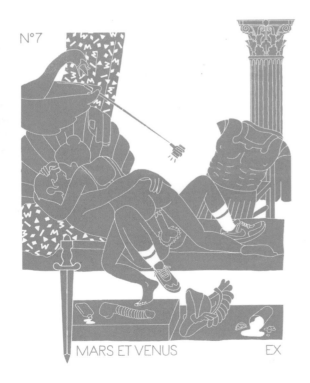

Paper! Tiger!

—

Aurélien Farina &
Gabriel Leger,
QUESTIONS / RÉPONSES,
100 postcards divided
into two boxsets, 2015
Front: Black + Medium Blue
+ Yellow + Red. Back: Black.
Boxes: Medium Blue

Les gens intelligents
sont à l'aise partout.

Riso Club
—
Riso Club calendar,
2016 Forever

Colour Code
—
Jimmy Limit,
Untitled
Mint, Fluo Pink, Yellow,
Black

MOON
MAZE POWER
B HYPNO
FM12017

WRITTEN AND PRODUCED BY JOHANNES ALBERT
AND JOHANNES PALUKA AT PASSAGEN B
ARTWORK C JULIAN BENDER

Above and opposite page:
Drucken3000

—

Julian Bender,
Moon E.P. (Frank Musik).
Cover inlay Riso-printed
in Custom White

**Charles Nypels
Lab**

—

Stéphanie Lagarde,
Above the clouds,
book 1, 2016
Riso-printed in three
colours, with screen-
printed cover on PVC

Hurrikan Press
—
Girls from Budapest, *Zina 1*

Paper! Tiger!
—
Sarah Haug,
Silky Nipple Fluffy Butt,
2016
A giant erotic puzzle
made of six A3 posters
Front: Yellow, Fluorescent Pink, Green.
Back: Fluorescent Pink

Right:
Viktor Hachmang

—

Blue Night, 2014

Below:
Viktor Hachmang

—

All Tomorrow's Parties (Inside Andy Warhol's Factory), 2014

Following spread:
Super Terrain

—

La ville qui danse

nine principles
to work in the new world

Joichi Ito — MIT Media Lab director

resilience instead of strength

That means you want to yield and allow failure and you bounce back instead of trying to resist failure.

you pull instead of push

That means you pull the resources from the network as you need them, as opposed to centrally stocking them and controlling them.

you want to take risk instead of focusing on safety

you want to focus on the system instead of objects

you want to have good compasses, not maps

you want to work on practice instead of theory

Because sometimes you don't know why it works, but what is important is that it is working, not that you have some theory around it.

it's disobedience instead of compliance

You don't get a Nobel Prize for doing what you are told. Too much of school is about obedience, we should really be celebrating disobedience.

it's the crowd instead of experts

it's focus on learning instead of education

Source
www.wired.com/business/2012/06/resiliency-risk-and-a-good-compass-how-to-survive-the-coming-chaos/

Typography
Akzidenz-Grotesk BQ

Printed in Risograph by
Risotrip Print Shop Co.

L = $\frac{10}{\sqrt{5}}$

3/4/5/6
PYTHAGORE
LE CORBUSIER
ROBIAL
DUPONT

476 | A-1
NOV 2015 | 5 | A-15

Above left:
We Make It
—
Fernando Leal,
Untitled

Above right:
476
—
Etienne Robial,
*3/4/5/6 - Pythagore -
Le Corbusier - Robial -
Dupont*

Right:
476
—
Etienne Robial,
Alphabet Normaal

Opposite page:
Risotrip
—
Joi Ito / Igor Arume,
*When design and self-
publishing become attitude*

ABCDEFGH
IJKLMNOP
QRSTUVW1
XYZŒ-?!0
123456789

ALPHABET NORMAAL

ALPHABET NORMAAL 2000
LES ALPHABETS (2)
ETIENNE ROBIAL

476 | 1/40
CXXIV 2016 | 18

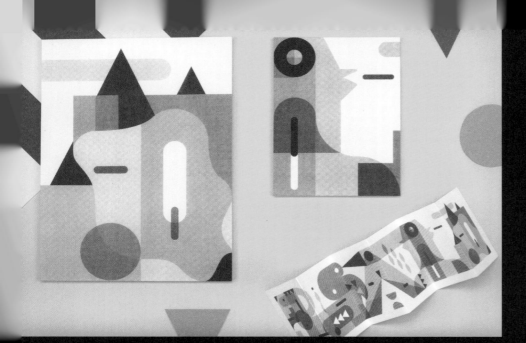

Atto
—
From *Forme Buone*

Lentejas Press
—
Juan Cardosa,
*Only The Children Were
Saved*

HS-LAB

子供だけが
救われた

ONLY THE CHILDREN WERE SAVED
JUAN CARDOSA / MIHARA / JAPAN

Atto
—
Geometry #2

Atto
—
Geometry #1

Ink'chacha
—
Rex Hoo,
Only you can take me,
2015

Paper! Tiger!
—
Sarah Haug,
There's No Coming Back
Medium Blue, Fluo Pink,
Yellow, coloured glue

《ONLY YOU CAN TAKE ME 取西經》

我很喜歡看舊港產片，以前的港產片總是充滿一種原始的爆炸力，就算是喜劇，我也能從中感受到那種力道。

三年前的某天，我忽然開始把一些對我面言印像深刻的港產片場面畫下來。在我從影碟中搜尋這些畫面的時候，我發現很多港產片的英文字幕都翻譯得很粗糙，而且往往把原意簡化。在我照著畫面作畫的時候，我發現如果把英文字幕也記錄下來的話，畫面反而呈現出一種奇妙的荒謬感。

我也想表現一種舊戲院的味道。以前的戲院廣告版，由於是畫師用人手逐幅畫的，加上面積大，儘管畫師努力地照把溜前的五官畫得神似，然面效果往往差人意，但手方法我也故意模仿那種風格，五官也不求神似, 純粹用

I have always enjoyed old local m
with a sense of explosiveness, e
even today.
Three years ago I had a thought
those movies, and when I was go
subtitles back in the day were so
lines were simplified or even mis
When I started drawing them fro
subtitles, it will give the drawing
In the old days, promotional poste
cially when it came to large scale
trator had put in, the features of
was what I enjoyed looking at the
are still trying to mimic that par
deliberately mishandling the body
capture the scenes with the most
would enjoy them as much as I d

Rex Koo

rexkoo@rex-air.net
www.rex-air.net
Facebook / Instagram : rexkoo

THIS IS THE SPOUT

THIS IS THE ELBOW

殺手雄

Ink'chacha
—
Rex Hoo,
Only you can take me,
2015

Bananafish
—
Sun Jia Yi,
Riso cards

Design Displacement Group, Drukkerij Tielen and the Van Eyck Charles Nypels Lab wish you a prosperous 2034.

Printed in silkscreen, riso and offset on Munken Polar Rough 150 gsm. Edition 250 © 2015.

Paper! Tiger!
—
Paper Tiger,
Random Fun

Alt Går Bra
—
Agnes Nedregård,
performance works,
The Big Toe, 2015
Gestetner print

Opposite page, above:
**Design
Displacement
Group**
—
*DDG wishes you a
prosperous 2034*,
2-colour offset,
2-colour Riso, printed
by Drukkerij Tielen and
Charles Nypels Lab

Opposite page, below:
**Design
Displacement
Group**
—
Contract 2015-2035,
3-colour Riso print,
A2, printed by Charles
Nypels Lab

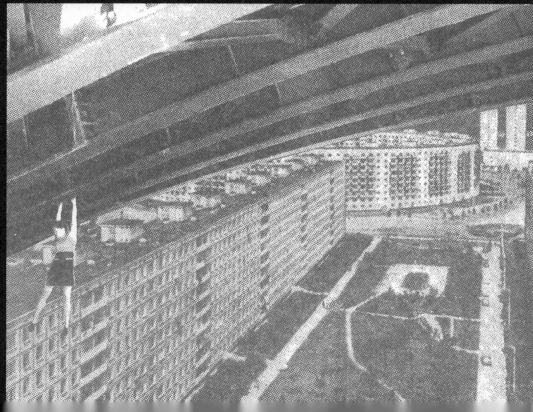

Left and below:
We Make It
—
Jeong Hwa Min,
Chicken of Beef,
cover, inside spread

Opposite page:
We Make It
—
Josephin Ritschel,
Untitled
Green, Crimson, Purple

PEOPLE ARE ON TRANSIT. THEY CAN'T SETTLE DOWN
ANYWHERE, CAN'T RECOGNIZE EACH OTHER.
THE GROUND ON WHICH THEY STAND IS PALE AND UNSTABLE.
THESE ARE PEOPLE WHO WILL DEPART SOMEDAY.

THUS THEY ARE ALL BORED, AND THEIR BODIES ARE EXHAUSTED.
THE SHORT BREAK BEFORE THE NEXT EXHAUSTION IS ABOUT TO END.

Alt Går Bra
—
Trykksak No. 1,
Gestetner print

Super Terrain

La ville qui danse,
self-published

Opposite page:
Inkwell Press
—
Super Quiet,
Shadow Mask, 2016

Drucken3000
—

Guillaume Kashima
a.k.a Funny Fun with
Guillaume a.k.a FFwG,
PIMP

Opposite page:
Corners
—

Dominic Kesterton,
Peeler, 24 pages, 2016

Risomat
—
Daniela Olejnikova, *Cierne diery: Trnavsky cukrovar - Sugar Factory in Trnava*, 2015

Risomat
—
Daniela Olejnikova, *Cierne diery: PostKablo - The Kablo Factory in Bratislava*, 2015

Opposite page, above:
Fotokino
—
Aurelian Debat, *La Grande motte*

Opposite page, below:
Lentejas Press
—
Selected, 2014

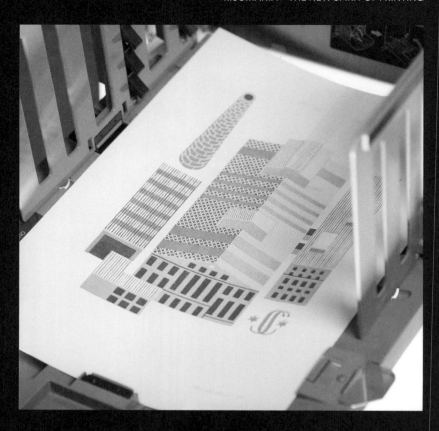

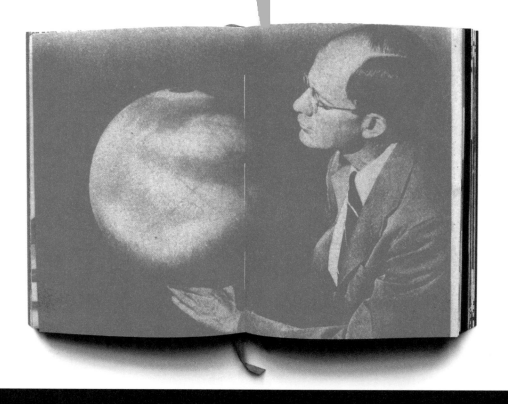

Opposite page:
Paper! Tiger!
—
Aurélien Farina &
Gabriel Leger,
microMEGA
Purple, Green

Lentejas Press
—
COR Issue 5

Inkwell Press
—
Cosimo Miorelli,
Red Tail, 2015
Purple, Red

Opposite page, top:
Inkwell Press
—
Paul Bizcarguenaga,
Bad, 2014
Printed on a Duplo 63S
Red, Blue, Black

Inkwell Press
—
Paul Bizcarguenaga,
FLVR, 2015
Printed on a Duplo 63S
Gold, Black

Below:
Bananafish
—
Bananafish Books,
Yancong Riso
Be Matisse

Following spread:
Dizzy Ink
—
Colour cylinders
arrayed on the
workshop table

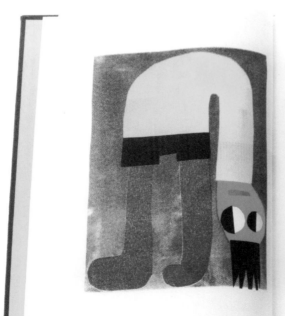

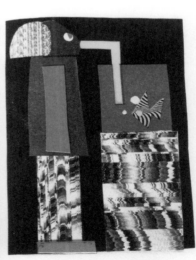

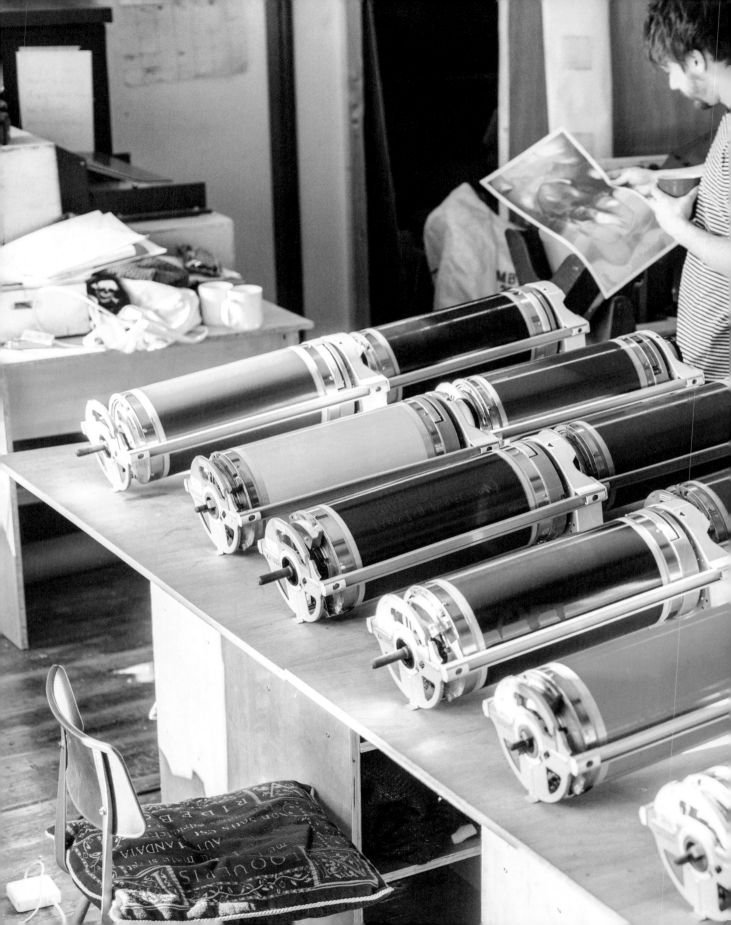

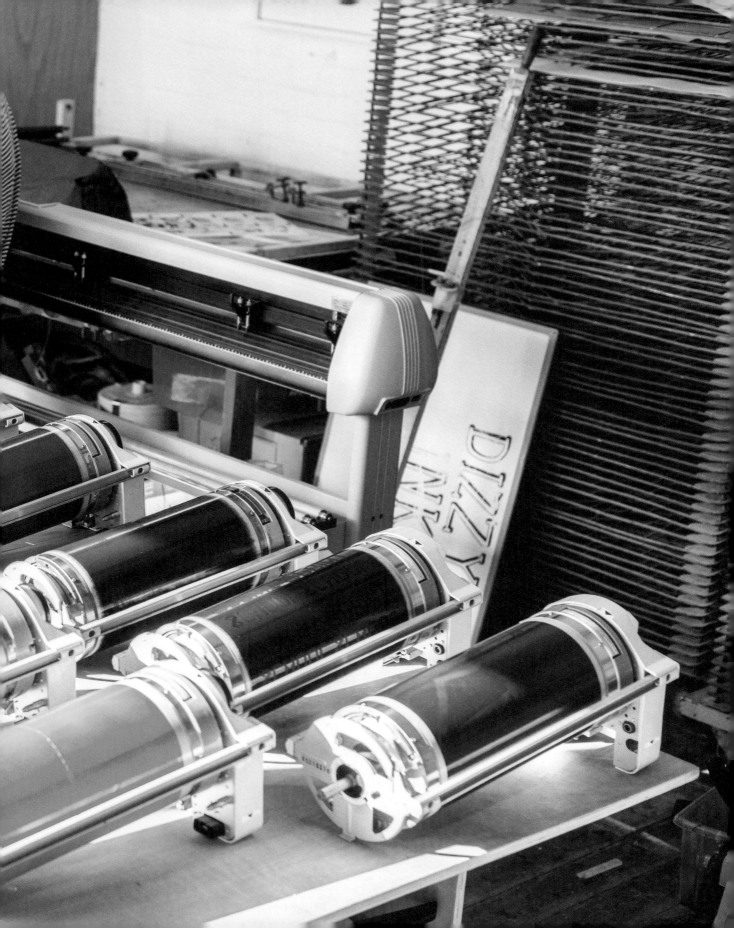

Inkwell Press
—
Maria Silvano,
Flowers, 2015
3-colour
Gestetner print

Drucken3000
—
Florian Haberstumpf,
Mascot
Red, Yellow, Light
Green, Black

Opposite page:
Colour Code
—
Jay Shuster, 2016
Mint, Raspberry,

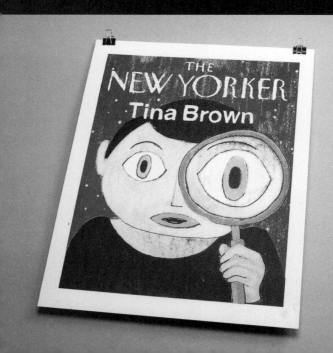

Hurrikan Press
—

Anita Nemes,
*When does it grow
dark today?*

Bananafish
—

Bananafish Books,
*The New Yorker /
Tina Brown*

Opposite page:
Paper! Tiger!
—

Aurélien Farina,
Metropolitiques,
poster, 2016

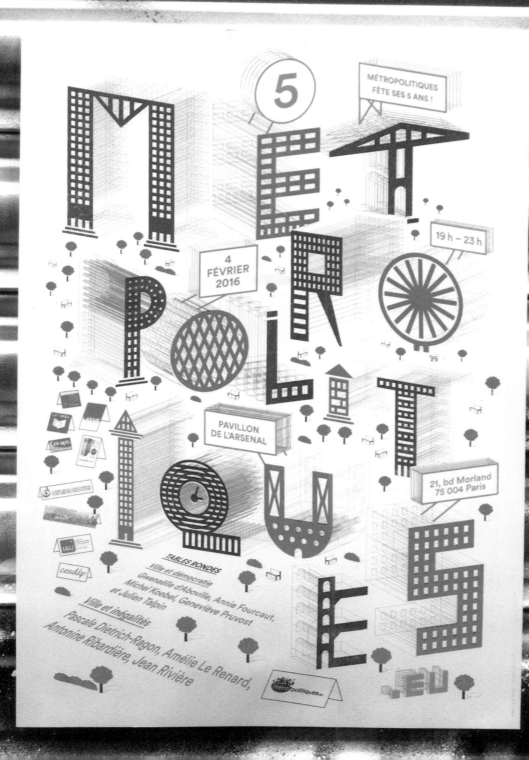

to get lost
in the
details

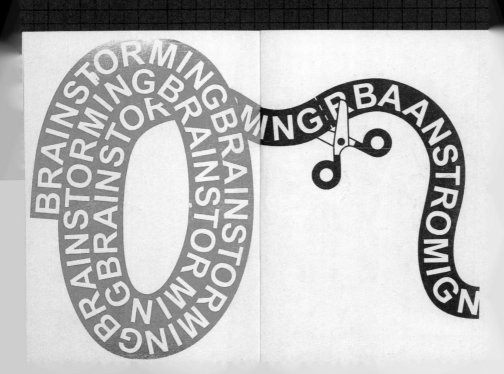

Opposite page:
Hurrikan Press
—
Nagy Zoli

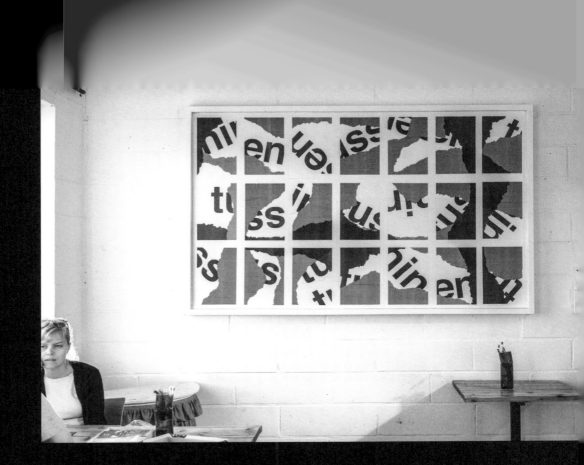

Topo Copy
—
Mathieu Billboard

Woolly Press

Colin Sutherland,
Junkyard Dogs, 2016
Green and Black Ink

Dizzy Ink
—
Craig Proud,
Paper Tiles, 2016
Gestetner print

**Bananafish
Books**
—
Little Monster Zines
Project

Opposite page,
above:
Inkwell Press
—
Luca Bogoni,
Unrationalism, 2016
Gestetner print

Opposite page,
below:
&soWalter
—
Benjamin Hickethier/Kristian Hjorth
Berge, *Risolove*
(detail)

**Charles
Nypels Lab**
—
Luca Bogoni,
Provoking DDG, A2, 2016

Opposite page:
Eleonora Marton
—
Red and Blue Posters

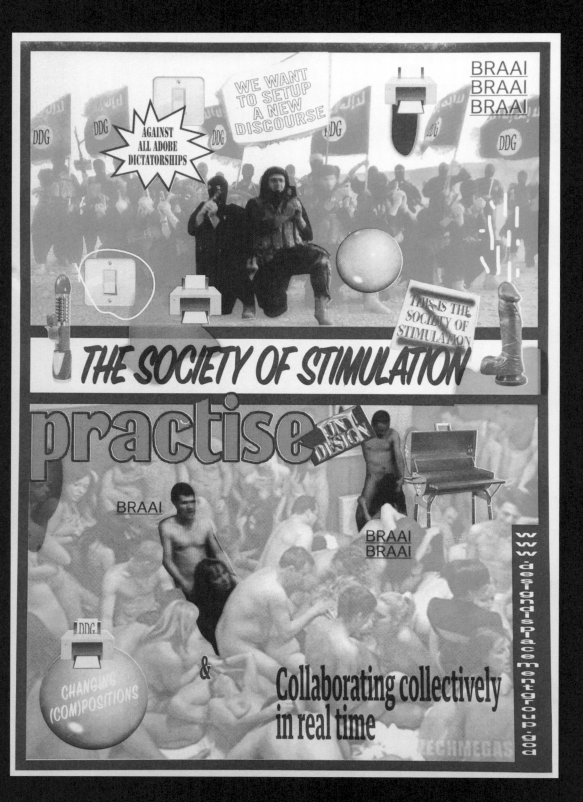

HIDE AND SEEK ALL-DAYER

I WOULD KILL FOR IT

LOST

BIG BLACK 4 LEGGED

A NIGHT OF LULLABIES

LOST

NOT TOO BAD

YAWN TOGETHER

SAY YES

NOT GOOD AT ANY SPORTS

Opposite page:
Bananafish Books
—
Yayi Liu, artist book

Atto
—
Sudario #01,
2015

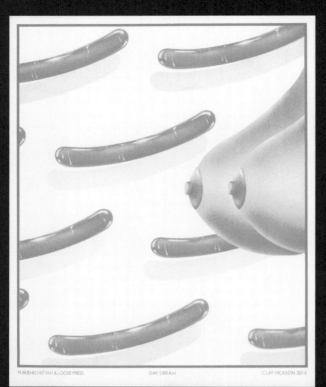

**Tan & Loose
Press**
—
Clay Hickson,
Day Dream, 2015

Dizzy Ink
—
A selection of prints
in the press space

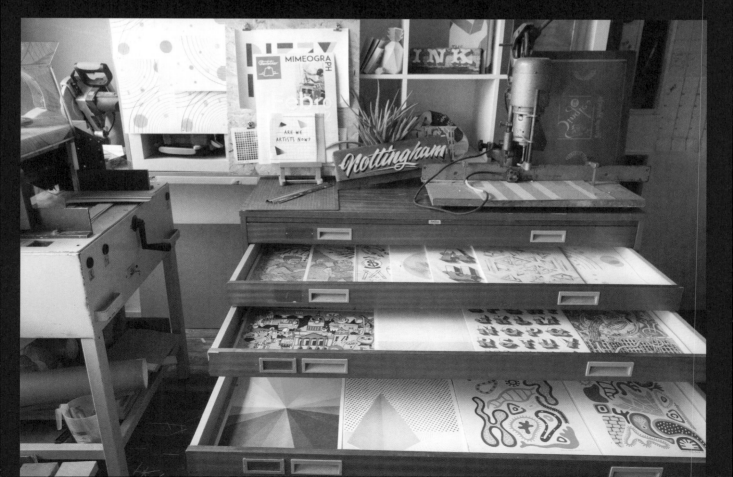

tem reunidos num mesmo campo todos os traços que constituem o escrito.

múltiplas, saídas de várias culturas e que entram umas com as outras em diálogo, em paródia, em contestação; mas há um lugar em que essa multiplicidade se reúne, e esse lugar não é o autor, como se tem dito até aqui, é o leitor: o leitor é o espaço exato em que se inscrevem, sem que nenhuma se perca, todas as citações de que uma escrita é feita; a unidade de um texto não está na sua origem, mas no seu destino, mas este destino já não pode ser pessoal: o leitor é um homem sem história, sem biografia, sem psicologia; é apenas esse alguém que tem reunidos num mesmo campo todos os traços que constituem o escrito. É por isso que é irrisório ouvir condenar a nova escrita em nome de um humanismo que se faz hipocritamente passar por campeão dos direitos do leitor. O leitor, a crítica clássica nunca dele se ocupou; 'para ela, não há na literatura qualquer outro homem para além daquele que escreve. Começamos hoje a deixar de nos iludir com essa espécie de antífrases pelas quais a boa sociedade recrimina soberbamente em favor daquilo que precisamente põe de parte, ignora, sufoca ou destrói; sabemos que, para devolver à escrita o seu devir, é preciso inverter o seu mito: o nascimento do leitor tem de pagar-se com a morte do Autor.

1968, Manteia.

A morte do autor · Roland Barthes · 1967

o nascimento do leitor tem de pagar-se com a morte do Autor

Risotrip
—
Igor Arume,
*Cuando design
e ãutopublicaçao
se tornam atitude*

Risotrip
—
Cleo Lacoste,
Exploratory Universe,
fanzine

C·I·T·Y

PARIS

C·I·T·Y

SEOUL

Keet is the tiny, mobile home of

Bianca Apostol ('91, Romania)
Daniel Vernooij ('90, The Netherlands)
Dok, the dog ('13, Slovakia)

keet

keet has been located at

Sprundelsebaan 60 — A squatted
 historical monument farm in Breda, NL
A small plot of forest in Etten-Leur, NL
Simon and Sanne's farm in Galder, NL
The Verbeke Foundation —
 an art museum in Kemzeke, BE
DOK — Ghent, BE

Andrea Fasciani

The View From Lucania

The view from Lucania is an independent organization founded by Stefano Tripodi in 2010. We support South of Italy through the implementation of audiovisual concepts, exhibitions, events, workshops, productions related to photography and cinema, overseen by international photographers and directors.

theviewfromlucania.com

Sudario n° zero

11

Spera II

a tua cucina di ceramica e marmo volevo
che ero, per quello che eravamo stati da
mbe d'acqua tirate col fiato corto nella
ingesti alla sera. Lontano da me. Tua sorella

to nero e la pelle di latte. Tu, Giovanna
nese balbettate di Bologna a piedi nudi
. C'è gente che non conosco e poi tutto il
d'estate a casa tua. Le pacche sulle spalle,
il profumo di incenso e le candele bianche
mie guance.

lcone, mi raggiungi. Fumo un toscano, lo
di lei. Dei suoi riccioli di legno, delle labbra
io petto che batte. Sto aspettando. Aspetto.
i abbracci. Giro gli occhi. Mi
o a parlare, Giulia. Non fare niente. Non
miti in tasca. Ho sempre invidiato il tuo

Aldo La Capra

IV

Sudario n° zero

2

Stefano Tripodi

The View From L[...]

Sudario n° zero

6

13

Salvatore Santoro

The View From Lucania

Spora 18

Densamente spopolata è la felicità.
Balormoa, C.S.I.

Il santo è uscito dal buio. Il sugo è [...]
domenica del dì di festa brucia di sole re[...]
di Gianni. Giovanna ha messo il vestito e [...]
suda, come tutti gli anni, ed il suo clarin[...]

La zia di Francesco siede matron[...]
i capelli blu e suo m[...]ito le tiene la ma[...]
destra. Margherita è un confetto aranc[...]
maschietto guascone, Enrico paga da [...]
cravatta comprata a Verona. Io ho la m[...]
mi tiene compagnia, bevo una bionda [...]
materializza tra la folla. I suoi capelli b[...]
d'oro per quarant'anni di lotte.

Rocco ha la banana in testa e i l[...]
occasioni, la camicia a righe e le labb[...]
figlia del Marinese e scoppiato il pett[...]
lui, la tiene d'occhio come fosse una [...]
Arriva la banda Ionica, il contrabbass[...]
mancano alla prossima sbornia.

Arrivi tu, Giulia, con quell'aria [...]
profumo troppo invernale. Sun Moo[...]
ricordo. Tu e la madre di mia figlia vi [...]
amiche e sembra un duello tra donn[...]
mento, non vedo i tuoi occhi, nasco[...]
bordeaux. Ti offro da bere, prendi u[...]
di malto sulle tue labbra lampone. C[...]
rocciose, i covoni di paglia, i caval[...]
all'intera processione. I miei occhi [...]
nuovo parroco. Ho i baffi sporchi di [...]
che partirai. Ad ottobre partirai. Ar[...]

Sudario n° zero

8

WAR CRIMES

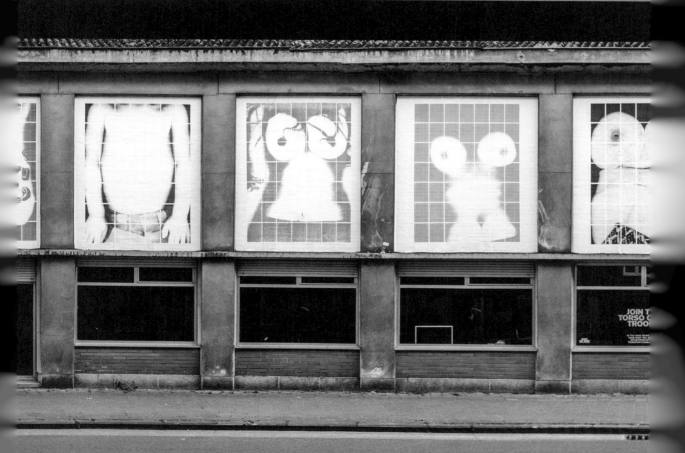

JOIN T
TORSO
TROO

Opposite page, above:
Calipso Press

Cano Neves,
*Why I Hustle to
Feed My Pimp*, 2016

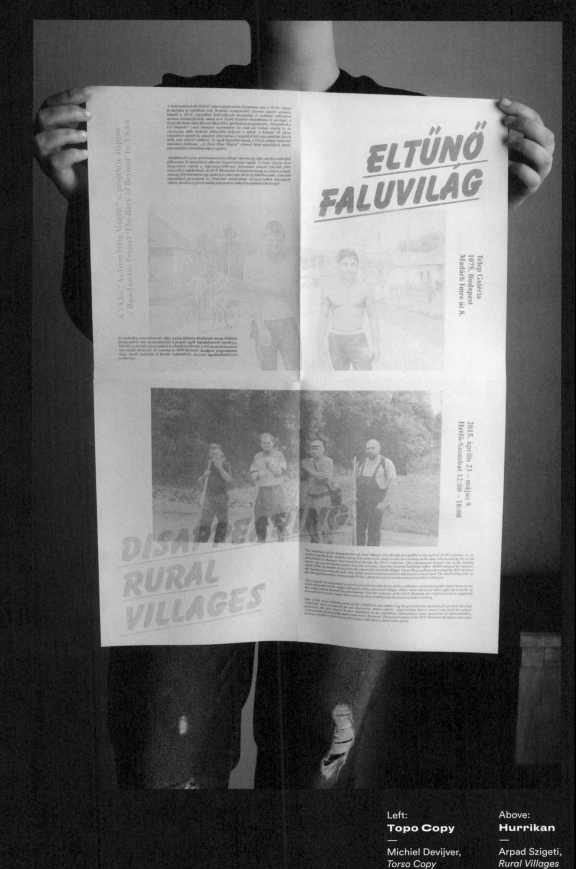

Left:
Topo Copy

Michiel Devijver,
Torso Copy

Above:
Hurrikan

Arpad Szigeti,
Rural Villages

El pájaro
perdido
*Zakaria
Mohamed*

caras

meteorito

Verano 2014

¡MIAU!

ANDREA GARCÍA

w
dic
sho

ONCE
POEMAS
AHMOUD
DARWISH

un
poema
mexi-
cano

diego enrique osorno

Huacal
Alexander Bühler

An
Interview with
Manuel
de Landa

Los Ot

Derrumbes

Abdellatif Laabi

Esta condición

llamada exilio,

o llevar

bellotas

Iósif Brodsky

Columnas
de humo

VIAJE A
MÉXICO
HORACIO
COSTA

ANTÍLO
P
LO

Lic.
Colo
-sio

Adiós *Oriol Vilanova*

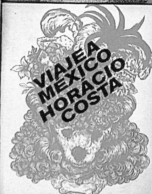

VIAJE A
MÉXICO
HORACIO
COSTA

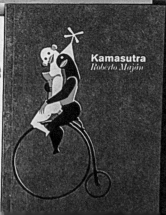

Kamasutra
Roberto Majàn

The
Book of
Pleasures
Chapter I

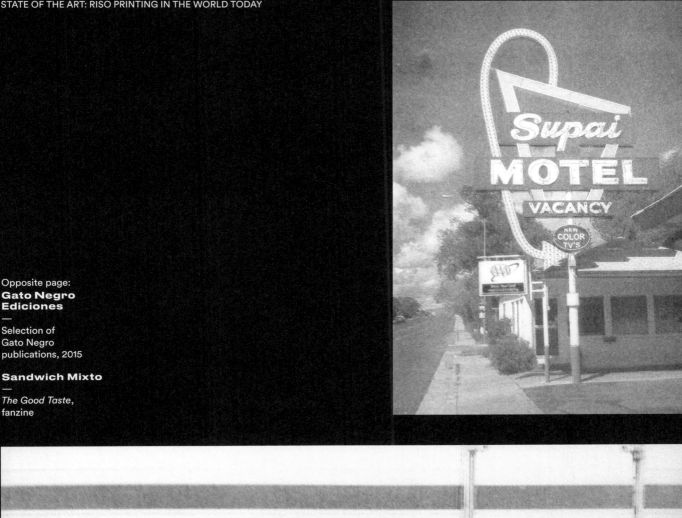

Opposite page:
**Gato Negro
Ediciones**
—
Selection of
Gato Negro
publications, 2015

Sandwich Mixto
—
The Good Taste,
fanzine

Colour Code
—

Arrington de Dionyso,
Shamanic Shunga, 2014
Cornflower Blue, Red,
Yellow, Black

Colour Code
—

Magic Snake, 2014

Opposite page:
Colorama
—

Aisha Franz

Following spread:
Topo Copy
—

Colour chart

RISO WORLD: GLOBAL HUBS, PRESSES AND COMMUNITIES

AN ATLAS OF MODERN RISOGRAPHY

140 NORTH AMERICA

UNITED STATES (115)

15 CHICAGO

CANADA (15)

30 NEW YORK

MÉXICO (10)

10 LOS ANGELES

NORTH PACIFIC OCEAN

NORTH ATLANTIC OCEAN

14 SOUTH AMERICA

BRAZIL (8)

ARGENTINA (3)
OTHER (3)

SOUTH PACIFIC OCEAN

N

W E

S

CITIES WITH THE MOST PRESSES

COUNTRIES WITH THE MOST PRESSES

UNITED STATES (115)

GERMANY (28)

FRANCE (28)

UK (19)

THE NETHERLANDS (19)

148 EUROPE

GERMANY (28)

FRANCE (28)

UNITED KINGDOM (19)

BELGIUM (12)

THE NETHERLANDS (19)

OTHER (42)

10 THE HAGUE

7 LONDON

10 BERLIN

5 PARIS

10 ASIA

TAIWAN (5)

OTHER (5)

16 AUSTRALIA

MELBOURNE 9

INDIAN OCEAN

SOUTH ATLANTIC OCEAN

7 NEW ZEALAND

A DIRECTORY OF PUBLISHERS, PRINT SHOPS, AND DESIGN STUDIOS

The data used to compile the atlas on the previous page is drawn from *stencil.wiki*, an online resource for artists, designers, and printers who use the Risograph as part of their creative practice. It was set up to share information about Riso and to help foster an international community of printers. The main focus of the site is an interactive map where studios and Riso users can upload their location, and the details of the machines and colours they work with. While it does not, of course, claim to be authoritative, this project shows where many leading Riso studios are based, as well as how they are distributed around the globe. *Stencil.wiki* is run out of Issue Press, an independent publisher based in Grand Rapids, Michigan.

FRONTLINE RISOGRAPHERS TODAY

We have explored some of what makes Riso printing such an attractive and productive option for artists and designers, and we will go into even more detail on the process itself later. Here, we would like to share the work of some leading Riso-orientated studios and artists, and consider how the Risograph is at the heart of an expanding global movement.

This movement reflects the multi-faceted nature of the Riso, in that it comprises a mosaic of different people and spaces. At one extreme is the artist who prints her own works on a single machine. Then there is a wide spectrum of studios, workshops and ateliers of differing sizes, services and hardware options. Many studios spring up when one or a few people's unquenchable Risomania comes to take over their whole lives: there are those that share their Riso machine with other organizations; those that are run as DIY, community projects, where people can come and learn and print their own work; those that offer profes-

sional services or are run as professional printing studios; and those that exist in an educational context, funded in part or entirely by a university or academy. In reality, most Riso studios are hybrids that combine several different approaches to printing. Many also feature other tech than Riso, often in the form of mimeograph-type or book production devices.

The Risograph is designed for heavy-duty printing – as we have seen, to make it economical you need to be making upwards of about 50 prints. A side effect of this is that Riso printing tends to be a collective, communal activity, and Riso studios are often hubs where people pool resources and know-how.

It makes sense to think of many Riso projects as true collectives more than mere conglomerations of individual artists. Amsterdam's Design Displacement Group, for example, consists of 16 people who collaborate "in shifting constellations," and "practice a working method that should be read as collective and post-signature; a mechanism to reflect, refract and speculate upon alternative frameworks for 'productive' engagement and exchange." The Hato Press in London, meanwhile, is conceived of as "an autonomous experimental space", where all profits from printing are ploughed back into the project. The current renaissance of Riso printing in part came out of the Netherlands where, ever since the heady days of Provo, DIY publishing and stencil duplicators have featured prominently in countercultural and artistic circles. Founded in 1983, legendary Dutch studio Knust first started using Gestetner and Roneo machines in the 1980s, and were in the early 1990s one of the first to exploit the possibilities of Riso and other digital duplicators. Indeed, among many veteran Dutch risographers it seems there is sense not so much of a revival in stencil duplicating but of an unbroken tradition stretching back for decades – one that evolved in pace with the technology.

Through the work of pioneers, many of them concentrating on book publishing, the Riso aesthetic

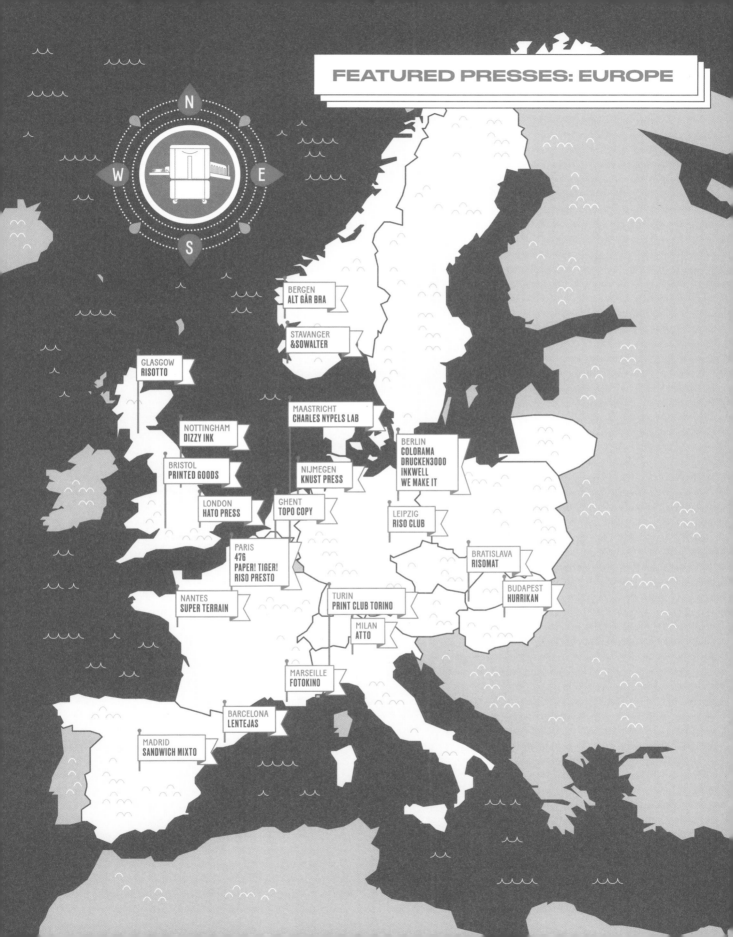

FEATURED PRESSES: EUROPE

N
W E
S

BERGEN
ALT GÅR BRA

STAVANGER
&SOWALTER

GLASGOW
RISOTTO

MAASTRICHT
CHARLES NYPELS LAB

BERLIN
COLORAMA
DRUCKEN3000
INKWELL
WE MAKE IT

NOTTINGHAM
DIZZY INK

BRISTOL
PRINTED GOODS

NIJMEGEN
KNUST PRESS

LONDON
HATO PRESS

GHENT
TOPO COPY

LEIPZIG
RISO CLUB

BRATISLAVA
RISOMAT

PARIS
476
PAPER! TIGER!
RISO PRESTO

BUDAPEST
HURRIKAN

NANTES
SUPER TERRAIN

TURIN
PRINT CLUB TORINO

MILAN
ATTO

MARSEILLE
FOTOKINO

BARCELONA
LENTEJAS

MADRID
SANDWICH MIXTO

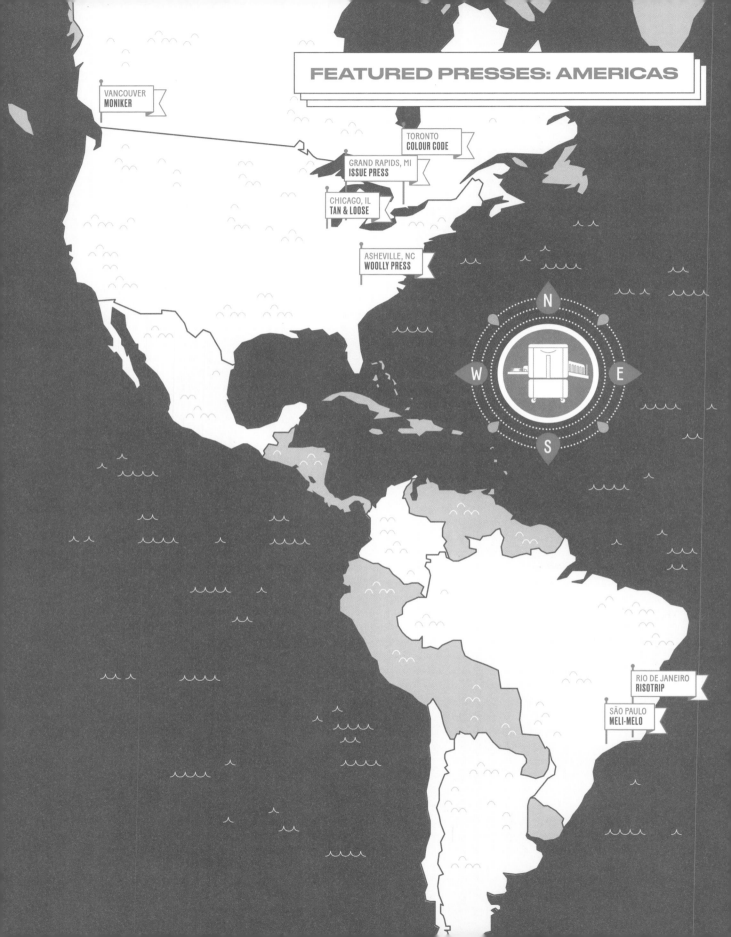

FEATURED PRESSES: AMERICAS

VANCOUVER
MONIKER

TORONTO
COLOUR CODE

GRAND RAPIDS, MI
ISSUE PRESS

CHICAGO, IL
TAN & LOOSE

ASHEVILLE, NC
WOOLLY PRESS

N

W E

S

RIO DE JANEIRO
RISOTRIP

SÃO PAULO
MELI-MELO

began to spread through Europe, establishing a particular foothold in Germany, France and the UK. But the Netherlands remains the focus of the European movement: MAGICAL RISO, the first International RISO Expert Meeting, was held in November 2014 at the pioneering Charles Nypels Lab, part of the Jan van Eyck academy in Maastricht.

And as Risograph machines are sold all over the world, all over the world you can find artists and designers who use them for creative ends; you can get a sense of the extent of the community from founder of Issue Press George Wietor's outstanding *stencil.wiki* project.

Whatever their set-up or location, all Riso spaces share one clear characteristic: a desire to get deep into the process itself. Risograph printing forces you to be hands-on, to understand the limits and possibilities of the technique through experimentation. Printing on a Riso generates a trial and error paper trail – the first drafts are still lying around when you come up with the finished version. This creates a feedback loop and sense of concrete development that are lost when you work exclusively on a computer and sketch your ideas in the sand.

And then there is the machine itself. For reasons we look at below, studios that use Riso for art- and design-related projects tend to own older models. While they still work more than perfectly with the right coaxing, senior Risos can be cranky, some more than others prone to jam or crash Photoshop repeatedly. Even changing the drum is an elaborate, physical process, ideally undertaken with two pairs of hands, involving opening a hatch on the device and pulling out a heavy cylinder, then setting it in its casing. No matter how pro you are, the ink gives you grubby thumbprints like you just voted, and sometimes the master jams and you have to unwrap the sheet of thick, vivid, glistening ink off the drum.

It is easy to forget that the studios we feature here probably represent a tiny fraction of the business that the Riso Kagaku Corporation does worldwide. In fact, studios like these very often only buy second-hand Risos, sometimes dating from as far back as the 1980s. There are several reasons for this. One is clearly price – new Riso machines are aimed at businesses and larger commercial organizations with budgets far beyond that of a DIY zine press. Another is the look itself. Earlier Riso machines gave a rough, primitive finish, which, combined with a tendency towards minute misregistration, is why they were of little interest to professional printers, and were marketed at a more lo-fi, design-lite consumer segment: church bulletins and AGM pamphlets. One of the company's great successes has been to increase the precision and clarity of the Riso print, to the point where it is a viable alternative to laserjet. But this process has resulted in what certain users see as a loss of some essentially Riso touch, and they still prefer to use the older, less precise, more exuberant models.

Precision is the bleeding edge of modern stencil duplicating, and Riso and its competitors are committed to making their prints ever more crisp and regular. In an interview with *Graphic* magazine, Jan Dirk de Wilde and Joyce Guley of Knust explained: "Sometimes, [Riso competitor] Ricoh sends their Japanese head to Europe to research how we use [our duplicating machines]. They can see that our printing is quite precise, so they want to know what our secret is. We tell them that it's all about pre-press, how you make colour separation in the computer, how you look at the spaces and how we can move maybe just a millimetre to get it right. And that was very disappointing for him, as he was selling the machine, not the pre-press."

It is worth noting that, as well as Riso, many of the presses we cover work with older stencil duplicators like mimeographs or Gestetners. Digital duplicators like Risos allow you to print directly from the computer, making them a somewhat hybrid technology; with mimeo, by contrast, the stencil master must be prepared painstakingly with tools or typewriter (remember Diane di Prima's exasperation). Designed to be operated

and run in-house, the Gestetner in particular is a small miracle of engineering that experienced hands can easily take apart and put back together again, uncomplainingly.

Both the use and the operation of mimeo-type duplicators thus require an incredibly close, tactile relationship with the material and the machinery. This relationship is reflected in the intimacy of the prints themselves, invested each one with a singular, fragile identity. And it means that mimeos are ultimately more responsive than digital duplicators, more pliable, easier to take to unexpected places: perhaps the best metaphor is to compare the mimeo to a horse, and the Riso to a race car.

There is something in the quality of mimeo prints that is dreamily redolent of past ages of industrial design. Many people use Riso ink to print with mimeographs, both because Riso is more vivacious than the original oil-based mimeo ink, and because most studios already have the stuff on

hand – a Chinese company recently started producing mimeo ink, but it is otherwise quite hard to find. Either way, what this does is allow you to run off prints that are imbued with a modern, Riso-y feeling, wrapped up with the unique, vivid but refined vibe of the mimeo.

Stencil duplicating represents an endlessly fruitful modus operandi. The Riso is close to cementing its role in contemporary global visual culture. And, as designers, illustrators and artists move further and further away from all things digital, coming years will surely see an increased prominence of mimeographs and their like. I have in conversation explained what this book is about on many occasions, each time needing to more or less start from the beginning of the story sketched here; there is little doubt, however, that within a few years stencil duplicating will come to occupy a sufficiently prominent place in contemporary artistic practice as to obviate the need for any prefatory explanation, as well as much of this text.

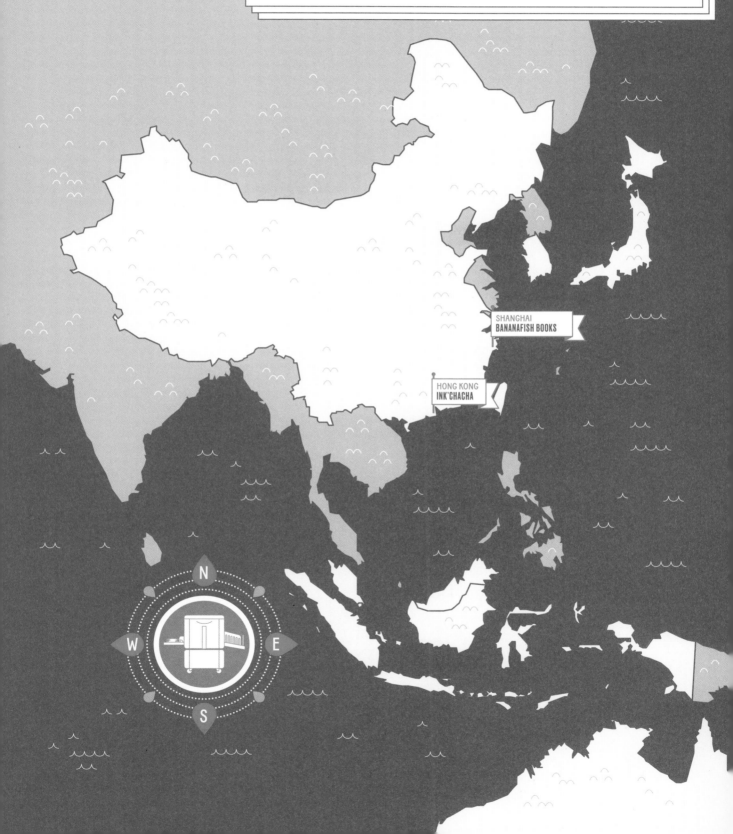

FEATURED PRESSES: ASIA & OCEANIA

SHANGHAI
BANANAFISH BOOKS

HONG KONG
INK'CHACHA

N
W E
S

TAN & LOOSE

CHICAGO, USA

MACHINES

RISO RP 3700

COLOURS

Black, Blue, Red, Yellow, Green, Fluo Pink, Orange, Orchid, Flat Gold

tlpress.bigcartel.com

Clay Hickson started Tan & Loose Press for no other reason than to be able to work with his favorite artists. He had seen some Riso prints online, but didn't know much about the process: he just knew he wanted one. It was the biggest investment he had ever made, but he found a second-hand machine in 2012 and decided to go for it.

When he first brought it home, he had no idea how to use it or what to use it for, so he just started experimenting and printing work for friends. Each machine is a little different and you have to get to know all of their little quirks to get good clean prints. The process feels both magical and extremely frustrating. Just when you think you've gotten the hang of it, he says, some little thing changes or breaks and you have to learn to adapt.

Once he got the hang of it, Clay emailed ten of his favorite artists (most of whom he had never met) and asked if they wanted to publish an edition of prints. To his surprise, everyone said yes. So he printed up all the work and hosted a little print release party called Tan Lines, and that's basically what he's been doing ever since.

Founder George Wietor first became aware of the Risograph in 2009. Thanks to his beloved Print Gocco he was already familiar with Riso as a company, but in the Risograph he found the intensity and "flatness" of colour that he had been looking for, without the backbreaking labour of screen printing.

He discovered many of the great European stencil printers, like Knust in the Netherlands, Rollo in Switzerland, and Landfill Editions/Many Mono in the UK. He became obsessed – "infatuated," in his words – with the work of these studios, and found a machine of his own when it popped up at a church in the local online classified ads.

He initially used the Risograph to print event flyers and zines for an all-ages music space he had helped to start years earlier, but was soon printing zines and print editions for friends as well, and that practice took over. Issue Press became less about working on Wietor's own projects and focused heavily on publishing as a curatorial practice. Through a combination of book sales and job printing, Issue Press has grown into a fairly complete Risograph print shop and full-service bindery.

In addition to publishing and printing, Issue Press is also home to several Risograph-focused research initiatives. In 2012, Wietor launched *An Atlas of Modern Risography* – a wiki map that lists studios and artists using the Risograph as part of their creative practice. It was created primarily to act as a census, in the belief that it would be impossible to build an international community of printers if they don't know that others exist.

Wietor is also very interested in how Risographs were used before the relatively recent explosion of interest from the art and design community. Most artists in North America can only afford to purchase machines second-hand, meaning they most often acquire ink drums with old masters from the last print job remaining and sometimes even machines with lost prints buried deep inside. These scraps provide clues about the past life of the machine. Be it a church programme, potluck flyer, or hospital intake form, Wietor collects these images as a fascinating record of a particular type of vernacular desktop publishing. The first volume of these materials were compiled into a booklet published by Temporary Services called *Past Lives: Found Risograph Ephemera*, but the collection is ongoing and he is always seeking submissions of found Risograph-printed materials.

MACHINES
RISO RP 3700 UI
RISO MZ 790

COLOURS
Black, Burgundy, Blue, Federal Blue, Lake Blue, Teal, Light Teal, Moss, Metallic Gold, Flat Gold, Yellow, Bright Red, Fluo Pink, Fluo Orange, Purple, Orchid, Green, Moss, Orange, Tomato Red, Bright Red

issue.press

ISSUE PRESS
GRAND RAPIDS, MI, USA

Fotokino is an association founded in 2000 dedicated to the diffusion of artworks. The Fotokino Studio, opened in October 2011, offers a space for experimentation and sharing for artists as much as for the public, through a programme of exhibitions, workshops and meetings. As part of this programme, Fotokino publishes the work of guest artists (posters, books, limited editions) using all kinds of techniques (offset, screen printing, woodcut and, of course, Riso).

Since 2013 (when Marseille was European Capital of Culture), Riso France has provided the organization with a RISO MZ 970. The studio uses this machine to publish fanzines and a collection of posters, and also many useful day-to-day documents: business cards, flyers, educational documents... As they do not have a space dedicated to printing, the Fotokino team store the Riso in a bathroom and wheel it out to print after closing to the public for the day. In addition, they often use the duplicator as an educational workshop tool, so that children of all ages can create posters and fanzines and learn about the whole chain that leads from an original creation to distribution of a printed object in bookshops.

Among other artists, Fotokino has published: Atak, Isidro Ferrer, Icinori, Aurélien Débat, Bonnefrite, Jochen Gerner, Nigel Peake, Paul Cox and Hannah Waldron. The goal of their image collection is to sell pieces which have a very singular quality, but at prices affordable for everyone, (unlike screen prints, for example), all this while allowing artists to experiment with great freedom.

At Fotokino, they believe that it is the hybrid nature of the Riso that makes it unique: it has a banal appearance, identical to that of a laser copier, but produces images as beautiful as screen prints. This is probably what appeals to most people who discover it.

MACHINES
RISO MZ 970

COLOURS
Black, Gold, Blue, Red, Yellow, Green, Neon Pink

fotokino.org

FOTO-KINO
MARSEILLE, FRANCE

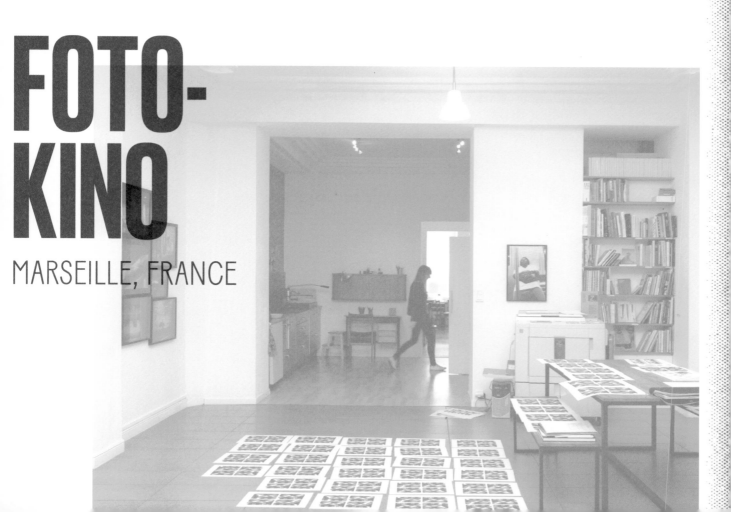

LENTEJAS

BARCELONA, SPAIN

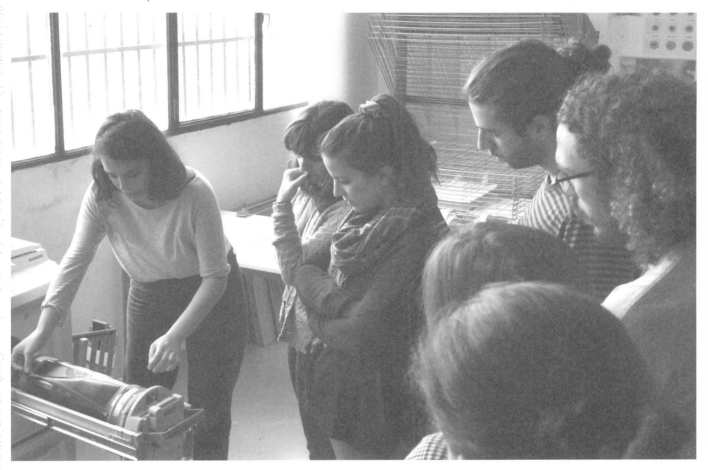

MACHINES
RISO RP 3700

COLOURS
Blue, Red, Yellow, Black

lentejaspress.tumblr.com

Lentejas Press is an independent print studio and small press based in Barcelona, made up of Spanish illustrators Elena López Lanzarote and Elena Ortiz and Italian graphic designer Francesca Danesi.

Lentejas was established in 2013 as a small press to function as an open experimental space to encourage illustrators and graphic artists to develop ideas and facilite their visibility. In 2014 they moved to a larger space where they could start offering an affordable means of production for others, paying particular attention to the creative process and handmade creations. They now run a range of courses for those interested in this technique.

Lentejas publications are a showcase for all the different artists that make the project possible. They are obsessed with printmaking, screen printing and, above all, Riso!

LONDON, ENGLAND
HAT○
PRESS

MACHINES
RISO MZ 770
RISO RP 3700

COLOURS
20 colours, including Metallic
Gold, Aqua Blue and Fluo
Green

hatopress.net

Hato Press is an independent printing and publishing house based in London. It was established in 2009 to act as a support structure to help sustain its members' practices and offer an affordable means of production for others.

Today Hato works as an autonomous experimental space that encourages collaborators to develop ideas and facilitate both the production and distribution of new content. Hato now comprises three parts: Hato Press, a printing and publishing house; Studio Hato, a design studio specializing in publications, exhibitions, education and workshops; and its newest member, Hato Labo, an interactive design studio. All profits are directed into purchasing new equipment for the workshop and making new books.

The word 'hato' means pigeon in Japanese.

The Riso Club is an open print shop founded in 2014 and run by designers Christiane Haas and Sina Schindler. The space is aimed at everybody, from bar owner to graphic designer, from small start-ups to venues that host events, or just anyone who is interested in Risography.

The GR 3750 seems "pretty solid" to the Riso Club founders, despite some bugs they have had to fix, such as sticking the 'feed tray paper guides' with tape to stabilize the position of the paper, or opening the machine up to fix the paper feed. Unfortunately, they do not have the option of printing via PC-interface: although they have a RIP, they have no idea how to get it working (they have asked people if they could help repair it, but for the moment are still waiting for a working solution).

As well as printing, the shop is a place to meet people. The owners like to hang out and have fun with friends and customers, and show people who may never have heard of Risography how beautiful the technique is.

MACHINES
RISO GR 3750

COLOURS
Yellow, Orange, Red, Fluo Pink, Purple, Blue, Green, Black

risoclub.tumblr.com

RISO CLUB
LEIPZIG, GERMANY

PAPER! TIGER!

PARIS, FRANCE

MACHINES
RISO RZ 370

COLOURS
Black, Medium Blue, Yellow,
Red, Fluo Pink, Green, Purple,
Flat Gold

papertiger.fr

Paper! Tiger! is a graphic design and micro-edition studio that has been active since 2011.

According to the founders, they were unaware of the Riso 'trend' among graphic designers and visual artists at the time they bought their first Riso: they saw it only as a cheap and convenient means to produce printed matter, in a totally independent and autonomous way. And after all this time, they say, they wouldn't really describe it any differently: it is a powerful means of production, that allows them to freely imagine, create and distribute printed objects, for themselves and for the artists and designers with whom they collaborate. "It

makes things possible that we otherwise wouldn't even consider doing."

From this perspective, they find the use of the Riso machine and its implications fascinating from social, political and economical points of view. The simple presence of the machine in the studio allows them to meet people from very diverse backgrounds, on an almost daily basis, driven by one single common interest, namely, a will to collaborate in order to create something in a entirely independent way. From this perspective, the use of Riso technology induces a number of other evolutions: "Developing and strengthening particular skills (project management! workflow! paper engineering! binding!), reaching out to a network of potential distributors for the editions, etc."

As far as the technical aspects are concerned, it's always been crucial for Paper! Tiger! that the machine be seen and understood as a tool, a tool that has its specificities, its properties and its limits: "In order to conceive and produce a project, you have to understand how it works and what it does; just like you wouldn't grab a hammer to knock a screw into a piece of wood. That being said, it's always exciting to realize that we keep learning, that our knowledge and know-how keep progressing with each new project we produce; in the preparation of the projects: color-separations, dithering (half-tones, patterns, angles, etc); as well as in the actual making and printing: troubleshooting, fine-tuning, all sorts of tips!"

In the words of the Paper! Tiger! team: "It's this back-and-forth between ideas/concepts/images and practical experience/experimentation that is probably the most interesting and exciting aspect of Risography for us: the way this particular technique informs and shapes the projects from the very beginning, in their conception. As such, this process is also a very good synthesis of the way we think about graphic design: not only the production of visual or typographic compositions, but also – and maybe more importantly – the creation of the objects that carry them into the world."

MACHINES
RISO RP 3505

COLOURS
Black, Bright Red, Blue,
Green, Fluo Pink

atto.si

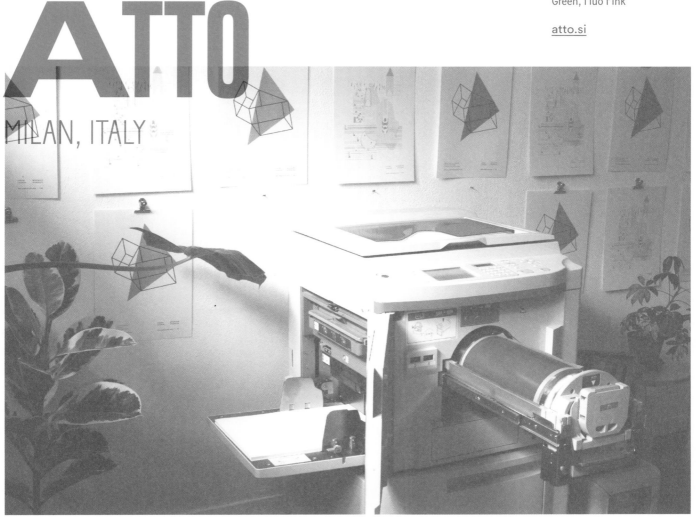

ATTO
MILAN, ITALY

Atto is a design consultancy based in Milan and directed by Sara Bianchi and Andrea Zambardi. They decided to set up an independent studio after working with different studios for several years. They believe in an open approach, and collaborate with a network of partners who help develop each project by contributing with their ideas and skills.

They are also passionate about printing and self-production, and when they decided to set up the studio they wanted to experiment in this area. They tried different printing techniques,

including silkscreen and letterpress, but needed something that would be a good fit with their studio activities. So in 2013 they bought a Risograph RP 3505.

At the time they didn't know anything about Risograph printing. There wasn't much information online, so they had to experiment a lot with the machine, making mistakes (including the purchase of an old and not particularly useful machine) and learning from them. In the end they learned how to handle the machine (almost), but, they

say, every time they switch the Riso on they learn something new.

Typically they use the Riso to print posters, postcards and fanzines they design. But they also give other people a chance to print by hosting workshops, sometimes in collaboration with schools or festivals.

CHARLES NYPELS LAB

MAASTRICHT, THE NETHERLANDS

MACHINES
MZ 1077 E
RISO A2 duplicator
6 Gestetner

COLOURS
Black, Metallic Gold, Blue, Green, Medium Blue, Bright Red, Purple, Flat Gold, Red, Yellow, Orange, Fluo Pink

janvaneyck.nl/en/labs/ charles-nypels-lab/

The Van Eyck Academie is a multidisciplinary post-academic institute for artistic talent development. Artists, designers, curators, photographers, architects, landscape architects and writers come from all over the world to work on their own and collaborative projects.

The Charles Nypels Lab is the printing and publishing workshop of the Van Eyck, and offers Risography as well as screen printing, letterpress, high-speed inkjet and photopolymer techniques. The workshop is fully equipped for the production of artists' books.

The multiform character of the Van Eyck appeals to the artistic and intellectual versatility of the participants. Their work is the effect and the result of various interlinked processes. The Van Eyck considers it important that doing and thinking be inextricably linked together in daily practice.

Drucken3000 is a Berlin-based Risography atelier run by graphic designers Alexander Branczyk and Florian Haberstumpf. Founded in 2014, the workshop is located in a beautiful back garden in Mitte and is open for everyone who loves to make their own prints. Alongside their wide range of colours, two colour drums are ready for iris print experiments. For post-print processing an Ideal 4700 Stack Paper Cutter, a Plockmatic 12 Sorter or a Plockmatic 80 Automatic Stapler & Folder can be used. Furthermore, there are several manual finishing tools available. Drucken3000 also publishes its own products, such as the *Fontografische Monatsb12tter* or the xplicit typographic sketchbooks.

MACHINES
RISO MZ 1070 E

COLOURS
Red, Purple, Medium Blue, Blue, Teal, Hunter Green, Yellow, Fluo Pink, Fluo Orange, Flat Gold, Brown, Grey, Black, Light Green, White, Metallic Gold

drucken3000.de

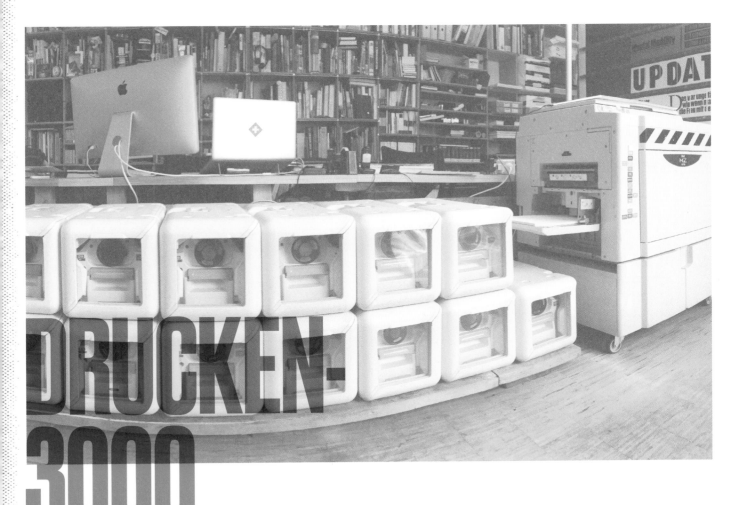

DRUCKEN-3000
BERLIN, GERMANY

MACHINES
RISO RZ 370

COLOURS
Black, Metallic Gold, Blue, Medium Blue, Green, Riso Federal Blue, Purple, Teal, Flat Gold, Red, Brown, Yellow, Orange, Fluo Pink, Fluo Orange

melimelopress.com.br

Meli-Melo Press is an independent publisher and printing studio based in the centre of São Paulo. Since opening in 2012, it has aimed to support and give structure to artists and designers, to help them develop their work using inexpensive production techniques. The acquisition of a Risograph RZ 370 was essential for the creation of this autonomous space in which experimentation and the development of new ideas is the main focus.

As a publishing house, Meli-Melo Press already has more than 70 titles in its catalogue. It functions as a fa-cilitator in the distribution of new content, disseminating the work of artists nationally and internationally. Supporter of the largest art book fair in Latin America, Feira Plana, it is always present in the biggest events in the field, such as Tijuana, New York Book Art Fair, Libros Mutantes, and Parada Gráfica, among others.

Moreover, it has acted as a propagator of information on fanzine culture, organizing several lectures and workshops in cultural spaces which cover various topics related to graphic production and the creative processes involved in self-publishing.

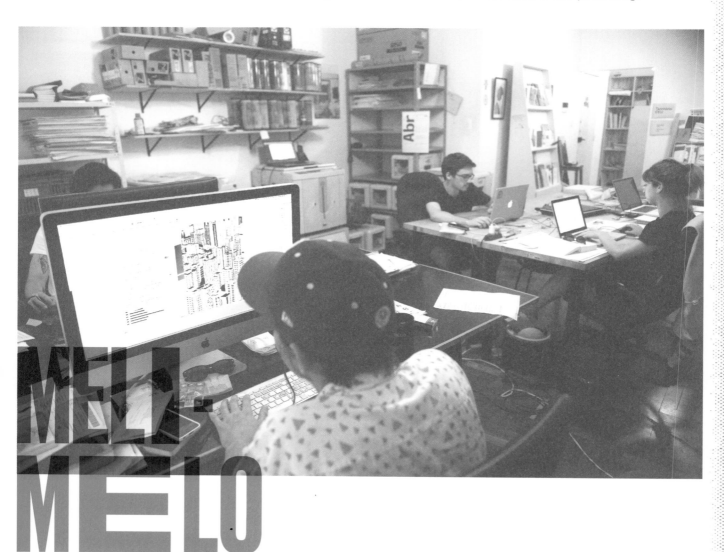

MELI-MELO
SÃO PAULO, BRAZIL

MACHINES
RISO RP 3700

COLOURS
Yellow, Blue, Red, Green, Brown, Burgundy, Black

topocopy.org

Topo Copy is a utopian print centre for creative people, an 'openlab-research-centre' for print, zines, paper, copy, ink and art. It runs a self-publishing label and (zine) library as well as activities such as workshops, lectures, interventions and expos. It runs an 'open atelier' with machines for creation using ink and paper. And it prints Riso!

Topo's aim is to make beautiful things. It handles print-related projects that are initiated in-house or proposed by artists, as well as on-demand jobs for festivals, cultural centres, galleries and off spaces.

You could compare the collective to a band: it rehearses, composes and goes out to play gigs!

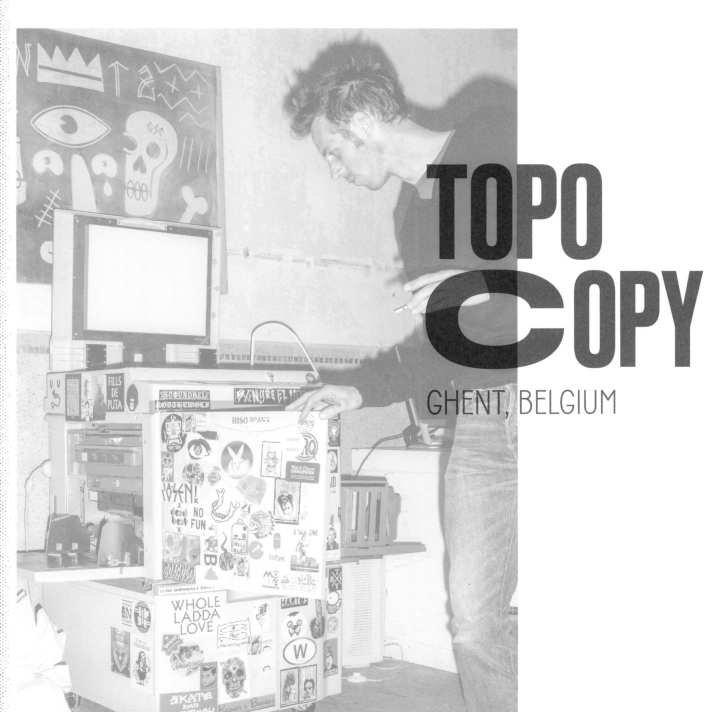

TOPO COPY
GHENT, BELGIUM

RISO PRESTO

PARIS, FRANCE

MACHINES
3 RISO GR 3770

COLOURS

Black, Grey, Metallic Gold, Flat Gold, Hunter Green, Green, Teal, Federal Blue, Medium Blue, Blue, Purple, Neon Pink, Burgundy, Bright Red, Warm Red, Orange, Neon Orange, Yellow

riso-presto.com

Riso Presto is Sarah and Aurélien, two French graphic designers and illustrators, united by a passion for printed objects. Great lovers of the Riso finish, in 2014 they opened their own workshop, gallery and shop in the 18ème, entirely devoted to Riso publishing and illustration.

At present, they are growing as a publishing house under the name Presto Éditions, working on collaborations with artists of all kinds. They are also seriously thinking about working with a small, two-colour offset press, in order to be completely independent in their productions, and make a greater variety of books.

What Presto find particularly interesting about Riso is the ability to play with the layers of colours, while modulating their subtly different opacities.

Bananafish Books is an art book-shop, a zine and artist book publishing house, and a social space that is unique in China in providing a platform focusing on zines and self-publishing printing services.

Bananafish Books hosts a dynamic programme of monthly workshops with in-house Risograph printing processes and mini art bookfairs and exhibitions. It provides a stimulating context in which to exchange ideas and promote zine culture on mainland China. The studio also provides Risograph printing services under the Pausebread Press brand.

Founded by Wei Guan, Pausebread undertakes various collaborative projects with many young artists and designers in China, among them the *Little Monster Zines Project*, an *Art Prints and Bananafish* project, the *We Make Zines* publishing project, and the forthcoming Risograph dual-colour magazine.

Risograph represents a unique visual language and a traditional printing history. Its limitations and possibilities stimulate people to either follow the lines or challenge stereotypes in making art to create something new. Works have a closer relationship with printing process and technologies. Bananafish Books and Pausebread believe that art and design should be colourful and playful, just as Risograph printing teaches us to be.

MACHINES
RISO RP 3790
RISO MD 6650

COLOURS
Black, Blue, Medium Blue, Green, Grass Green, Bright Red, Purple, Teal, Flat Gold, Brown, Light Grey, Yellow, Orange, Fluo Pink, Fluo Orange, Metallic Gold

bananafish-books.com

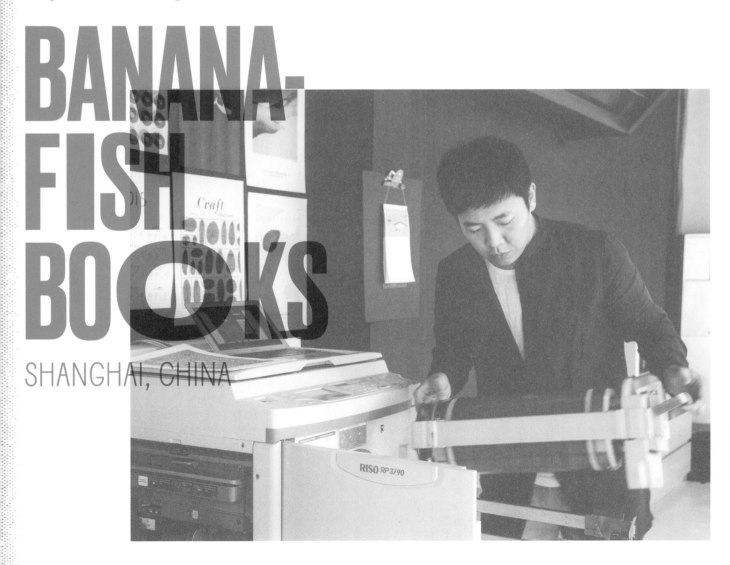

BANANA-FISH BOOKS
SHANGHAI, CHINA

476

PARIS, FRANCE

Set up by graphic designers Etienne Ro-
bial and Maxime Barbier, 476 is a struc-
ture for the production and publishing of
printed images; they publish artists, de-
signers and graphic designers. The studio
is particularly attached to the added val-
ue of the Riso 'flat colour' process which
makes possible overlays, combinations
and new blends of colour, providing a
unique, tailored approach to each artist
published. The name 476 refers to the
DIN 476 A (paper formats standardized
by the Deutsche Institut für Normung in
1922, size 1,414 √2).

MACHINES
RISO ME 9350

COLOURS
Black, Crimson, Federal Blue,
Yellow, Flat Gold, Orange

476.fr

Colour Code Printing was established in 2012 as a means of extending Jesjit Gill's art practice as a printmaker after graduating from art school. Risograph printing was an economical and environmentally friendly printing process that provided Jesjit with an affordable way to publish graphic novels and artist books which he could print and fund himself. Now in its fourth year, Colour Code has grown as an independent publishing platform with a focus on producing artist books, print editions, graphic novels and other printed matter by emerging and fringe Canadian and international artists. Today, Colour Code is a collaborative partnership with Jenny Gitman. In addition to publishing, Colour Code also provides an affordable printing service.

COLOUR
CODE
TORONTO, CANADA

MACHINES
RISO MZ 790 U
RISO MZ 990
RISO RZ 990

COLOURS
Black, Purple, Violet, Aqua, Blue, Teal, Green, Hunter Green, Mint, White, Yellow, Sunflower, Orange, Red, Fluo Pink, Fluo Orange, Raspberry Red, Brown, Metallic Gold

colourcodeprinting.com

RISO-TRIP

MACHINES
RISO RZ 370

COLOURS
Black, Blue, Bright Red,
Fluo Pink

instagram.com/risotrip

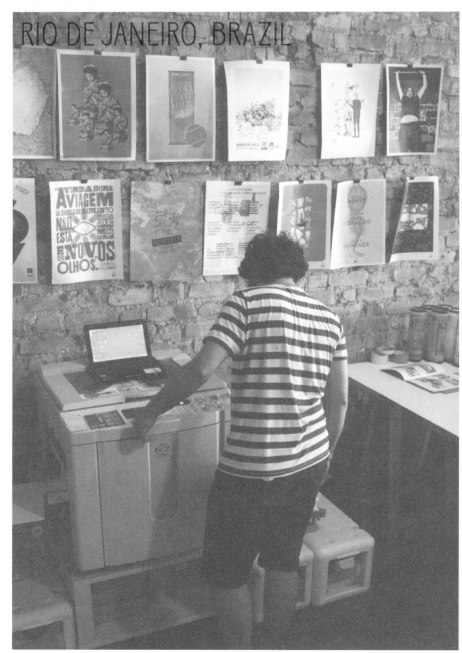

RIO DE JANEIRO, BRAZIL

Risotrip Print Shop Co. is an independent design studio and printing press based in Rio de Janeiro, Brazil. Established in April 2015 by Daniel Bicho and Igor Arume, a duo of graphic designers with a passion for travelling and exploring the outdoors, the venture started with a second-hand Risograph RZ 370 with black, blue and bright red colours – later in that year fluorescent pink joined the team. After two workshops, participations in zine fests and art book fairs, and ten zines published, Risotrip is the first printing studio fully dedicated to Riso printing in Rio. It aims to be a place to encourage and promote the work of local artists and creatives and give them an opportunity for high quality printing at affordable prices.

INKWELL

BERLIN, GERMANY

Inkwell Press was born of the combined experience of Luca Bogoni Design Studio and Vetro Editions, two independent organizations brought together by a shared passion for research into printing techniques, independent publishing and graphic experimentation. Inkwell exists in a plural space composed of diverse realities that intersect, overlap and express themselves singularly or in chorus: an atelier shared by creatives of different disciplines; a graphic design studio; a publishing house; a vintage stationery shop; a space for workshops and presentations. Inkwell is located in Neukölln, the dynamic Berlin neighbourhood that lies alongside the abandoned Tempelhof airfield.

A Risograph MZ 770e, a Gestetner 300 and 360, a Duplo DP63s and a reserve of about 250 litres of soy-based inks are the cornerstones of the press. Illustrators, artists, graphic designers and writers are invited periodically to print and present their work: recent projects have included collaborations with the Acid Arab collective and publishing venture Countless Books. Inkwell loves Riso and other stencil printing machines because of the incredible variety of low-cost experiments they allow, as well as their crunchy low-fi aesthetic and hypnotically powerful prints.

MACHINES
RISO MZ 770 E
2 Gestetner
Duplo DP63s

COLOURS
Black, Red, Teal, Yellow, Fluo Pink, Purple, Blue

inkwell.space

Printed Goods was started by twin brothers George and Raphael, both of whom are illustration graduates. They were both interested in Risograph printing because of the way it complements their graphic styles, lending a tactile aesthetic to printed matter. There was nobody offering this print process in Bristol when they started, and they were aware of the growing number of Risograph presses in London and other parts of the UK, so it seemed natural, they say, to start their own. It has proved an excellent way to support their own work by providing them with a living and a way to strengthen the creative scene in Bristol. Their aim is not solely to provide a print service, but to create a platform from which they can pursue other creative endeavours, such as an in-house publication they are currently working on that showcases local artists.

The brothers would advise anyone starting out in Riso not to be afraid to ask for help: "It can save you a lot of time in the long run, and people are far more willing to help than you may sometimes think." It is also important to be aware of your brand and what you want to do with it: "A strong brand aesthetic is important, especially now that social media plays such a strong role in self-promotion."

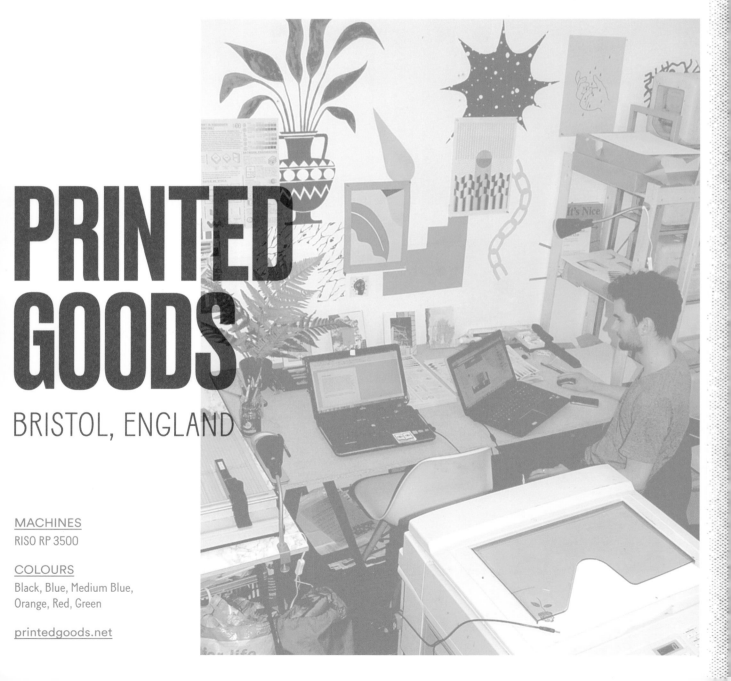

PRINTED GOODS
BRISTOL, ENGLAND

MACHINES
RISO RP 3500

COLOURS
Black, Blue, Medium Blue, Orange, Red, Green

printedgoods.net

DIZZY INK

NOTTINGHAM, ENGLAND

MACHINES
Gestetner 366
RISO 370 EP
RISO ME 9350 E

COLOURS
Black, Burgundy, Blue, Green,
Medium Blue, Purple, Teal,
Flat Gold, Hunter Green, Red,
Yellow, Fluo Pink

dizzyink.co.uk

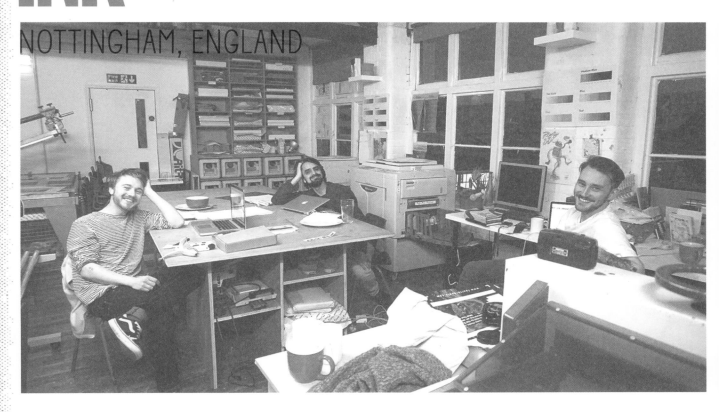

Dizzy Ink is a design, print and creative workshop studio that has two main principles: education and DIY attitude. It is not a studio that simply prints for commercial purposes, but prefers to engage with the client to realize how best to take their print projects to the next level, and then encourage them to join the small press and publishing community by selling or swapping at fairs, and exhibiting or collaborating with other creatives.

Dizzy Ink comprises duo Craig Proud and Benjamin Kay, who each have different yet overlapping strengths regarding

the projects that the studio undertakes. Workshops are Benjamin's thing; he is a curator of events like print parties including the venture Made In A Day. Craig's artistic practice often involves designing and producing hefty conceptual books using analogue printing methods, combining mimeograph, letterpress, Risograph and thermography.

Dizzy Ink is currently in the process of establishing The School of Print, an open access screen printing studio that offers guest workshops and the opportunity to use rare equipment in an environment used by professional print artists. Dizzy

Ink has built a reputation as a place to realize the potential of print.

Being the first UK studio to offer the use of a mimeograph machine, Dizzy Ink is looking forward to bringing the stencil duplication movement back to an era predating the Risograph. Using various engineered extra parts, the machines are able to print onto fabric, 600 gsm card and rolls of paper, as well as blend colours using one stencil, and produce artwork directly onto a master – techniques that are all impossible on a Risograph printer.

COLO-RAMA
BERLIN, GERMANY

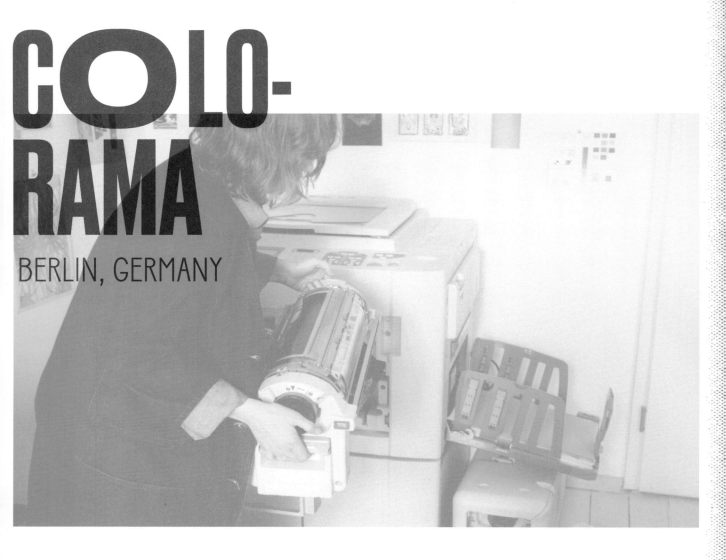

Colorama is a Riso-printing studio with a small comic distribution and publishing section based in the Kulturhaus ACUD in Berlin. The studio is run by Johanna Maierski, an illustrator and cartographer, and was co-founded in 2015 with Charlotte Collin, a freelance graphic designer.

Colorama was born out of an urgent wish to work as independently as possible, and the desire to create a network of creators, to work on collaborative projects and support each other. So far the studio has worked with universities, authors and artists to produce scientific works or monographs in larger editions, as well as with illustrators and comic artists for smaller printruns, as well as, of course, with neighbours and friends for spontaneous printworks such as flyers, posters and invites.

In addition, last year Colorama started hosting workshops in collaboration with universities, artists and professionals. The workshops are meant to be a platform for kids and grown-ups to exchange their approaches and experiences, and to hone the processes of creative output and shared authorship.

Colorama aims to share its craftmanship in order to make the process of designing, illustrating, conceptualizing, printing, binding, publishing and distributing as accessible as possible. Colorama believes in the power of collectivity and diversity, and therefore aims to realize projects with many different contexts and budgets.

MACHINES
RISO MZ 970

COLOURS
Black, Blue, Medium Blue, Red, Yellow, Flat Gold, Green, Fluo Orange, Fluo Pink, Burgundy, White, Purple

colorama.space

Risomat is Slovakia's first Riso-printing studio. Founded by Michal Tornyai and Radko Cepcek in 2015, it is run out of the graphic design studio KAT.

In collaboration with the *Cierne diery* (Black Holes) project, it currently focuses mostly on prints of Risograph artworks featuring abandoned industrial landscapes, created by artists, graphic designers and illustrators. The artworks are printed in limited editions (from 30 to 70 copies); to date more than 27 have been printed, and many of them sold out almost immediately. The goal of this project is the promotion and preservation of Slovak industrial heritage.

Apart from cooperation with *Cierne diery*, Risomat has printed a typeface specimen for a local type foundry, four issues of *¾ Revue*, a Slovak magazine of alternative culture, various artistic publications and works of leading young Slovak visual artists, and much more. Risomat also took part in the Bratislava Design Week 2015, holding a Riso-printing workshop and exhibition of Risograph prints.

MACHINES
RISO RP 3700

COLOURS
Black, Blue, Green, Purple, Yellow, Fluo Pink

risomat.sk

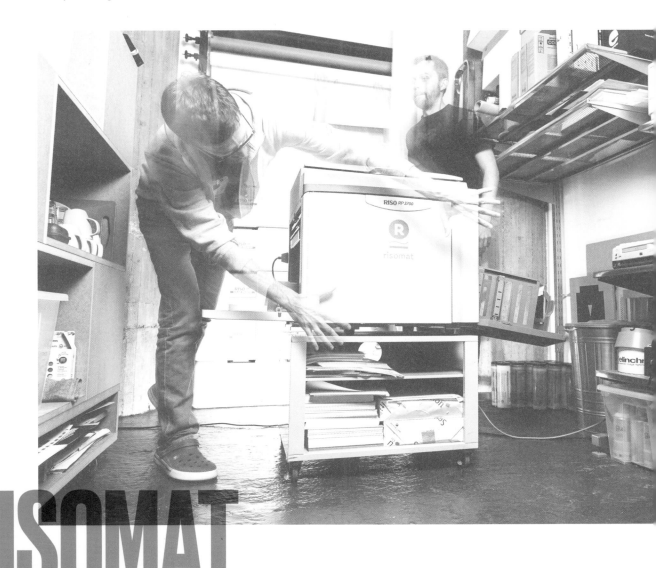

RISOMAT
BRATISLAVA, SLOVAKIA

MACHINES
2 Risograph RP 3700
Risograph 3105 EP

COLOURS
Black, Blue, Green, Purple,
Teal, Flat Gold, Red, Brown,
Yellow, Orange, Fluo Pink

superterrain.fr

SUPER TERRAIN

NANTES, FRANCE

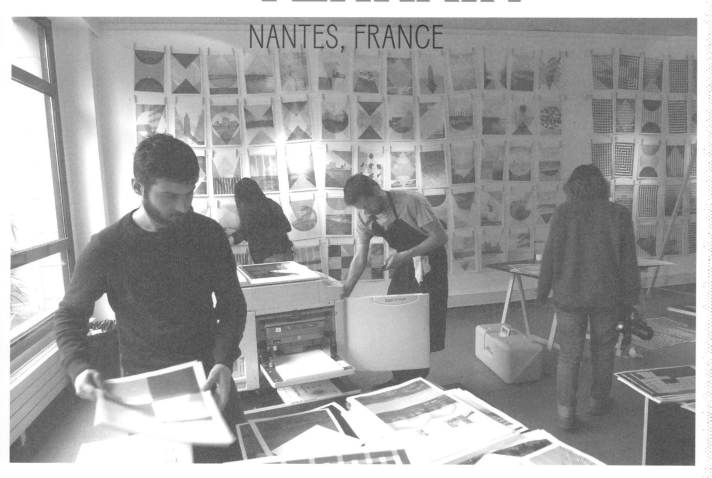

Super Terrain is a Nantes-based collective of graphic designers, composed of Quentin Bodin, Luc de Fouquet and Lucas Meyer. They mainly work in the cultural, institutional, associative and educative fields. Through commissioned graphic works, teaching workshops and public space interventions, or in their own works, they explore questions linked to editorial forms and printed matter. They focus on every stage of a project: creating content, the printing process, diffusion and promotion, and the context of intervention.

Knust Press began as a publishing studio in 1983. In 1990 Knust became part of the new initiative Extrapool, an artist-run organization, and in 1991 bought their first Risograph. They used Roneo and Riso together for about six years. In the beginning they didn't accept commissions, so when people asked them to print books they replied that they could come and do it themselves. The amount of people asking to make their own books slowly grew from about one in 1986, to many by the mid-Noughties.

But the people they really wanted to come weren't applying, so they started two residency series in 2010: one is *Art Prison*, for which they invite people, and the other is *Work Holiday*, which is open call. They still produce books for other people, people still come to make and publish their own books, and they still make their own books and zines. In the mid-90s they also started to accept regular print jobs, and became the alternative

printer in town, making them an independent organization.

The decline of the graphic industry started to affect Knust in 2012. They are no longer the alternative and cheap printer, and say they no longer ever get questions from people who want to make 1000 books or so. The residencies, jobs from people who like Riso and rough paper, and their own work are now their main business. In 2014 they set up a second Riso studio in AGA (Amsterdam Grafisch Atelier). It is DIY and run by volunteers. In 2015 they bought the new Riso A2 machine, and have started coming up with concepts for books based on the A2 sheet size.

Knust uses the following machines: Riso V8000 (2 in Nijmegen, 1 in Amsterdam); Riso MZ 1070 E (1 in Nijmegen, 1 in Amsterdam); Riso A2; Ricoh Priport JP8500; Ricoh Priport TCII; Seriprinter (UV extension of Priport); Riso Print Gocco (3); and a mimeograph stamp from the

fifties. They have old stencil machines they use for special occasions: Roneo 865 and 870 (6); Roneo 750; Rex Rotary D490; and 2 Roneo and 2 Gestetner A3 stencil machines that could be revived. Knust now have 61 different colours. They mix Riso ink, have Priport custom colours made, and make Roneo ink.

MACHINES
Full details in text

COLOURS
Full details in text

knustpress.nl

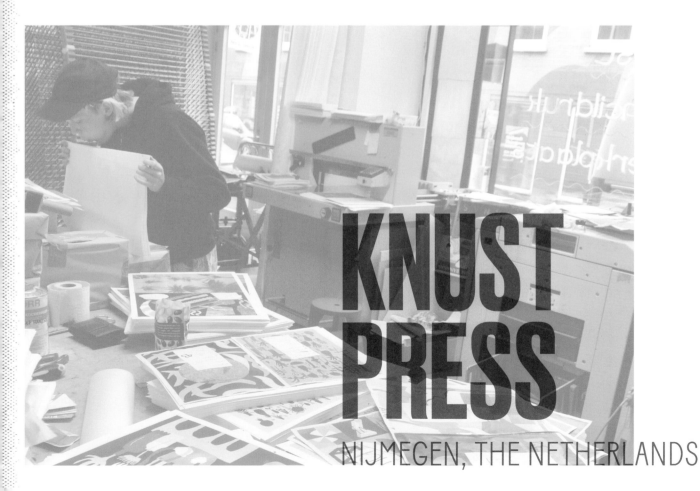

KNUST PRESS

NIJMEGEN, THE NETHERLANDS

Based in sunny Glasgow and headed by designer Gabriella Marcella, RISOTTO is Scotland's leading Risograph specialist, servicing and supplying independents and organizations with playful print.

RISOTTO was born out of Marcella's love of being able to play and experiment with equipment, and the speed and unpredictability of the process has proved extremely influential on the house style. The Risograph encourages experimentation with quick decisions and fast outputs, producing a fantastic range of printed matter through a limited ink spectrum.

The relationships and collaborations that have emerged since launching RI-SOTTO have allowed Marcella to meet and work with a whole spectrum of creatives both locally and internationally, regularly trading prints, skills and technical advice.

The evolving products that emerge seasonally through the studio create a platform for the house style to take the limelight, and showcase new patterns and print across an assortment of papers and products. Posters are the studio's speciality, as the format and texture make a great pairing.

The various strands of the studio have been shaped by Marcella specifically to fuel her different interests in outputs, processes and people.

MACHINES
RISO MZ 770
RISO RP 3700
RISO GR 3750

COLOURS
Yellow, Orange, Fluo Orange, Fluo Pink, Bright Red, Lilac, Purple, Teal, Green, Aqua Blue, Medium Blue, Black, Grey, Burgundy, Gold

risottostudio.com

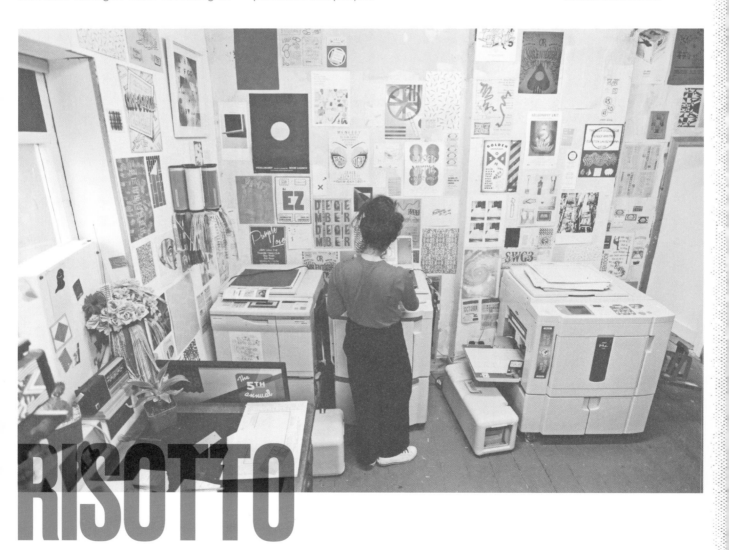

RISOTTO
GLASGOW, SCOTLAND

HURRIKAN

BUDAPEST, HUNGARY

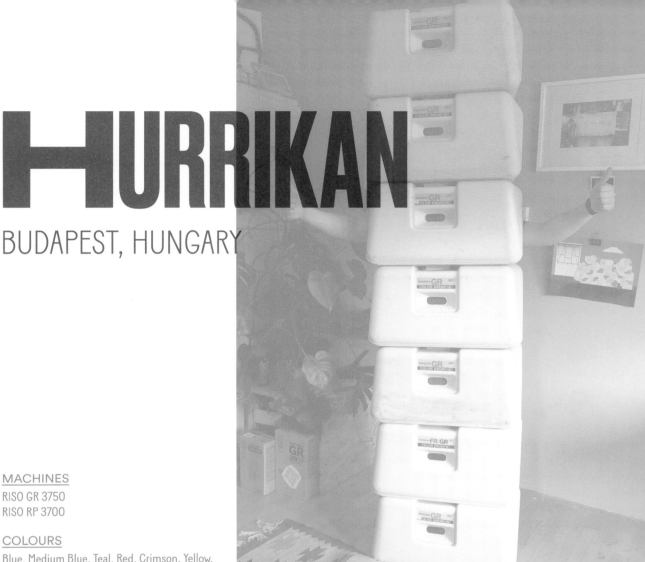

MACHINES
RISO GR 3750
RISO RP 3700

COLOURS
Blue, Medium Blue, Teal, Red, Crimson, Yellow, Green, Flat Gold, Fluo Pink, Fluo Orange, Black

cargocollective.com/hurrikanpress

The Hurrikan story began in 2011, when founder Arpad Szigeti first came across some Risograph-printed publications at the second One Day Independent Publishers and Fanzine Fair in Vienna, Austria. At this particular event he also decided to buy a machine and start his own business. His very first printer was an old, scrapped Riso GR 3750 with Black, Blue and Red colour drums; this he bought in 2014, finding soon after another one for parts.

Since buying his first Riso he has continuously carried out experiments with it and pushed the envelope of the technology, by for example producing A2 size prints. In 2016 Arpad was lucky enough to get an RP 3700 Riso in good condition. He decided to move his work equipment to a bigger place, moving in with Hungarian letterpress and design studio Absoloot. They provided him the opportunity to become an "external member" of their team. They use a wide variety of printing technologies, meaning they can mix their techniques and processes, merging letterpress with Risograph.

As Riso machines are mobile devices, Arpad is able to organize pop-up workshops and events in Budapest, as well as to take part in seminars around the whole country, as for example in the summer of 2015, when he participated in the Bánkitó Festival as a guest artist with the Csakoda Team. Here, they edited and printed magazines and daily papers for the Bánkitó Festival community as well as organizing workshops.

MONIKER PRESS
VANCOUVER, CANADA

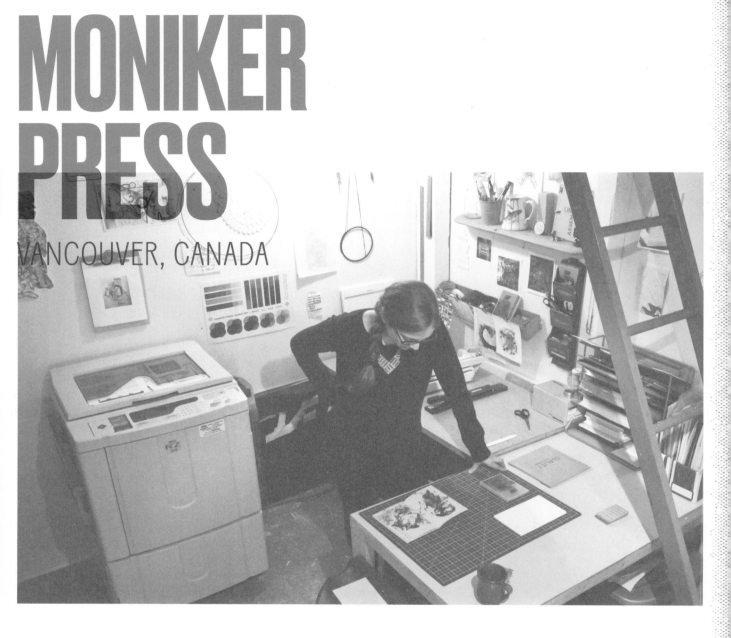

Moniker Press is a small Risograph publishing studio located in Vancouver, British Canada. Moniker offers commercial print services, and works with artists and writers to produce small editions of books, zines and print ephemera. As a modest operation undertaken between other jobs, Moniker uses a collaborative process of Risograph printing and bookmaking to find creative solutions to budget and resource limitations.

Moniker is owned and operated by artist and designer Erica Wilk, whose most recent publishing project involves creating zines while in transit between various countries in Europe. Called *Mobile Moniker*, it is a continuous openstyle project that will be compiled into a zine/book. Its focus is on exploring collaboration as well as the inner workings/processes of small scale Risograph shops and the artists who run them. *Mobile Moniker Vol. 1* will be launched at the Vancouver Art/Book Fair.

MACHINES
RISO RZ 990
RISO MZ 790

COLOURS
Black, Bright Red, Medium Blue, Green

monikerpress.ca

Alt Går Bra is a group of visual artists based in Bergen, Paris and London, with a studio in Paris 5ème. Created in 2015 by a core group of members working in performance, video, installations, printing, and philosophy, Alt Går Bra has shown work at the Palais de Tokyo, Bergen Kunsthall and other venues.

The printing studio produces publications and artwork for exhibits and performances. The masters for their printers are produced by burning or scratching stencils of different types. To burn the stencils, Alt Går Bra uses a Gestefax and a modified Risograph CR 1610 EP. To scratch the stencils, Alt Går Bra makes use of a variety of devices including Gestetner styli and a Gestescope to draw and write directly on the stencils. Typewriters, dot matrix printers, and other experimental procedures are also used.

The Gestetners are inked manually with Risograph ink. Alt Går Bra produces full colour (quadrichromy), duotones, prints with colours mixed simultaneously while printing, and other experimental colouring effects.

In March 2016, Alt Går Bra finished producing its first book fully designed, printed and bound at its studio, a 104-page post-exhibition catalogue for the 2015 exhibit and event *Victor Charlie*. Alt Går Bra's second publication of this type was released in July 2016. This is a 90-page book about the performance practice of Alt Går Bra member Agnes Nedregård.

MACHINES
Gestetner 366
Gestetner 466
RISO CR 1610 EP

COLOURS
Black, White, Red, Blue, Yellow

altgrabra.org

ALT GÅR BRA
BERGEN, NORWAY

Print studio Ink'chacha was founded in 2013. It is dedicated to exploring printing techniques both new and old, to see how artistic innovation can be brought to a local industry that, perhaps, needs more imagination and inventiveness. As well as Riso, Ink'chacha features letterpress printing, colour digital printing, foil stamping technology, and polygon business card cutting.

The biggest event they have organized so far was the *Zine Scene 2015* in February 2015, in which the studio helped 65 artists publish their own independent zines. An exhibition was held at Odd One Out in Wanchai to show the final products.

In addition, Ink'chacha has collaborated on various artistic ventures, as well as actively sponsoring activities carried out by organizations and individuals which align with its social and artistic values. In order to promote various methods of printing in art and de-sign, it has given lectures and held workshops for groups and individuals, and from time to time also collaborates with groups or specific events, including the Academy of Visual Arts (AVA) at Hong Kong Baptist University, the BA in Environment and Interior Design at Hong Kong Polytechnic University, the YMCA, the Hong Kong Design Institute, the Caritas Bianchi College of Careers, the 2014 HK Book Fair at KUBRICK, and the 2014 Kowloon City Book Fair.

INK' CHACHA

HONK KONG, CHINA

MACHINES
RISO RP 3700
2 RISO MZ 1070 A

COLOURS
Bright Red, Red, Fluo Pink, Orange, Fluo Orange, Yellow, Neon Green, Green, Spring Green, Aqua Blue, Blue, Medium Blue, Purple, Lavender, Moonbeam Silver, Mocha Brown, Metallic Gold, Black

inkchacha.ink

We Make It is a Risograph print and design studio, library, and exhibition space dedicated to artists, designers and people who love handcrafted printed matter. Alongside Riso printing, they have a variety of machines for processing and binding, including a guillotine, a stack cutter, a collator, a scoring machine, a hot foil press, several machines for perfect binding, pad binding and all the tools needed for their favorite, the 'pamphlet stitch'.

We Make It was set up by Franziska Brandt and Moritz Grünke, the founder of Gloria Glitzer, a small press for artists' books. They think of self-publishing as an artistic practice: "Making books is a process, based on autonomous power and action. It can be an emancipatory-critical act, and gives ideas a chance to survive and thrive."

At We Make It they share their knowledge, creativity and experience to help people to get their ideas into artzines, artists' books or other printed matter. On top of this, they collect artists' publications. A selection of their collection, focused on Risograph-printed artists' books, is available to the public at the Herbarium Riso library at the We Make It studio.

WE MAKE IT

BERLIN, GERMANY

MACHINES

RISO RZ 1070
RISO FR 3950
driven by a PostScript RIP

COLOURS

Black, Medium Blue, Blue,
Yellow, Crimson, Grey, Green,
Hunter Green, Teal, Brown,
Fluorescent Pink, Purple,
Orange, Burgundy

we-make.it

Sandwich Mixto is a 'fanzinería', a place where fanzines and self-published books are created, distributed and sold. The term was inherited from the place where Sandwich Mixto was born, the traditional food market of Antón Martín in Madrid. Fanzinería refers to everything related to editorial practices, methodology, process, and DIY culture.

One important aspect of Sandwich Mixto is their Risograph printing service, which gives them greater control over the process, and lets them print their own material and help others' wildest dreams come true. They produce material under the MIXTO BOOKS imprint and through SandwichClub, a club for hardcore fans of Sandwich Mixto who receive monthly, exclusive publications by post.

Another important part of what Sandwich Mixto does is related to the digital world: SAVE THE FANZINE, an online digital archive of self-published books, intended not to replace the physical with the digital but to pay homage to self-publishing culture and to record unique publications.

SANDWICH MIXTO

MADRID, SPAIN

MACHINES
RISO GR 3750
RISO MZ 1070 E

COLOURS
Bright Red, Red, Fluo Medium Blue, Blue, Fluo Pink, Black, Flat Gold, Green, Yellow

sandwichmixto.com

WOOLLY PRESS

ASHEVILLE, NC, USA

Established in 2013 by Mica Mead and Colin Sutherland, Woolly Press has produced a variety of publications, products, and artist prints. They strive to provide an outlet that supports original content and displays high quality creative technique with a commitment to the environment and excellence in printing. They are always interested in meeting new creatives looking for a way to utilize Riso technology. In 2016, Woolly Press curated the Riso Museum, an exhibition exploring the process, culture, and renaissance of the Risograph, and featuring work from a selection of top Riso presses from around the world.

MACHINES
RISO RP 3700

COLOURS
Black, Flat Gold, Bright Red, Fluo Pink, Yellow, Green, Blue, Teal, Burgundy, Metallic Gold

woollypress.com

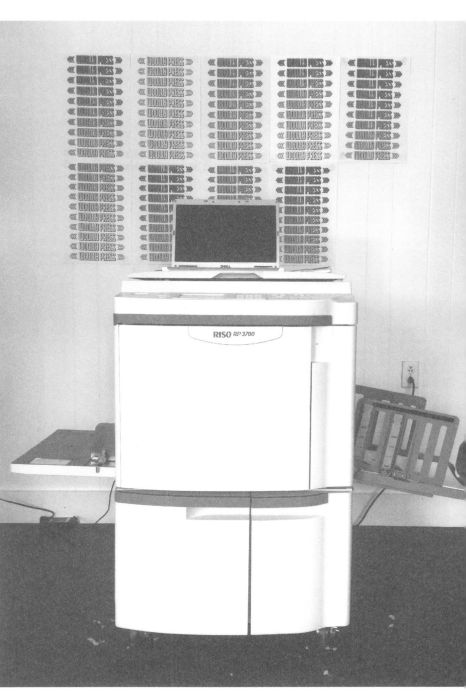

MACHINES
RISO RZ 970 E

COLOURS
Black, Medium Blue, Brown

printclubtorino.it

PRINT CLUB TORINO

TURIN, ITALY

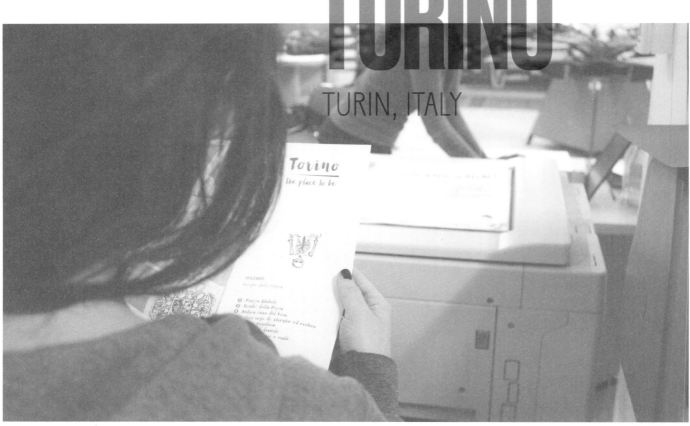

Print Club Torino is a print and graphic experimentation lab located in Turin. Its aim is to provide designers, illustrators, students and enthusiasts the opportunity to complete their graphic projects independently or supported by the Club's technicians.

The laboratory features a mix of innovative and traditional techniques. There are digital inkjet, laser and Risograph printers, several benches and a carousel for screen printing, and the machinery needed for print finishing and manual bookbinding.

The access to machinery is reserved for members. The membership card, set on an annual basis, allows

users to access the lab whenever they like, and offers discounts on workshops and lab items.

Print Club Torino believes in teamwork, exchange of knowledge and information. The team is committed to the promotion of local artists and activities. They want to give students and designers the opportunity to learn by doing, and develop vocational skills. They put a lot of importance on manual skills and self-production, and love getting their hands dirty by experimenting with paper and ink.

The lab offers a full calendar of events including workshops, meetings and training courses, all of which

embody the philosophy of participation and sharing of knowledge which is the basis of Print Club.

&soWalter (usw.) is a small printing studio in Stavanger, Norway. The studio was established in 2015 and is named after Walter Benjamin, the famous inventor of the mechanical reproduction of artworks. Most of their work is self-initiated (mainly by visual communication researcher Benjamin Hickethier and illustrator Goedele Teirlinck), but they do a lot of commissioned work too – for other artists, designers, and their communication design clients. In addition, they organize workshops and invite artists to print sessions. They have strong links to Grafill, the Norwegian organization for Visual Communication, and the multi-hearted art and design collective Fazed Grunion. &soWalter is part of the co-working space Consulatet (together with silkscreen printing artist DridMachine and others).

&SO-WALTER

STAVANGER, NORWAY

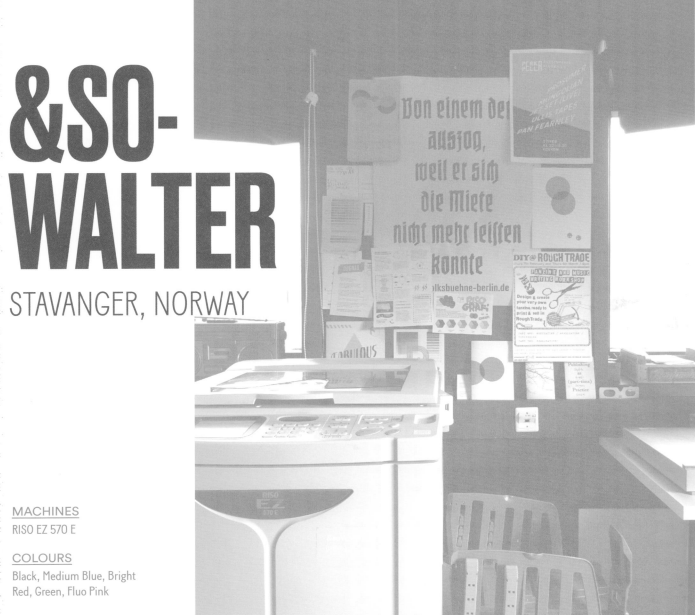

MACHINES
RISO EZ 570 E

COLOURS
Black, Medium Blue, Bright Red, Green, Fluo Pink

usw.press

STENCIL BASICS: A STEP BY STEP GUIDE TO RISO & MIMEO PRINTING

RISO PRINTING

Digital duplicators enable you to use a computer interface or an inbuilt scanner to create highly accurate stencils. In both cases, the image is transferred to a master sheet, which is wrapped around a colour drum in the heart of the machine. You feed the paper in one side of the machine and it comes out the other. The stencil acts as a screen through which ink is pressed directly onto the paper. For multi-coloured prints, the paper is sent through the printer multiple times, once for each colour. The trick to successful Riso printing is in the pre-printing process: setting up the stencil correctly and ensuring that the machine and its accoutrements are working smoothly. The more time you spend preparing the image to be printed, the less time you will have to spend in needless trial and error while printing.

SETTING UP THE ARTWORK

If you are using a computer, save the image at 300 dpi. The file must either be created in or converted to greyscale. If you are printing several colours, make a PSD file with layers, with one colour per layer and each layer named for its colour.

PRINT SIZE AND MARGINS

Most Risos print A4 or A3, although there is an A2 model. The Riso doesn't print full bleed and you will need to bear in mind that prints always include a white margin.

PAPER THICKNESS

Ideal paper thickness depends on the amount of ink you will use. 225 gsm is the thickest, 40 gsm the thinnest.

MISREGISTRATION

Risos were not originally designed for multi-colour printing. When you insert the paper for a second or third run, the registration might end up a bit off. This is part of the charm.

COLOURS

Riso inks come in 21 standard colours and more than 50 custom colours.

PRINTING PHOTOS

You can print full-colour using a faux-CMYK approach. The standard Cyan, Magenta (substituted by Pink Fluo or Red for the Riso), Yellow and Black can be varied with other colours.

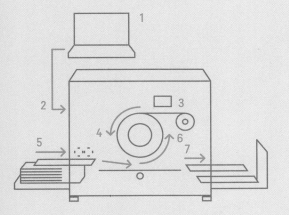

287 mm

420 mm 394 mm

297 mm

Opposite page:
A range of Riso inks contained
in their cylinders.
Image courtesy of Issue Press
and Jaimé Johnson

Above:
The final print followed by two
layers, each one correspond-
ing to a different colour (Blue
and Fluo Orange), courtesy
corners.kr

A schematic representation of
the functioning of the Riso.
The full printing area of the
machine does not extend to the
very edge of the sheet of paper.

Left:
Corners
—
A misregistered print

Previous spread:
Topo Copy
—
Colour chart

Following 2 spreads:
Artwork in the tutorial
by Mizuho Aida

PRINTING WITH A RISOGRAPH

01 Place the paper in the paper feed tray. Adjust the guides on the feed tray.

02 Insert the colour cylinder corresponding to the first ink you want to be printed.

PREPARING THE STENCIL VIA COMPUTER (A)

3A If you are using software, compose your image, breaking it down into layers corresponding to the colours you want to print in. Each of these layers will then form the basis of a single stencil, which will print only that colour.

4A Select the first layer corresponding to the first colour, and via the option panel select the desired colour and the relevant options. Hit print and the computer sends the machine an order to burn the first master.

5A

The transfer of the image for each colour level is made with a thermal head that creates the master.

6A

Select the number of copies. It's a good idea to select a larger number than you need, in case of slip ups.

7A

The first colour comes through. Adjusting the paper guides properly prevents jams and enables the prints to stack neatly.

8A

Second layer, second colour. Change the colour cylinder. Send the second master to be burned.

9A

Once the second master is ready, feed the paper back into the machine, making sure it's the right way round. Wait, ideally, some hours before you do so, or else the wet ink might get on the rollers and stain the next round of prints.

10A

Hit print. The second colour is printed and the prints come out in the output tray. Let them dry a bit and presto!

VIA INTEGRATED SCANNER (B)

3B

If you are using the scanner, place the original in the scanner, using the editor to reduce or increase the size; adjust the image contrast and other basic settings.

4B

Once everything is set up, tell the Riso to make the master stencil.

5B

Here, the process is identical to printing off of software: the first colour comes through.

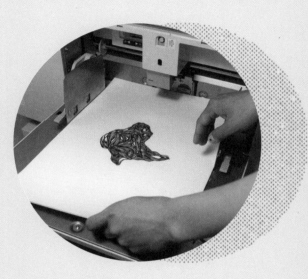

6B

Again, if you want to print with more colours, you will need to wait two hours for the ink to dry, and put the paper through the machine again.

7B

The second original is prepared for printing. Note that this analogue approach requires great precision and orderly thinking.

8B

The process is repeated for every subsequent colour. You may choose to make colours overlap, creating new tones.

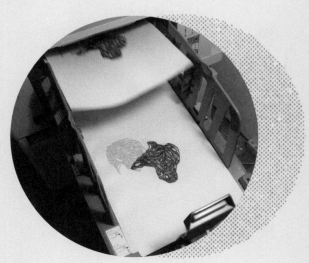

MIMEO PRINTING

Now, relative to contemporary digital duplicators like the Riso, printing with the mimeo is a more complex and laborious task, but one that maybe allows for greater creative freedom. This freedom lies mainly in the fact that you can more easily interact with and 'hack' the device to obtain experimental results that were not envisaged by its original inventors. Another important factor, as we have seen, is that the mimeo is a fully hands-on technology, which obliges users to reconnect with the materiality of the medium.

The first step in stencil duplicating is, naturally, the stencil. While digital duplicators contain a unit that allows you to make a stencil directly in the machine, mimeo stencils could only be hand-drawn (with a stylus) or typewritten on a special stencil paper. Today, it is very hard to get your hands on original stencil paper. The first option is to scour flea markets, old stationery stores or office suppliers that still have old stock. Failing this, various alternatives are being explored by enthusiasts of the technique – a valuable source of ideas is the Facebook group Mimeomania.

One of these alternatives is simply to adapt a Riso stencil by giving it a 'heading' to make it compat-ible with the mechanism of a mimeograph: this heading, affixed to the top edge of the stencil, is made of perforated cardboard punched with holes corresponding to the pins on the mimeo-graph drum. Different manufacturers of mimeo-type devices each had their own pin arrangement for holding the stencil in position on the drum, and thus produced different types of heading, so their stencil paper could only be used with their own range of machine.

A more expensive alternative is to use machines like the Gocco Pro that make stencils similar to those of the Riso; people also adapt the thermal stencils that are used by tattoo artists. There are also those who have hacked old Risos so they can interrupt the preparation process after the stencil is produced, but before it is automatically applied to the cylinder: this is a very fiddly technique, though, given the complexity of the machine, and not recommended for beginners.

There are or were many, many different brands of mimeograph, each one with its own specific features and peculiarities. The essentials of the process, however, are essentially the same. Here we cover the operation of a Gestetner 300 – the aspiring mimeographer will be able to modify and adapt the steps to her own instrument.

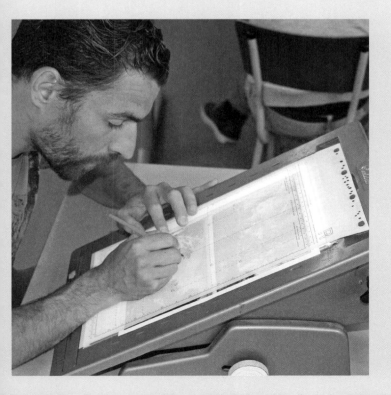
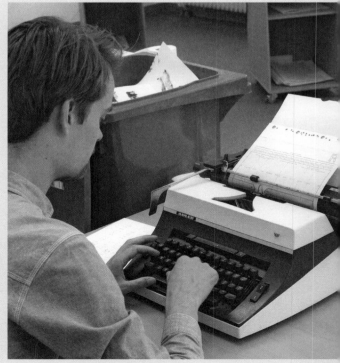

Opposite page, below:
In the images you can see
two ways to prepare a stencil,
either with a typewriter
or directly by hand

Right:
Erwin Blok has also
experimented with printing on
rolls of paper and textile

Below:
The Gestetner or mimeo
allow you to experiment
creating 'rainbow' gradients
of ink, mixing the inks
directly in the machine

Below left:
Different stencil headers
from different brands

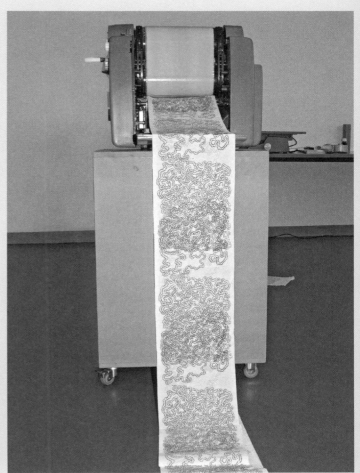

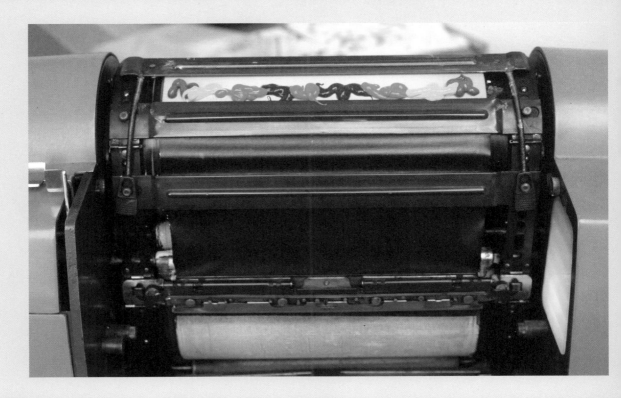

PREPARING A STENCIL (ANALOGUE)

01 Note that the traditional mimeo stencil has three strata: the stencil proper, the backing paper, and a sheet of carbon paper between the two.

02 There are a range of metal styluses, each with different contact surfaces, that can be used to design a stencil by hand.

03 Use a mimeoscope or tracing light box to create the desired design, putting underneath it a special plastic sheet.

04 Trace the design with the tools. Take care not to pierce the fibrous part of the stencil, as this ruins it. You can also achieve a textured effect using 'frottage' techniques.

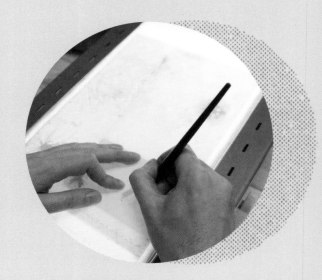

PREPARING A STENCIL (DIGITAL)

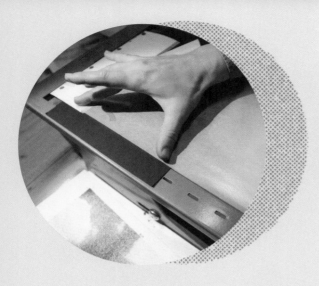

01 This is not a precise science. You can either recuperate the header from an original mimeo stencil, or make your own, with perforations that correspond to the pins on your model.

02 Connect the header to the stencil with tape, The mimeoscope (light table) features pins that help to hold the header in place.

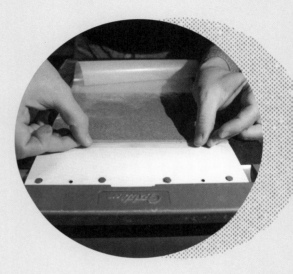

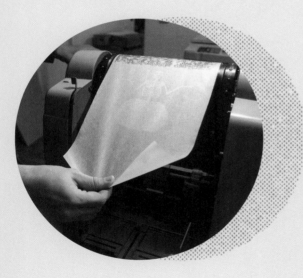

03 Attaching the stencil to the machine by lining up the pins and the holes in the header. It must also be attached at the foot.

04 Hold the stencil in place with another strip of tape and you are ready to print!

PREPARING THE MACHINE AND PRINTING

01 It is hard to find mimeo ink today, so most people use Riso ink, applying it directly to the upper cylinder. Give it a couple of spins with the handle and an even, thin film of ink will be visible, giving a slight sheen to the surface of the ink screen.

02 Turn the handle clockwise until the stencil fixing bar is at top of machine. With the typed side of stencil facing inwards, affix the header to the pins as shown on previous page.

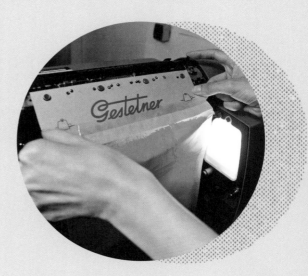

03 Raise the back and side guides and move them fully outwards.

04 Pull back guide all the way back. Fan out the paper and square it. Then place it on feedboard fully forward and use the scale to position the stack in relation to stencil. Move side fences to rest lightly against paper stack. Slide back guide towards paper stack until it almost touches it; lower the paper weight on to the paper.

05 Raise the feedboard until the paper stack contacts the paper height stop. The raising knob is automatically disengaged when this position is reached.

06 Depress feed lever, slowly turn handle clockwise and, as soon as feed mechanism begins to operate, raise the feed lever whilst completing clockwise turn of the handle.

07 Examine copy for correct position. Turn print height adjuster upwards to raise and downwards to lower the copy. This adjustment is unnecessary if the print height adjuster is set at 'O'.

08 Set counter to number of copies needed by turning the setter anticlockwise to 100s required. The image shows the counter set for 1,025 copies. When the required number of copies has been printed, the counter registers 'O', automatically stops the feed mechanism and switches off the machine.

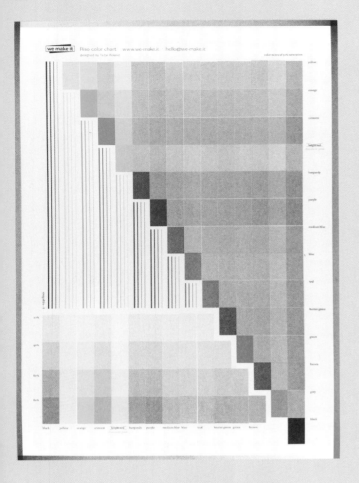

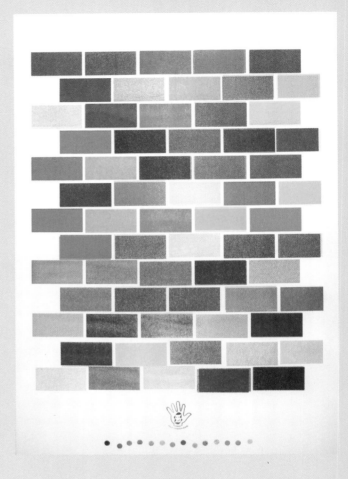

Colour charts and printing guides are printed by studios to lay out the capacities of the Riso. One key function of the colour chart is to show what happens when colours are overlaid on other colours, giving rise to new tones. Printing guides illustrate the difference between printing from PDF vs. JPEG, for example. Here we show a selection of different materials from different studios.

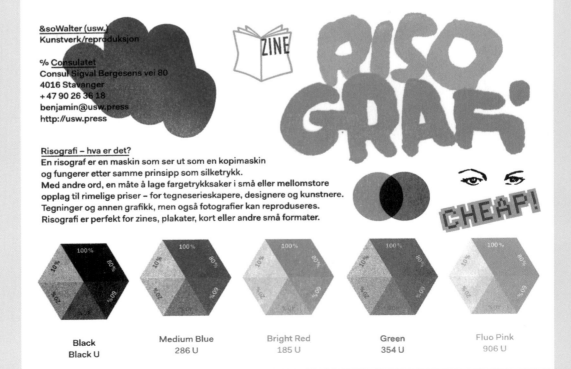

&soWalter (usw.)
Kunstverk/reproduksjon

℅ Consulatet
Consul Sigval Bergesens vei 80
4016 Stavanger
+ 47 90 26 36 18
benjamin@usw.press
http://usw.press

Risografi – hva er det?
En risograf er en maskin som ser ut som en kopimaskin og fungerer etter samme prinsipp som silketrykk.
Med andre ord, en måte å lage fargetrykksaker i små eller mellomstore opplag til rimelige priser – for tegneserieskapere, designere og kunstnere.
Tegninger og annen grafikk, men også fotografier kan reproduseres.
Risografi er perfekt for zines, plakater, kort eller andre små formater.

| Black | Medium Blue | Bright Red | Green | Fluo Pink |
| Black U | 286 U | 185 U | 354 U | 906 U |

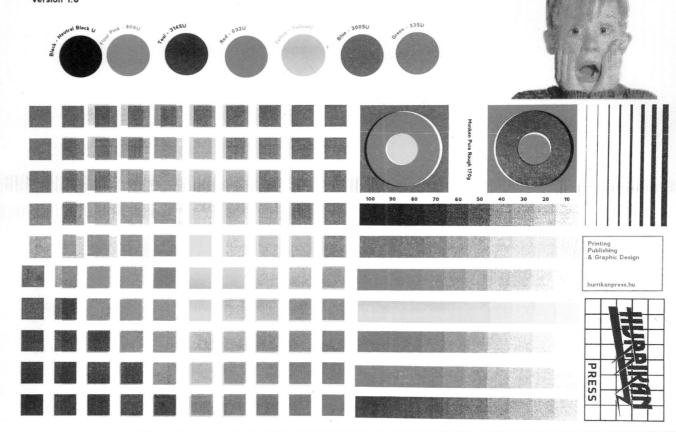

HURRIKAN PRESS COLOR CHART 2015
version 1.0

Black - Neutral Black U Fluor Pink - 806U Teal - 3145U Red - 032U Yellow - YellowU Blue - 3005U Green - 335U

Munken Pure Rough 170g

100 90 80 70 60 50 40 30 20 10

Printing
Publishing
& Graphic Design

hurrikanpress.hu

PRESS

Opposite page,
clockwise
from top left:

**We Make It,
Riso Presto and
&soWalter**
—
Colour charts, 2016

Hurrikan Press
—
Colour charts, 2015

RISOTTO Studio
—
Sample pack, 2015

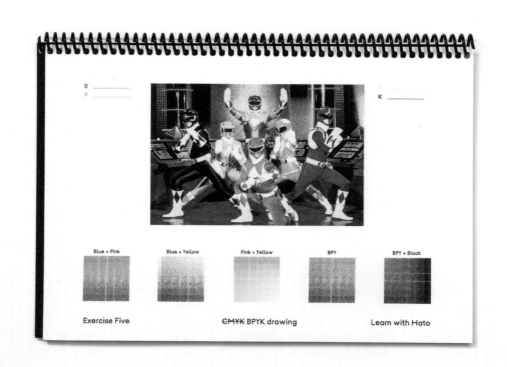

meli-melo 60 pt
meli-melo 55 pt
meli-melo 50 pt
meli-melo 45 pt
meli-melo 40 pt
meli-melo 35 pt
meli-melo 30 pt
meli-melo 25 pt
meli-melo 20 pt
16 pt
12 pt
10 pt
8 pt

Gula

B _____ Y _____
P _____ K _____

Blue + Pink	Blue + Yellow	Pink + Yellow	BPY	BPY + Black

Exercise Five ~~CMYK~~ BPYK drawing Learn with Hato

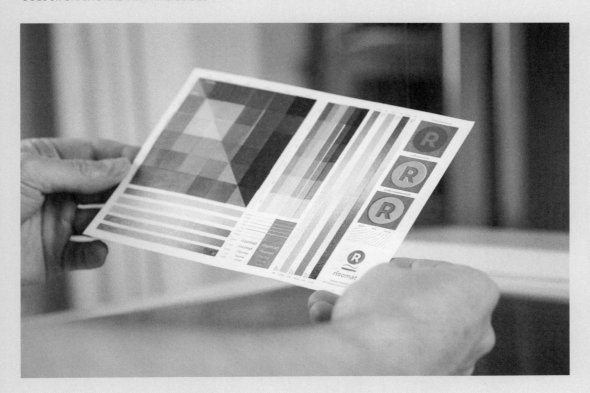

Opposite page:
Meli-Melo

Printing guide

Hato Press

Colour charts

Risomat

Colour charts

Atto

Printing tests

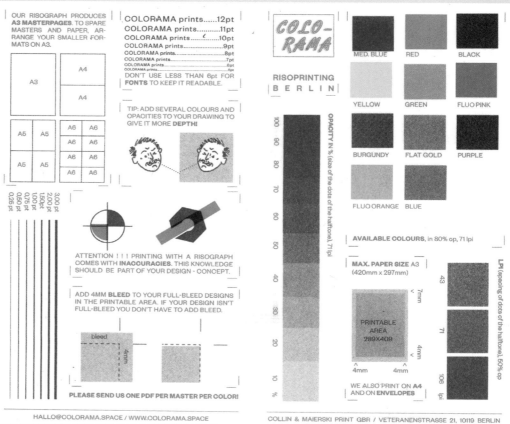

Colorama
—
Printing guide

Ink'chacha
—
Colour chart

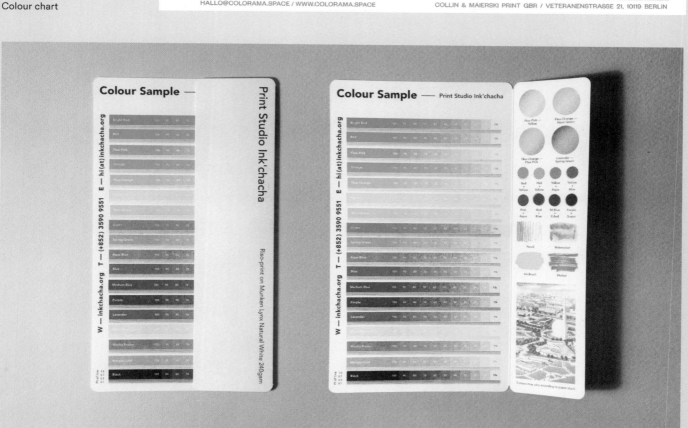

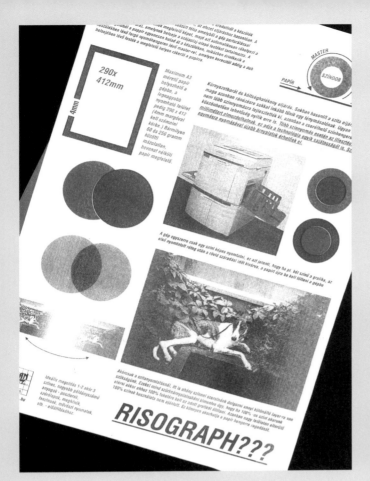

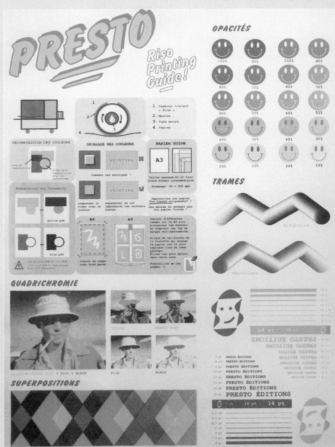

Clockwise
from top left:

Hurrikan Press
—
Printing guide

Riso Presto

Printing guide and
colour chart

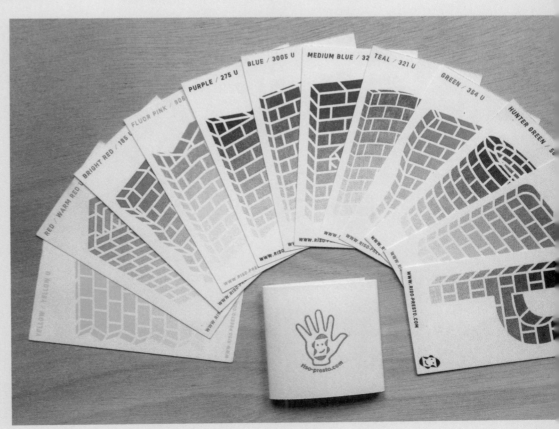